IMAGES
of America

CLOSTER
AND ALPINE

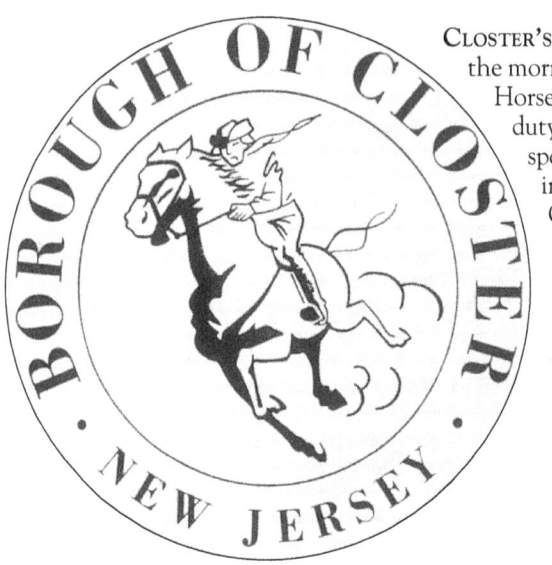

CLOSTER'S PAUL REVERE AND BOROUGH SEAL. On the morning of November 20, 1776, Closter's Lone Horseman, probably a farmer on military sentry duty posted at the crest of the Palisades Cliffs, spotted the British general Cornwallis landing by boat with 5,000 troops at the Lower Closter Landing. The horseman raced south nine miles to warn the fort at Fort Lee. The fort was captured by the British, but without loss of patriot lives; those soldiers of Washington's army lived to fight the Revolution.

This book is dedicated to the citizens of Closter and Alpine on the eve of their centennial celebrations. May these images of centuries of former residents and their achievements provide a touchstone for future community pride. Also to my daughter Christina, husband Manuel, and to Bill Zimmer for their patience.

He saw the Redcoats on the Eastern Hills
The Closterman who galloped through the mist
To warn the troops in Fort Lee's garrison,
His plow horse carrying him to glory
On the most momentous ride in history . . .
The hinge on which the door of Freedom swung.
 —From *Along the Palisades*, by Dan T. Mahoney

IMAGES
of America

CLOSTER AND ALPINE

Patricia Garbe-Morillo

Copyright © 2001 by Patricia Garbe-Morillo
ISBN 978-1-5316-0529-2

Published by Arcadia Publishing
Charleston, South Carolina

Library of Congress Catalog Card Number: 2001088732

For all general information contact Arcadia Publishing at:
Telephone 843-853-2070
Fax 843-853-0044
E-mail sales@arcadiapublishing.com
For customer service and orders:
Toll-Free 1-888-313-2665

Visit us on the Internet at www.arcadiapublishing.com

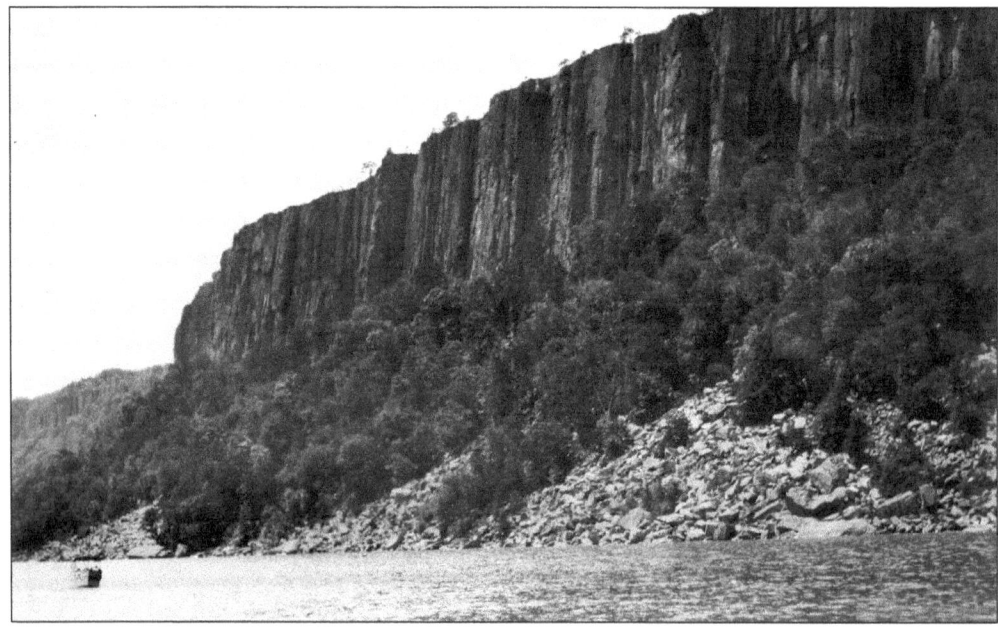

THE PALISADES CLIFFS. Magnificent views are afforded by the cliffs that rise 500 feet above the Hudson River. The cliffs form the entire eastern border of Alpine and are world famous for their scenic beauty. The first European to record their grandeur was the explorer Giovanni da Verrazano when he sailed up the Hudson River in 1524. He named the Palisades area the Land of the Grand Scarpe (La Terre de l'Anormee Berge) and referred to the cliffs as "beautiful beyond description." Throughout the 19th century, the cliffs were quarried and were nearly destroyed by the 20th century, when the Palisades Interstate Park Commission was created, sparing them. (Courtesy Palisades Interstate Park Commission, New Jersey.)

Contents

Acknowledgments		6
Introduction		7
1.	The Prehistoric Period	9
2.	Early Settlement and the Colonial Period	15
3.	The American Revolution	37
4.	The Railroad Suburb	45
5.	Skunk Hollow	99
6.	Alpine: The Hudson River and the Palisades	105
7.	The Twentieth Century	111

Acknowledgments

The Closter Historical Society and I would like to thank all the people of Alpine and Closter who searched their closets to find images of our area's past and entrusted us with their heirloom photographs. A great resource has been the commemorative books published by various authors through the years. They include *Closter: The First 285 Years, 50th Anniversary, 1954*, edited by Sophia Speake Maples; the 75th-anniversary publication *Historic Homes in Closter*, by Jeanne Gurnee and Joan Bastable, 1979; and the Alpine Bicenntenial Committee's *Crossroads of History*, by Stanley Bradley, 1976. The present historical book is intended to commemorate the 100th anniversary for both the Borough of Closter and Borough of Alpine.

I would like first to thank Bill Zimmer for offering his computer and scanning equipment, time, and patience in exchange for minimal compensation. Without his work, this book could not have been completed. Also to Tim Adriance, Eric Nelson, and John Spring for their editorial comments. Uma Reddy was responsible for many of the newer photographs, and Jean Stella helped with maps.

Major sources of historic photographs were provided by the collection of Harvey Conklin's late-19th-century glass negatives, Walter Mall Studios, the Belskie Museum, the Palisades Library, the Palisades Interstate Park Commission—New Jersey Section, the Centennial AME Zion Church, Charles Lyons, Emil Giotta, Pat Gianotti, Tim Adriance, M.J. Bogert-Semmens, Diane Crowe, Mary Anne Clarke (Demarest Historical Society), George Trautwein, and the Closter Fire Department. Other individuals who lent photographs and provided information regarding Closter and Alpine include the Alpine Radio Tower Company, the Bergen County Division of Cultural and Historic Affairs (Bergen County DC&HA), Irene Borghesian, Bill Cahill, Madlyn Cooper, G. Gerrard, B. Peterson, Clive Pearson, Tim Hamilton, Gayle Metzkier, John Mangano, Alice Parsells, Bert Pieringer, Frank Saladino, John Spring, Mark Gerub, Liz Holtzbach, Eric Nelson, Lois Knepp, Barbara Guile, the New York Public Library, Kenneth Thompson, Orlando Tobia, Geraldine Marshall, George Potterton, Jane Westervelt, and Kevin Wright.

Many sections in this book rely heavily on unpublished information located in the Closter Historical Society files, the Bergen County Department of Parks DC&HA, and *Historic Sites Survey for the Boroughs of Alpine and Closter*. Major informational published resources included *The Revolutionary War in the Hackensack Valley*, by Adrian Leiby; *Palisades and Snedens Landing*, by Alice Munro Haagensen; *The Story of the Ferry*, by Winthrop Gilman; *Skunk Hollow: A Nineteenth-Century Rural Black Community*, by Joan Geismar; *The Architecture of Bergen County, New Jersey*, by T.R. Brown and S. Warmflash; and *Closter, New Jersey* (Trade Improvement Association, 1903, Tenafly Publishing Company).

INTRODUCTION

The modern boroughs of Closter and Alpine are wedged between the Hudson River, the Palisades Interstate Park, and the downward slope of the Palisades cliffs on the east. Closter's western border is formed by the Hackensack River and the United Water Company reservoir. The Dwarskill Stream forms the present northern boundary with Norwood and drains the 126-acre wetlands known as the Closter Nature Center. A second stream, the Tenakill, flows north and passes through the western section of the borough. Streams rushing down the steep slopes of the Palisades provided a ready source of power for Colonial mills.

The area is geographically part of New Jersey's Piedmont Lowlands, and the Northern Valley was once the bottom of a prehistoric glacial lake. When the clay-bottomed lake receded, the deposits were overlain with thick organic plant matter. This rich mix provided lush vegetation and organically rich soils. These were attractive conditions for both prehistoric inhabitants as well as Colonial farmers and truck farmers after the Civil War. The receding lake also left behind a series of low sandstone ridges, which became the building blocks for the earliest settlers' homes.

Bergen County was formed in 1710. The area of the Northern Valley, of which Closter and Alpine are a part, was initially called Old Hackensack Township as early as 1693. By 1775, it had become Harrington Township. Much of this territory had been part of a bitter boundary dispute and was governed by both New Jersey and New York State during Colonial times. The final boundary line between the two provinces was not settled until 1769. Alpine and Closter finally incorporated as boroughs in 1903 and 1904, respectively.

From whence the name Closter derives remains a mystery to this day. There are several theories, however, none of them scientifically proved. The most probable one is that the name derives from an obsolete English word *closter*, which means enclosed place and which refers to the sheltered location of Closter. (The Dutch spelling for this word would be *clooster or klooster*.) Alpine, formerly known as Upper Closter, was officially named Alpine when the post office there opened in 1870.

From Revolutionary times through much of the 19th century, the name of the area between Englewood and Tappan was Closter. When the Northern Railroad cut through in 1859, Closter remained the commercial, educational, and religious hub of the valley area until well into the 20th century.

This book is arranged in chronological order, lavishly illustrated, and divided into time periods. The first chapter begins with the major discovery of the 10,000-year-old mastodon skeleton and prehistoric and Native American artifacts. The second chapter is devoted to the earliest European settlement and the Colonial era. The third describes the Revolutionary events

and Tory raids that so defined Closter. Chapter 4 is illustrated with images of the railroad suburb with its commercial, residential, and institutional developments. Chapter 5 is that of the Centennial AME Zion Church and the African American population that came from Skunk Hollow, a freed slave community, located in present-day Alpine. Chapter 6 is devoted to Alpine and includes the Upper Closter area and the Hudson River ports that were formerly known as the Closter Landings. Finally, the 20th century and a way of suburban life that evolved from the general use of the automobile and other technological inventions completes the book.

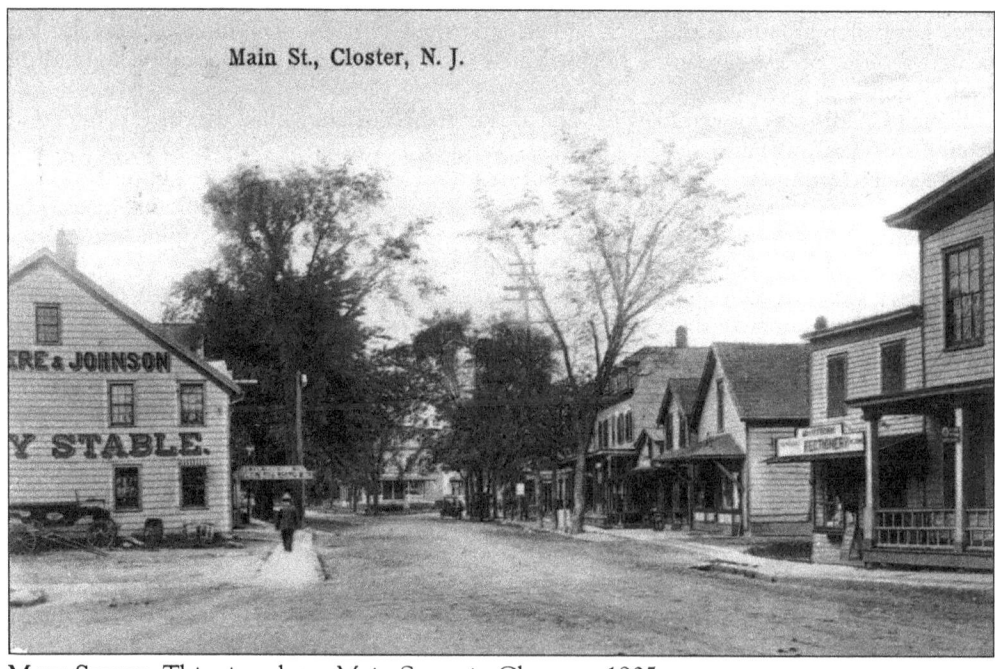

MAIN STREET. This view shows Main Street in Closter c. 1905.

One
THE PREHISTORIC PERIOD

During the Pleistocene epoch, the two main geographical features of northeastern Bergen County were the Husdon River Palisades and the huge glacial lake that covered the valley area to the west. As these lakes dried up, many swamps and wetlands formed above the old clay bottoms of the lakes. These bogs were valuable sources of food for prehistoric animals that would sometimes become mired and entombed in them. Early Paleo-Indian humans followed game here and left their distinctive spear points. Later, more sophisticated indigenous groups settled our area. They spoke an Algonquian language and are today referred to as the Lenni Lenape Indians. At first they subsisted exclusively as hunters and gatherers. By the time Europeans arrived in the 17th century, the Lenni Lenape had evolved a sophisticated culture that centered on settled village life. They exploited a varied ecosystem and were also cultivating crops such as maize and beans. Following European contact, these indigenous peoples did not survive long enough to witness the end of the 19th century.

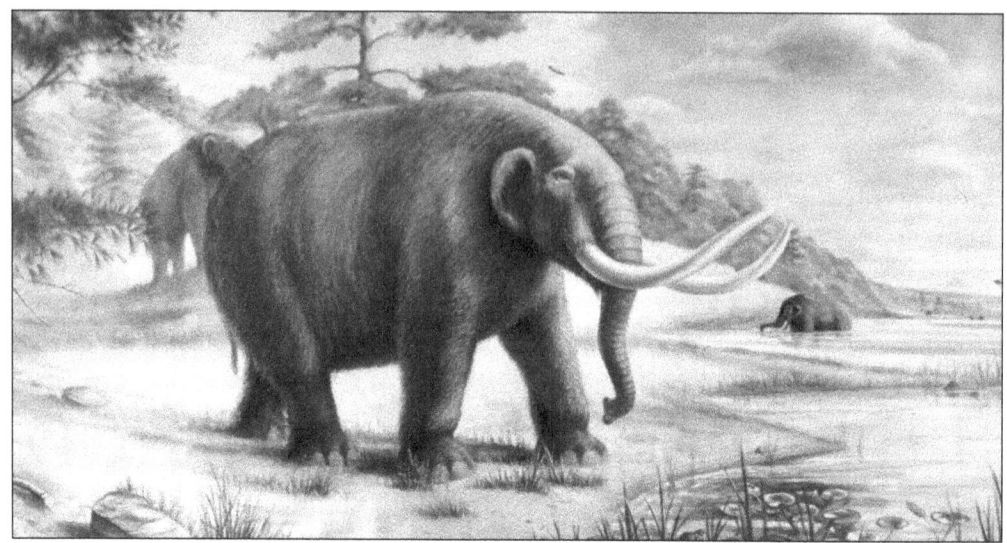

GRAZING MASTODONS IN NEW JERSEY. This oil painting shows mastodons feeding in the marshes and creek beds left by the Pleistocene-era lake beds in northern New Jersey. The large mural by Paul Ortlip formed the backdrop of the mastodon exhibit at the Bergen Museum of Art in Paramus. Mastodons were herbivores that stood between 9 and 10 feet tall at the shoulder and were about 15 feet long. Long hair covered an approximately eight-ton body with a flat head with small ears. Both sexes had tusks 6 to 10 feet long that were used for defense against predators, the dire wolf and the saber-toothed tiger, as well as against each other in cases of territorial invasion or mate competition. (Courtesy Bergen Museum of Art and Science.)

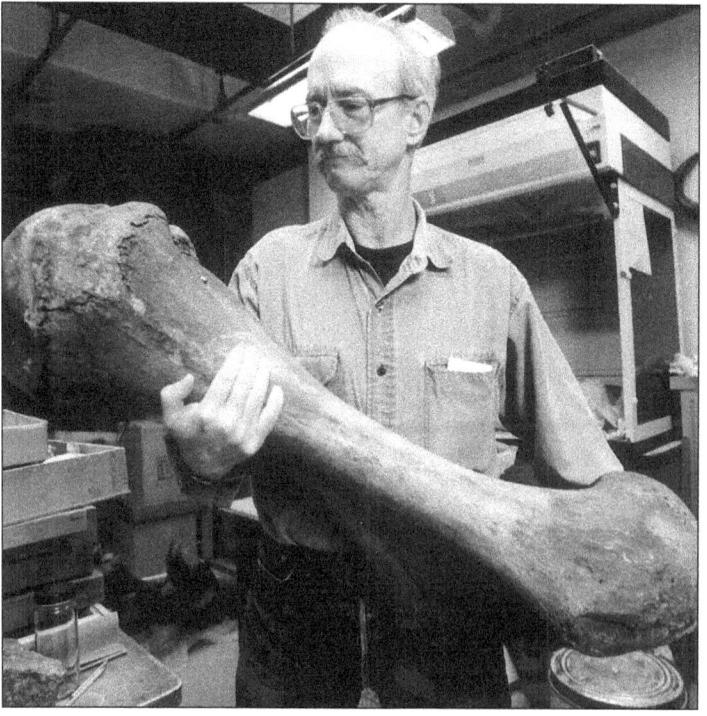

DAVID PARRIS HOLDING A MASTODON FEMUR. David Parris is curator of natural history at the New Jersey State Museum in Trenton. The Dwarskill mastodon skeleton was removed here when the Bergen Museum of Art in Paramus closed in 1999. Closterites affectionately refer to the specimen as Wooly. The Dwarskill specimen was a large animal weighing between 10,000 and 13,000 pounds. (Courtesy Bergen Record.)

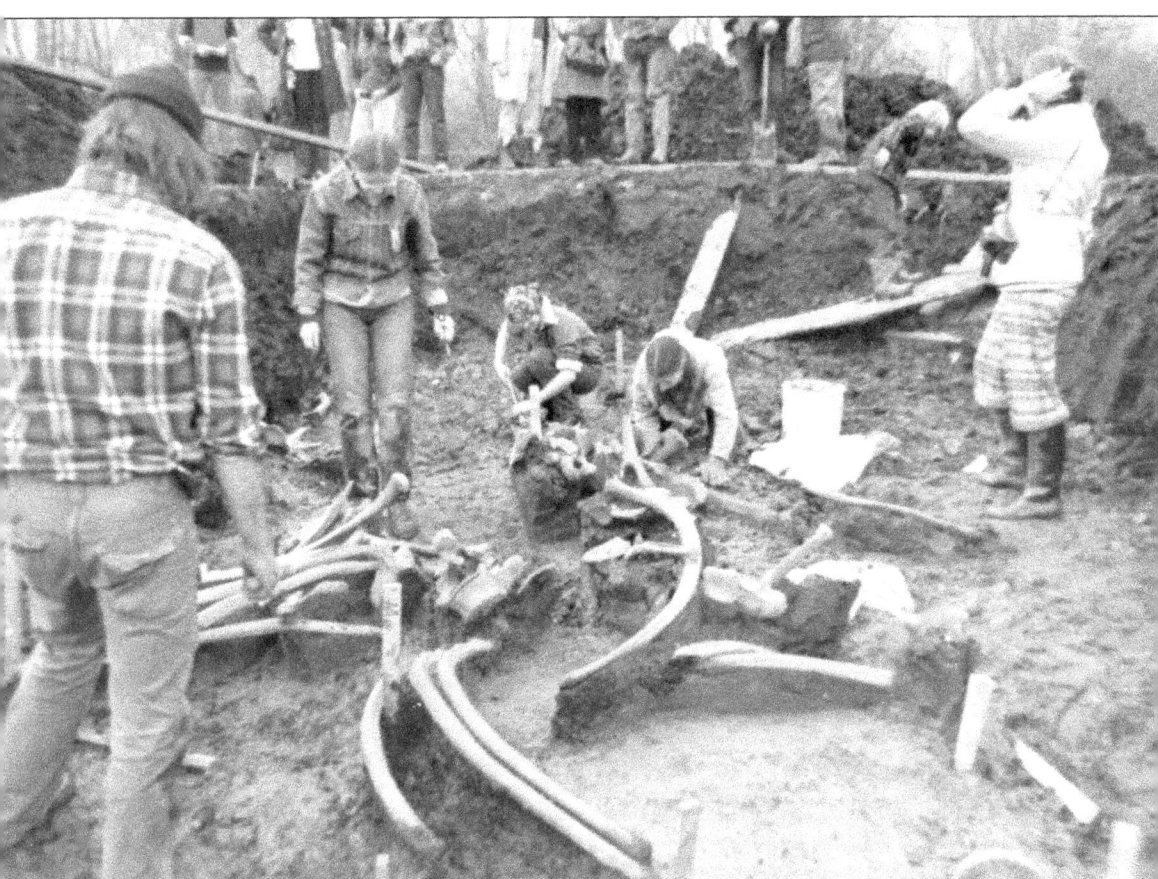

EXHUMING THE DWARSKILL MASTODON. In the spring of 1974, a shovel operator, employed by the Hackensack Water Company, was dredging in the area where the Dwarskill stream empties into the Hackensack River, at the northwest border section of Closter and Harrington Park. He discovered this almost complete (75 percent intact), 10,000-year-old, male, hairy mastodon. The excavation carried out by the American Museum of Natural History in New York City and the Bergen Museum of Art and Science was one of the best-documented scientific excavations of a mastodon skeleton in New Jersey. Jessica Harrison, the dig director, is pictured second from the left. (Courtesy Bergen Museum of Art and Science.)

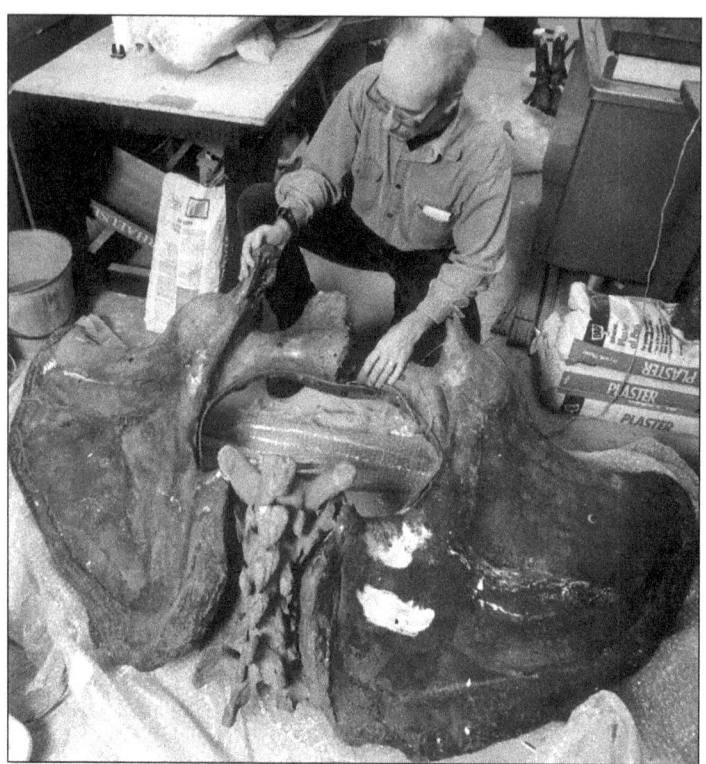

THE DWARSKILL MASTODON. This photograph shows the huge pelvis of Wooly. While at the New Jersey State Museum, Stockton College student Susan Johnson studied Wooly as part of a comparative research project. She studied numerous mastodon pelvises to find out whether sex could be determined from this piece of anatomy. The Dwarskill animal was a robust male specimen that became mired in the marshes in Closter about 10,000 years ago. (Courtesy Bergen Record.)

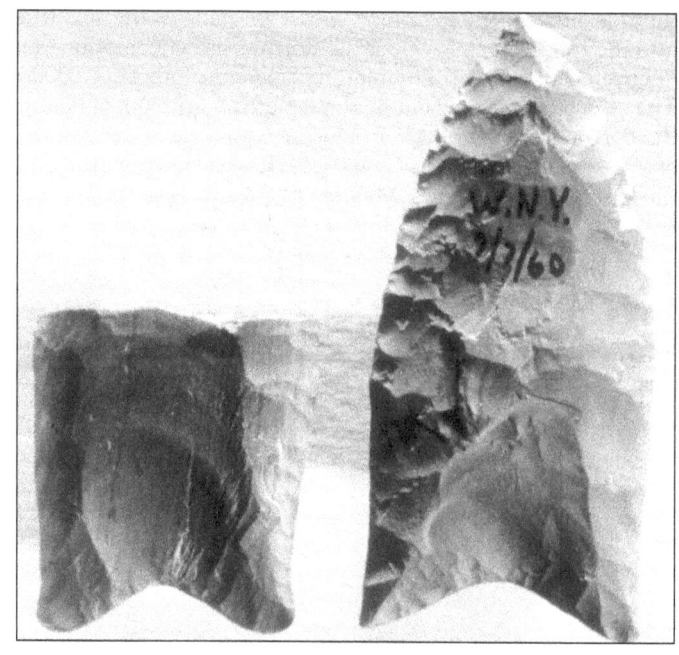

PALEO-INDIAN CLOVIS POINTS. These points were used as spearheads by nomadic Paleo-Indian hunters who entered our area c. 10,000 B.C. in pursuit of game animals. The broken point on the left was found in Closter near the Dwarskill mastodon site; the complete point, right, is from Nyack, New York. The definitive feature of this point was the flare of the end, or "ears," of the concave base. (Courtesy Emil Giotta.)

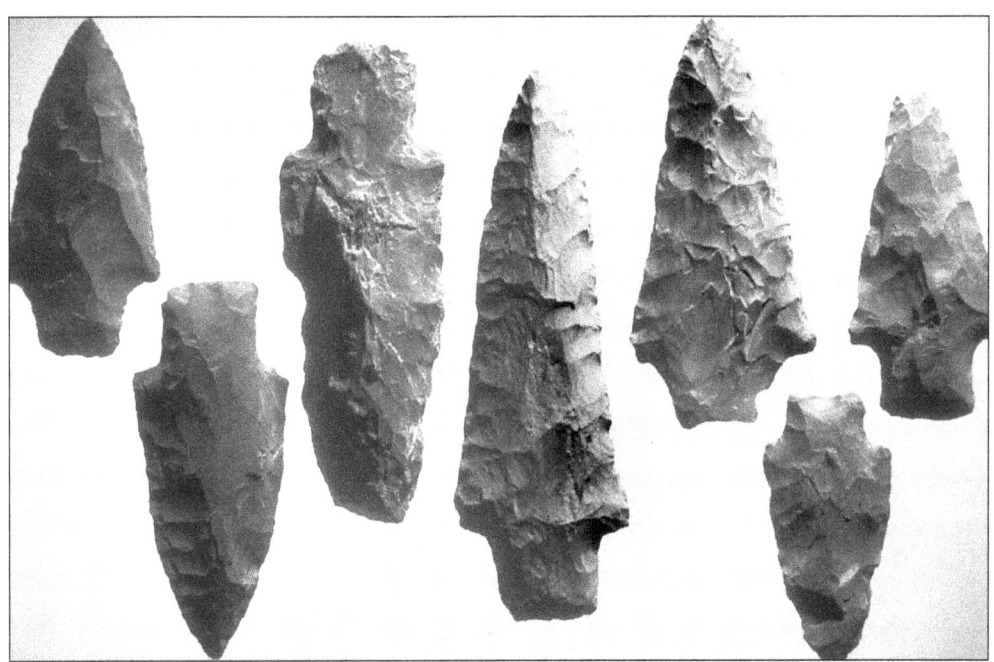

GENESEE POINTS FROM ROCKLAND COUNTY, NEW YORK. These spear points date from 6,000 to 2,000 B.C. Similar finds are known from Tenafly in the Northern Valley to Rockland County, New York, and throughout the Hackensack River drainage area. (Courtesy Emil Giotta.)

STONE AXES FROM THE CLOSTER AREA. This photograph shows a small grooved example on the left and a large lipped axe on the right. (Courtesy Emil Giotta.)

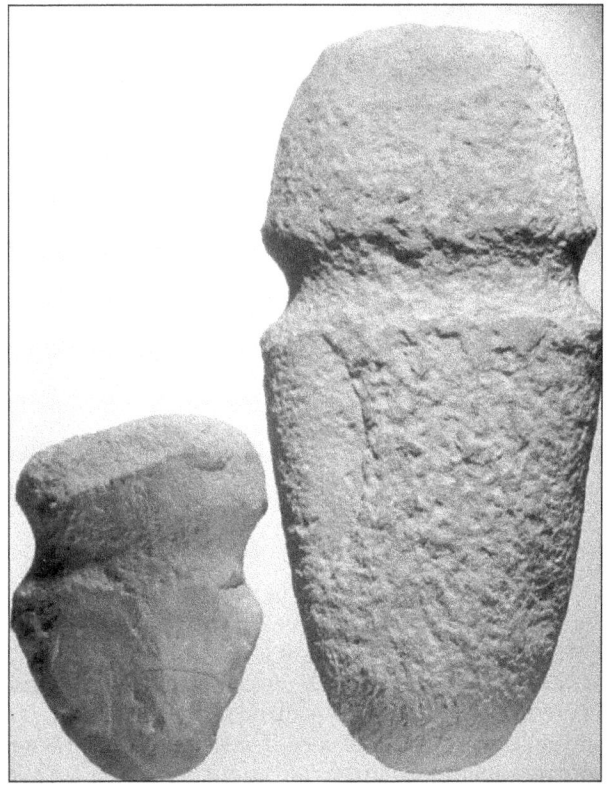

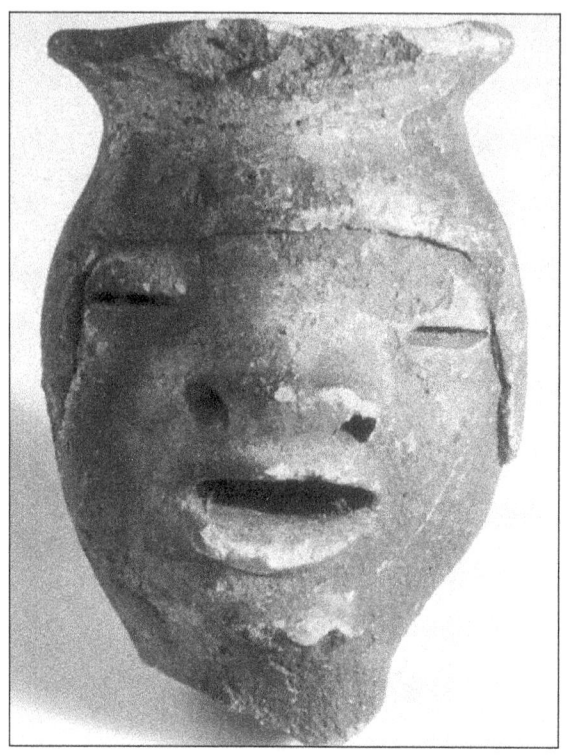

HUMAN EFFIGY POTTERY HEAD FROM HARRINGTON PARK. This fine example of the bowl of a smoking pipe dates from the middle Woodland period (around A.D. 500) and was made by the Lenni Lenape Indians. It illustrates trade and contact with the Mississippian peoples of the southeastern United States. (Courtesy Emil Giotta.)

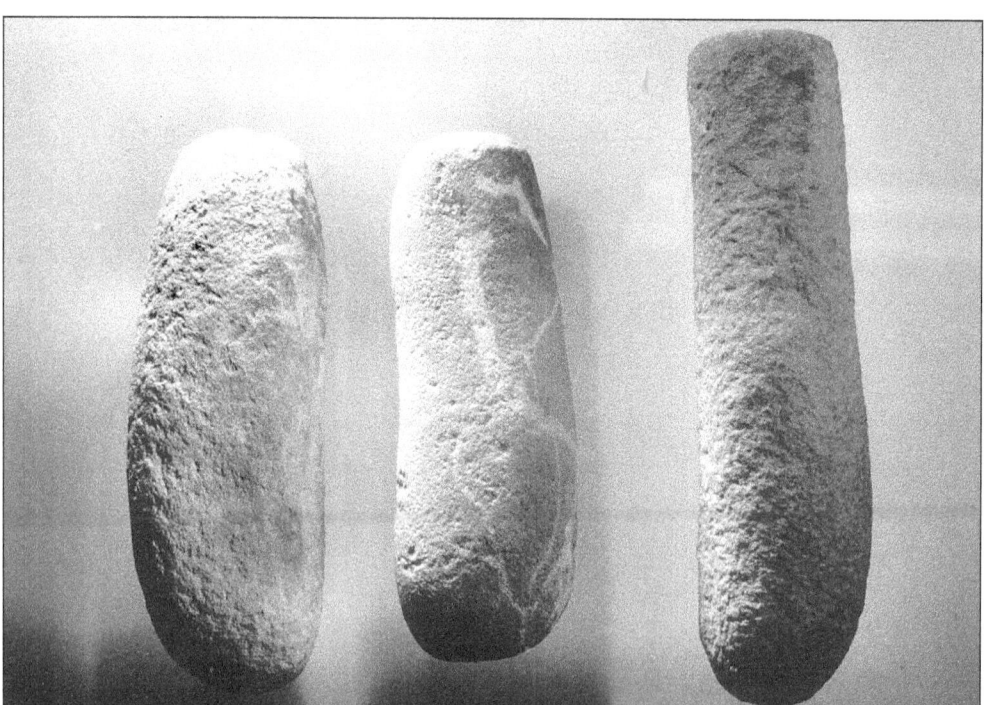

PESTLES. During the late Woodland period (after A.D. 1,000), the natives were settled in villages and growing crops such as corn. These utilitarian items were used for cracking nuts and grinding corn and grains. (Courtesy Emil Giotta.)

Two

Early Settlement and the Colonial Period

In 1686 the Tappan Patent, located just north of Closter, produced some of the earliest European settlement in our area. A group of 19 farmers with names such as Haring, Blauvelt, Ariaensen, De Clerque (De Clark), DeVries, and Tallman purchased the land from the Tappan Indians. The Lockhart Patent in 1685 included lands along the Hudson River in the Northern Valley and southern Rockland County, New York. Settlement in New Jersey on this tract was mostly by the Haring family after 1725.

Most of present-day Closter was owned by Barnabous VerValen in 1708. He sold the eastern portions of his land (which also included Alpine, Norwood, and Rockleigh), which was known as the King's Woods, to a Captain Syms in 1709. Syms in turn sold 1,030 acres of the land on the east side of Pieromont Road to Barent and Resolvent Naugle in 1710. Initial settlement and farming in Closter was begun by the VerValen and Naugle families in 1710. Other early families to settle in town were the Auryansens, Van Horns, Westervelts, Huylers, Bantas, Zabriskies, Montaque, Parsells, Jordans, and Coles.

An additional tract of land extending from south of Closter Dock Road into present-day Demarest and Cresskill was part of the original 2,000-acre Balthazar-De Hart Patent. These early settlers traced lineage to many European countries and Africa. (Only about half of 17th-century immigrants to New Netherlands were actually Dutch.) Many of them intermarried and, thus, cultural distinctions between them became more blurred. By the mid-18th century, however, these same multicultural groups were speaking Low Dutch, or Jersey Dutch, and some English in Closter.

As was the case elsewhere in Bergen County, the hybrid Jersey Dutch architecture, language, and customs dominated the cultural landscape for about 150 years. They built characteristic sandstone-walled houses with gable or gambrel roofs and sweeping eaves from the 1730s until c. 1850. In the Northern Valley, there are 39 of these distinctive homes, 10 of which are in the present boundaries of Closter. A second architectural tradition in the early 19th century was a group of frame residences found in Closter and elsewhere in Bergen County.

THE RESOLVENT NAUGLE HOMESTEAD, 119 HICKORY LANE. Constructed c. 1735, this is the oldest extant building in Closter and one of the earliest sandstone houses in the Dutch tradition in the county. The walls are coursed rubble with a diamond-shaped stone inset on the side of the entrance door. The gable roof has sweeping eaves and faces south like all of the stone houses in Closter. This was to catch the low arc and light of the winter sun. Resolvent and his older brother Barent were among the earliest settlers here in 1710. During the Revolution, four members of this household served in the Bergen County Militia under George Washington. One of the tasks of the militia was to build the fort in Fort Lee to protect the area against plundering parties and guard the shores of the Hudson River. The present eight-acre property with still operates as a farm. (Courtesy Bergen County DCH&A.)

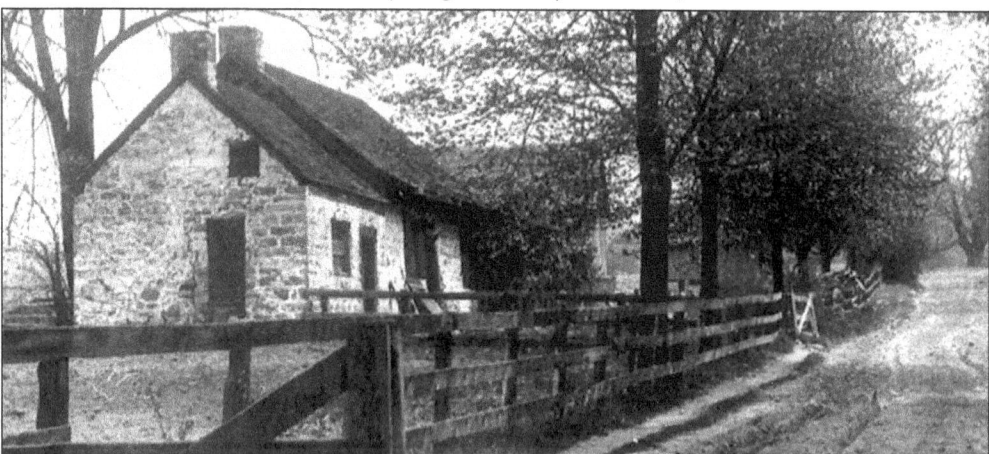

THE BARENT NAUGLE HOMESTEAD AND HARVARD STREET. Barent's property consisted of the northern lands, which included a strip of property along the Palisades on the Hudson River north to the New York border. His stone house was earlier than his brother's and stylistically has a more archaic feel to it. It probably had only one room when it was built. It is one and a half stories high, a garret providing the half story. The gable roof of the main section has flaring eaves. The house functioned as a schoolhouse throughout the 19th century and, during Prohibition, as a still. The house was totally destroyed when the still blew up and burned in the 1920s. This view is east from the juncture of Piermont Road and Harvard Street. (Courtesy Harvey Conklin Sudios.)

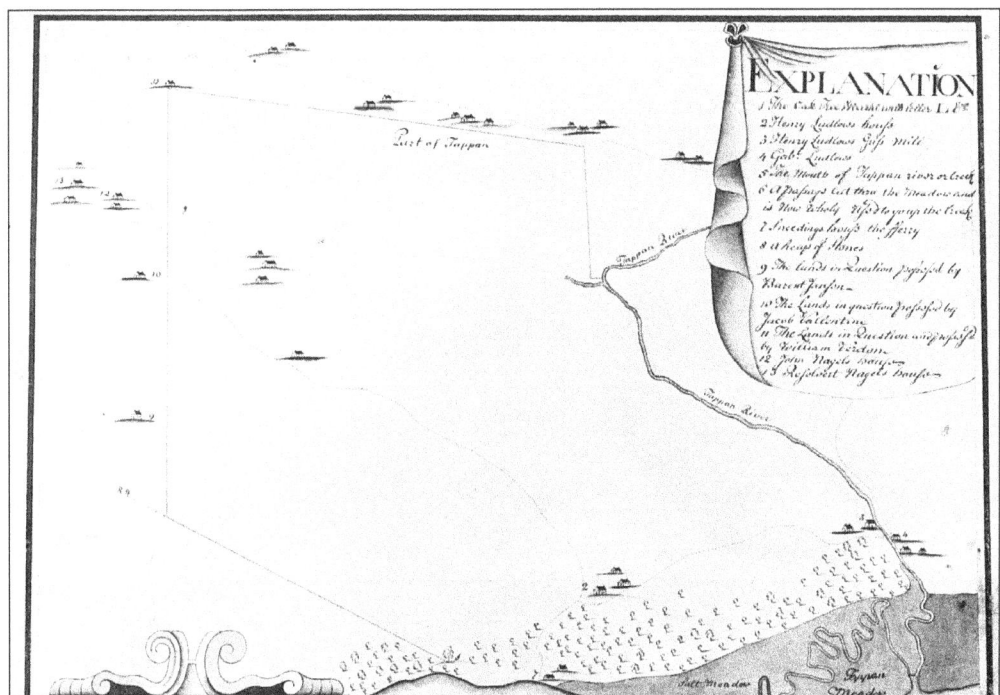

THE PHILIP VERPLANCK SURVEY MAP OF 1745. A detail shows some of the earliest homes in Closter. Included are those of Resolvent Naugle (13), Barent and John Naugle (12), and William Ferdon (11). Also shown are houses just north of here in present-day Rockleigh. The survey was commissioned by Resolvent and his nephew John to define the neighboring Lockhart patent to the north because the Naugles believed the boundaries of that tract infringed upon their lands. An interesting note is the heap of stones as a boundary marker (8). The map proved that the boundaries were appropriate. (Courtesy Palisades Library.)

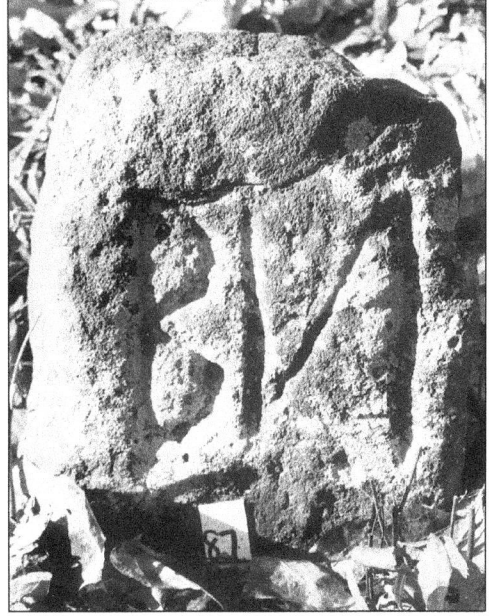

CARVED BOUNDARY MARKERS. In 1748, the Naugle brothers officially deeded and divided their tract east of Piermont Road to facilitate conveyance to their heirs. One boundary between them was a black oak tree marked with the initials R.N. and B.N., another was two carved stone markers with the same initials. The carved stones were placed in the old burying ground, or the historic Naugle-Auryansen cemetery on Hickory Lane. Miraculously they have survived into the 20th century. Unfortunately, Barent and Resolvents' tombstones in the same cemetery have long disappeared. (Courtesy Closter Historical Society.)

RESOLVENT NAUGLE. Descended from the line of original settler Barent Naugle, Resolvent was born in 1795 and died in 1872 at the age of 77. He married Mary Lozier in 1815 and had four children. He was the grandfather of Debbie Naugle, who lived on West Street and married Thomas Tate. (Courtesy Sally Tate Joslin.)

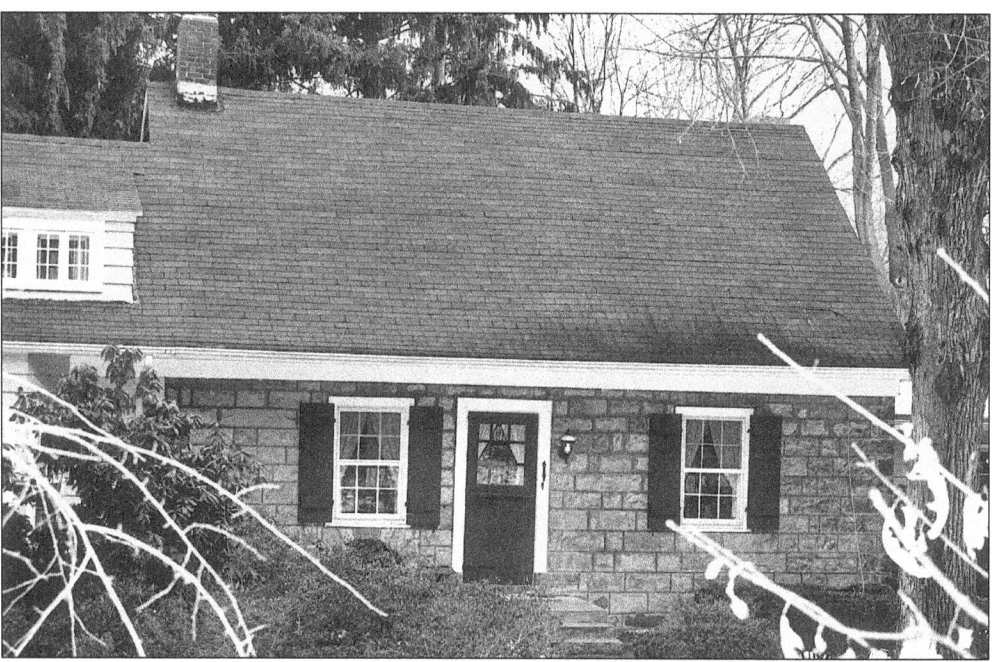

THE JOHN NAUGLE HOUSE, 75 HARVARD STREET. This one-and-a-half-story, two-room house with gable roof and kick eaves dates from before 1745. Barent's eldest son, John, and his wife, Elizabeth Blauvelt, built it behind the earlier house on a slope overlooking the Closter Road beside the Dwarskill. The stone is more finely worked into ashlar blocks than Barent's house. John's son David and his wife, Dirkie Haring, inherited the property in the 1770s. They added a one-story frame kitchen ell to the west side and built a gristmill just to the east on the Dwarskill. By 1789, Harrington Township tax records stated that they owned 128 acres, the gristmill, and a male slave, placing David in the top 10 percent of wealth in the township. David and his son John are noted in historical records as being "honest millers." The property and house were sold out of the Naugle family in 1878 after 168 years and five generations of family ownership. (Courtesy Uma Reddy.)

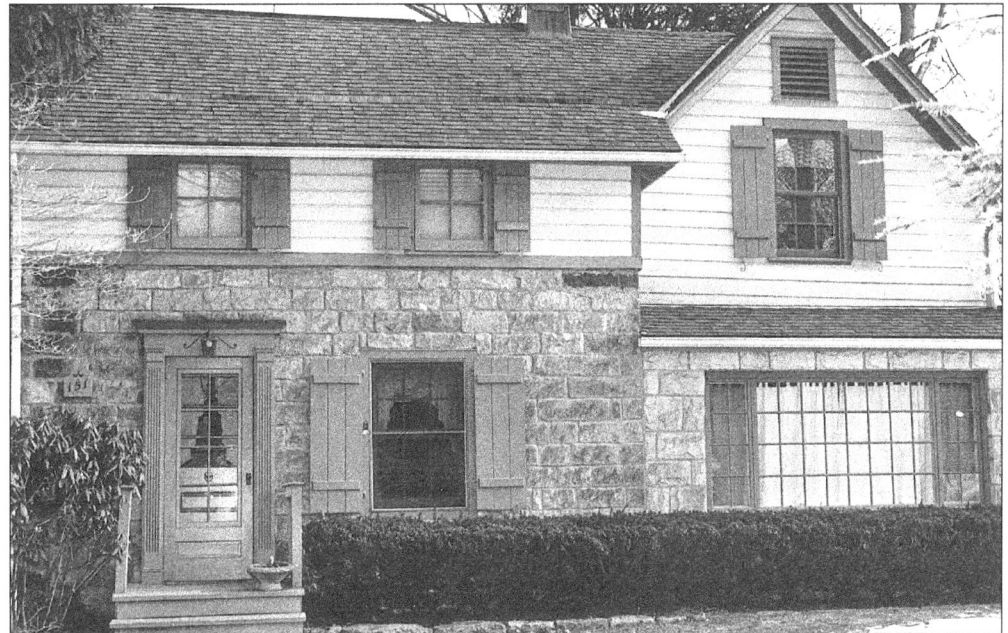

THE VER VALEN HOUSE, 151 WEST STREET. Originally a one-room dwelling, this is the smallest of the Closter stone houses. It is on the approximate site of Bernardus VerValen's c. 1713 house. He arrived here from New Rochelle, New York, with his family in 1710. He purchased an L-shaped tract of 3,600 acres south of the Lockhart Patent boundary, including four miles of land (the King's Woods) along the Hudson River. The size of the house is appropriate to an early time; however, the ashlar sandstone blocks appear quite sophisticated for such an early date. (Courtesy Uma Reddy.)

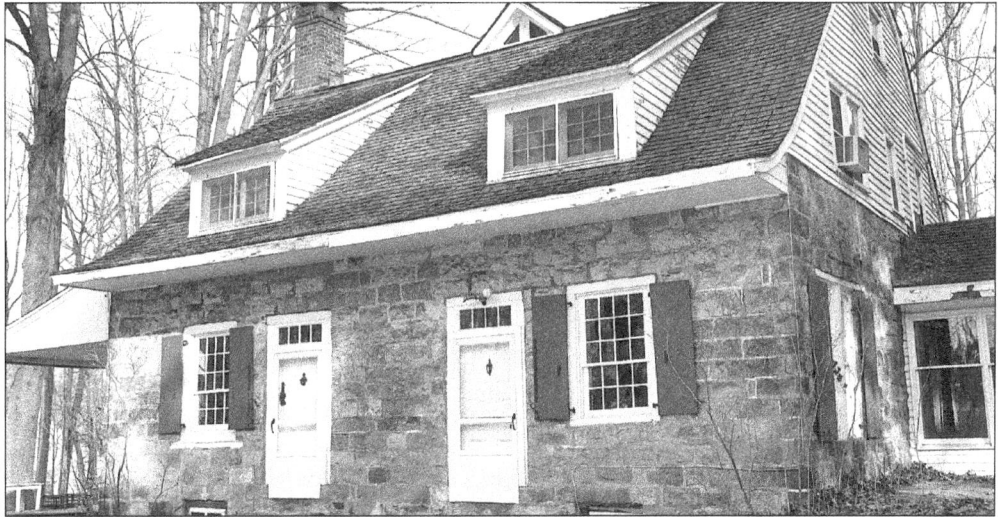

THE ISAAC NAUGLE HOUSE, 80 HICKORY LANE. Isaac and his wife, Maria Auryansen, built this handsome one-and-a-half-story, four-bay, gambrel-roofed stone home c. 1780. The double entrance doors originally led to two separate entrance rooms, with a room behind. The possible intent was to house two generations of the same family under one roof. The dividing wall has since been removed. The west wall of the interior had a jambless fireplace marked by large ceiling joists. (Courtesy Uma Reddy.)

ISAAC NAUGLE HOUSE INTERIOR, 80 HICKORY LANE. The photograph shows an iron lock attached to the inside of the west Dutch door. The lock is an original and rare survivor, of which only a few can be found in historical Bergen County homes today. The present appearance of the interior is more primitive and original than other Closter stone houses. It is unusual because the house retains exposed heavy hewn beams, and the front elevation has two Dutch doors with rectangular transoms. The original windows were replaced in the early 20th century but still have multipanes and are double hung. Exterior shutters are large and hinged, covering the window area. (Courtesy Uma Reddy.)

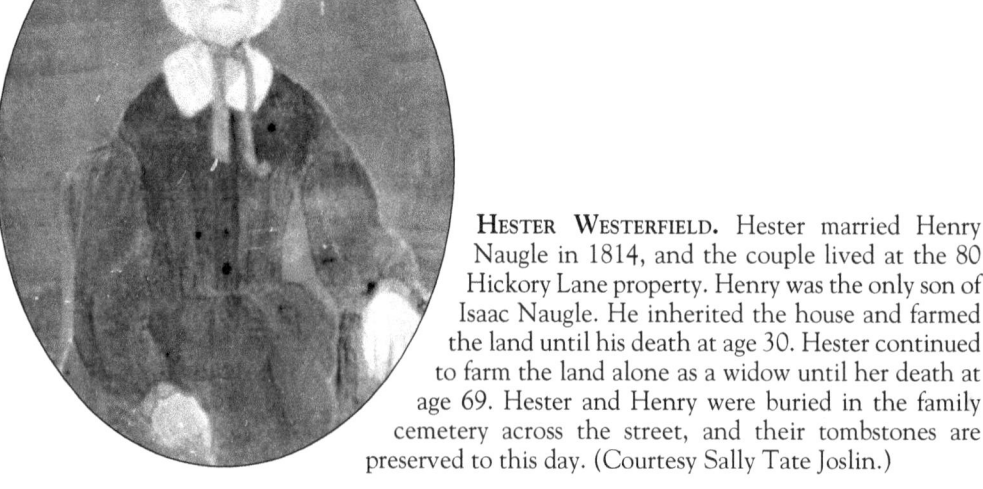

HESTER WESTERFIELD. Hester married Henry Naugle in 1814, and the couple lived at the 80 Hickory Lane property. Henry was the only son of Isaac Naugle. He inherited the house and farmed the land until his death at age 30. Hester continued to farm the land alone as a widow until her death at age 69. Hester and Henry were buried in the family cemetery across the street, and their tombstones are preserved to this day. (Courtesy Sally Tate Joslin.)

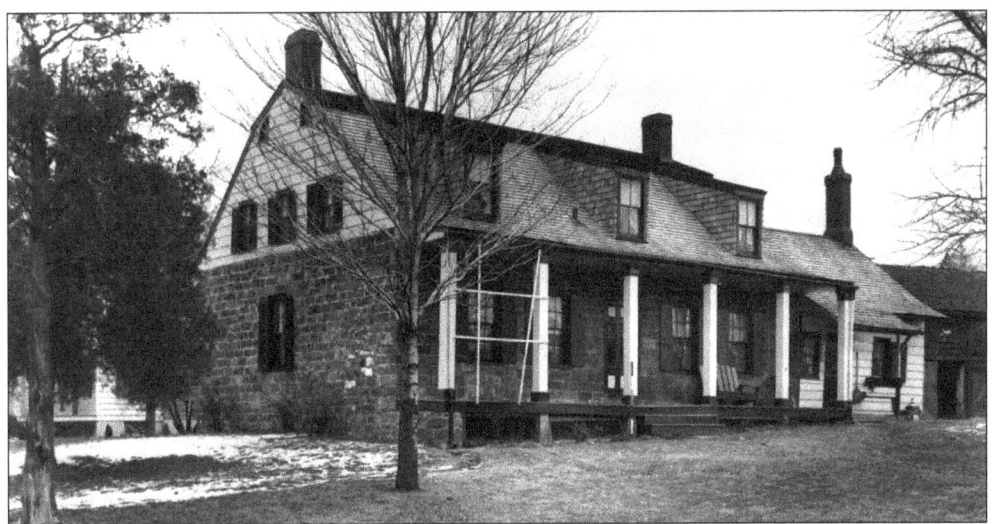

THE DANIEL DE CLARK HOUSE, 145 PIERMONT ROAD. In 1786, Daniel and his wife, Sarah Nagel, built this handsome stone house on 170 acres of land. The center-hall house is five bays wide and one and a half rooms deep. It has paired interior gable end brick chimneys and walls of coursed stone that measure 20.5 inches thick. The one-and-a-half-story building is capped with a gambrel roof. According to tax records in 1786, Daniel had 150 acres, five horses, and 66 horned cattle (one of the largest herds in Harrignton Township). A one-story kitchen wing was added in the early 1800s. In 1815, William De Clark inherited the house; he sold it to his grandson Jacob Outwater in 1849. Jacob built a sawmill on the property and sold the house out of the family in 1856. (HABS photograph, 1936; courtesy B. Peterson and G. Gerrard.)

THE WALTER PARSELLS HOUSE–LONE STAR TAVERN, 639 PIERMONT ROAD. This sandstone house was built by Parcells, a mason, on 34 acres fronting Closter New Road in 1795. Of the several hundred stone houses in the county, this homestead is only one of two that can be attributed to a known architect or builder. The main block is a Federal-style, gambrel-roofed, one-and-a-half-story, three-bay, side-hall house, two rooms deep, with a frame kitchen wing on the west side and an eastern wing that was removed before 1876. By 1860, the house was operating as the Lone Star Tavern, an inn and hotel serving travelers on the stagecoach route from Liberty Pole in Englewood to Nyack, New York. Cornelius Parcells "Granny" Vanderbeck, three times married and widowed, and her son operated this establishment until the 20th century. The house was sold out of the Parcells family in 1961. (Courtesy Lois Knepp.)

CORNELIA BLAUVELT-PARSELLS-JOCHEM-VANDERBECK. Affectionately known as Granny Vanderbeck in the *Blauvelt Genealogys*, she was one of the more memorable women of 19th century Closter. She was born Cornelia Baluvelt in 1806, married Jacob Parcells (brother of Walter) and had five children. Jacob died in 1833. Cornelia married John Jochem in 1835 and John Vanderbeck in 1847. She opened a public house on the stagecoach route in the old Walter Parsells homestead sometime between the death of her third husband in 1851 and the death of her son Jacob in 1858. In the 1860 census for Harrington Township, Cornelia is listed as 53 years old, a hotel keeper, and owning real estate valued at $3,000 and a personal estate of $200. Also with her was son Edo Jochem, a wheelwright, and other family members. By 1870, her son Peter Parsells was the hotel keeper. Her granddaughter Jennie, wife of Daniel Van Sciver, acquired the property in 1908 and subsequently conveyed it to their son Cornelius Van Sciver in 1911. Cornelius died in 1958. (Courtesy Lois Knepp.)

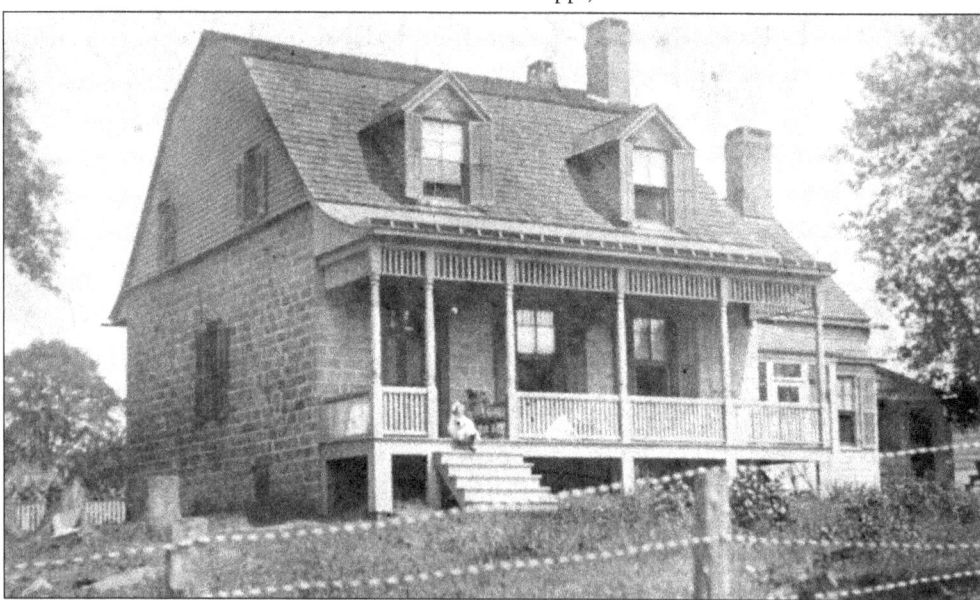

THE AURYANSEN HOUSE, 377 PIERMONT ROAD, C. 1915. This handsome dwelling was probably built by Jan and Daniel Auryansen in 1794. The one-and-a-half-story, gambrel-roofed main block has a three-bay facade, a side entrance, and is two rooms deep. The sandstone blocks on the facade and sides are evenly cut; the rear stonework is more rustic. This trend to dress front and sides visible from the street is found elsewhere in the county in houses of this period. A one-story frame wing on the east side functions as the kitchen today, as it always has. The kick eave of the front has been extended farther to create the front porch. (Courtesy Tim Adriance.)

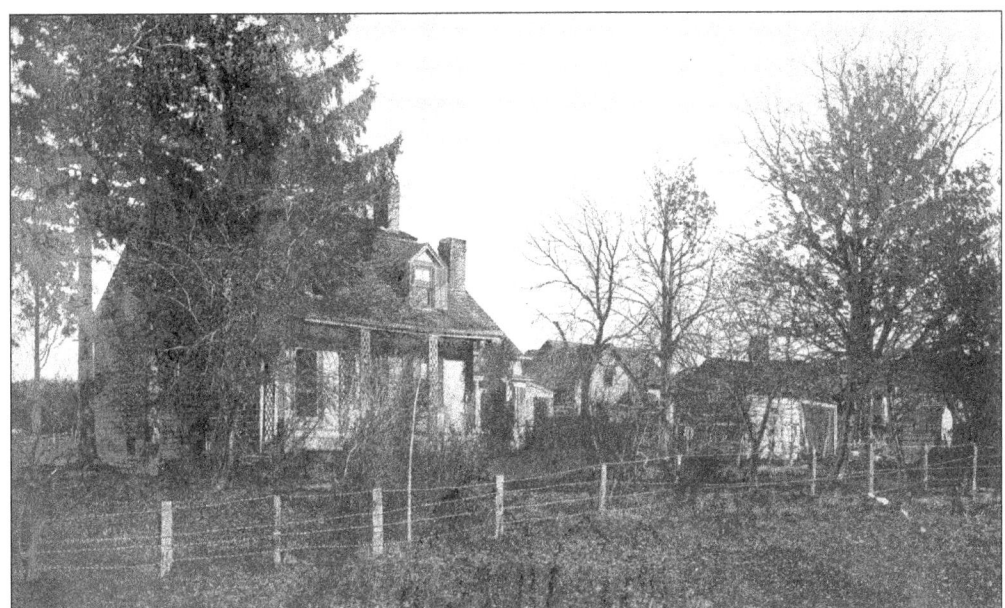

THE AURYANSEN HOUSE AND OUTBUILDINGS, 377 PIERMONT ROAD. This c. 1906 photograph shows the farm complex located on the original Naugle brothers tract of 1710. The house sits on the property inherited by Ari Auryansen from Resolvent Naugle, his father-in-law. (Courtesy Tim Adriance.)

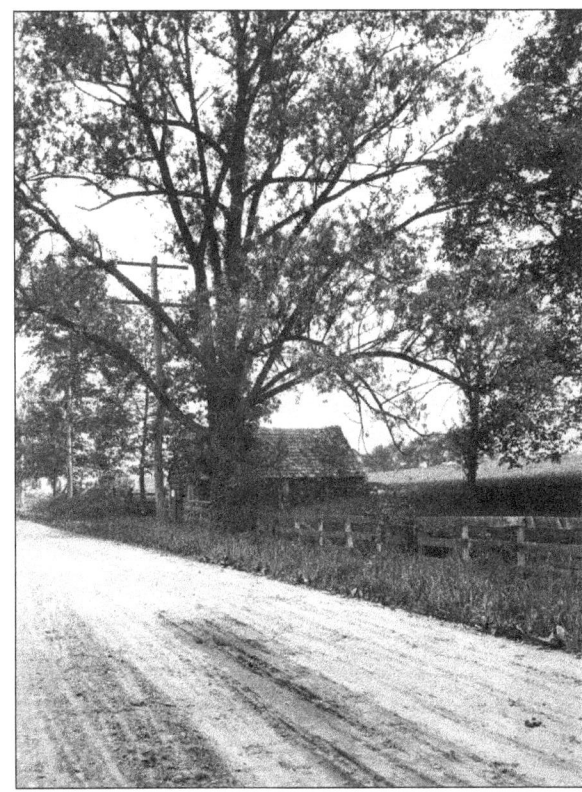

THE AURYANSEN BLACKSMITH SHOP, PIERMONT ROAD. The shop was located across the street from the house on the west side of Piermont Road. Its location along the route from Closter to Dobbs Ferry, New York, made it a commercial landmark where public notices were posted. (Courtesy Tim Adriance.)

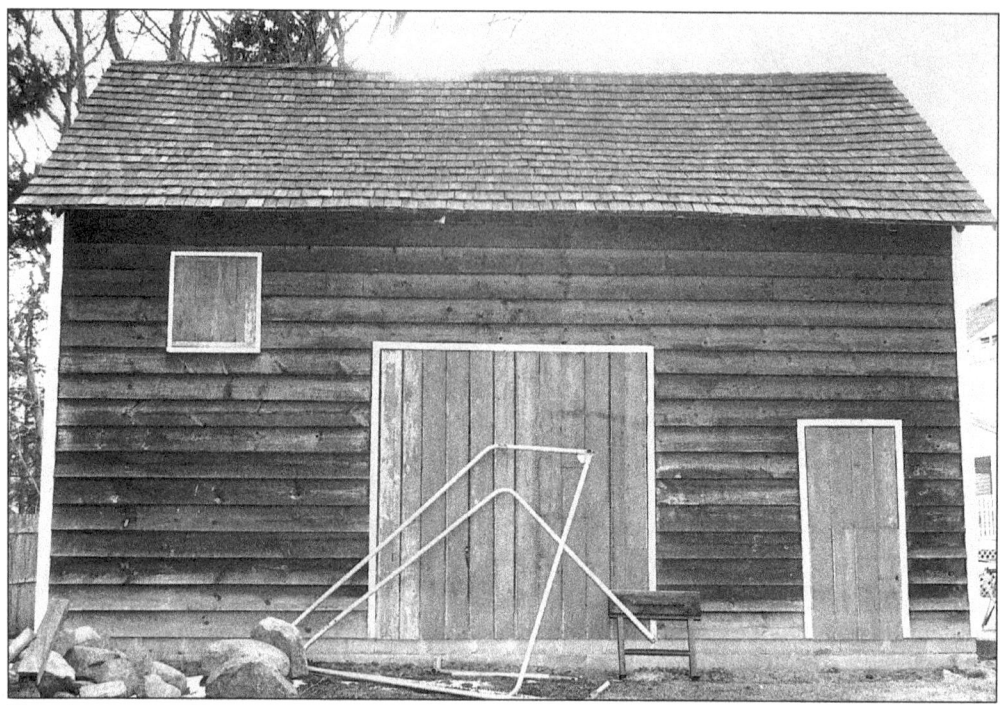

THE AURYANSEN BARN, 377 PIERMONT ROAD. This 200-year-old cattle barn is the oldest one still extant in Closter. The structure was moved to its present location next to the homestead in 1989 and restored by George Turell and Auryansen family historian Tim Adriance. The present barn retains its original framing, including H-frames of chestnut and oak, and some of its original siding and doors. (Photograph by Uma Reddy.)

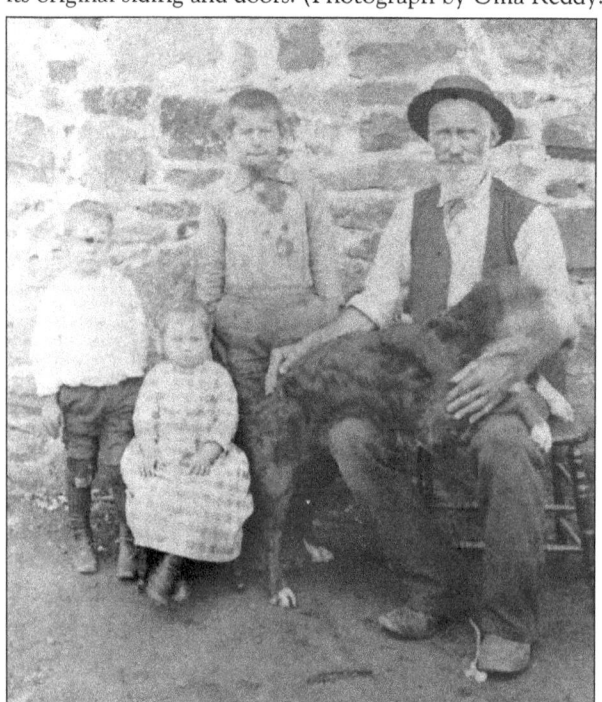

THE AURYANSEN (ADRIANCE) FAMILY. Members of the family photographed are, from left to right, James Van Horne Adriance, Mabel Adriance, Warren Adriance, and Bingo. John J. Auryansen was born in Closter in 1825. He married M.J. Jordan from nearby Alpine and changed the family name to Adriance around the time of the Civil War. (Courtesy Tim Adriance.)

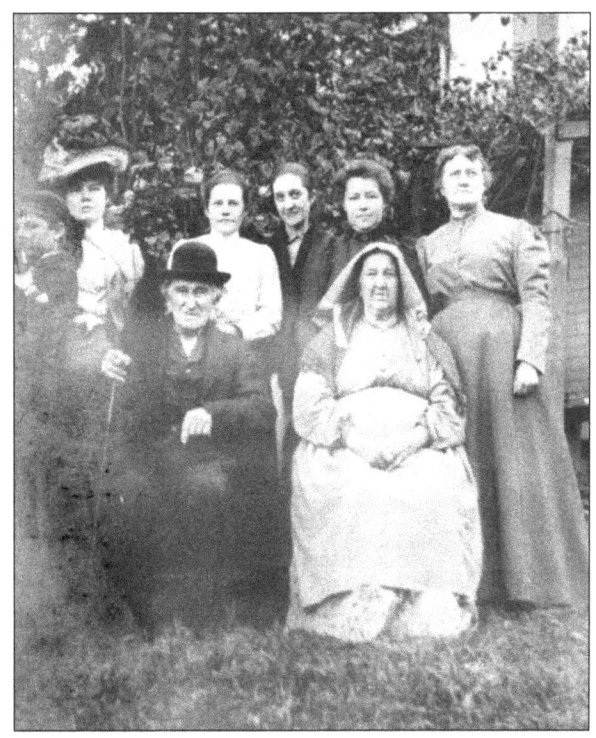

AN AURYANSEN-BLOOMER FAMILY GATHERING. Family members shown are, from left to right, Arcie Bloomer, Violet Bloomer, Abraham I. Auryansen, Ellen Auryansen Bloomer, Ida Auryansen, unidentified, Cornila Haring, and Elisabeth Auryansen. (Courtesy Tim Adriance.)

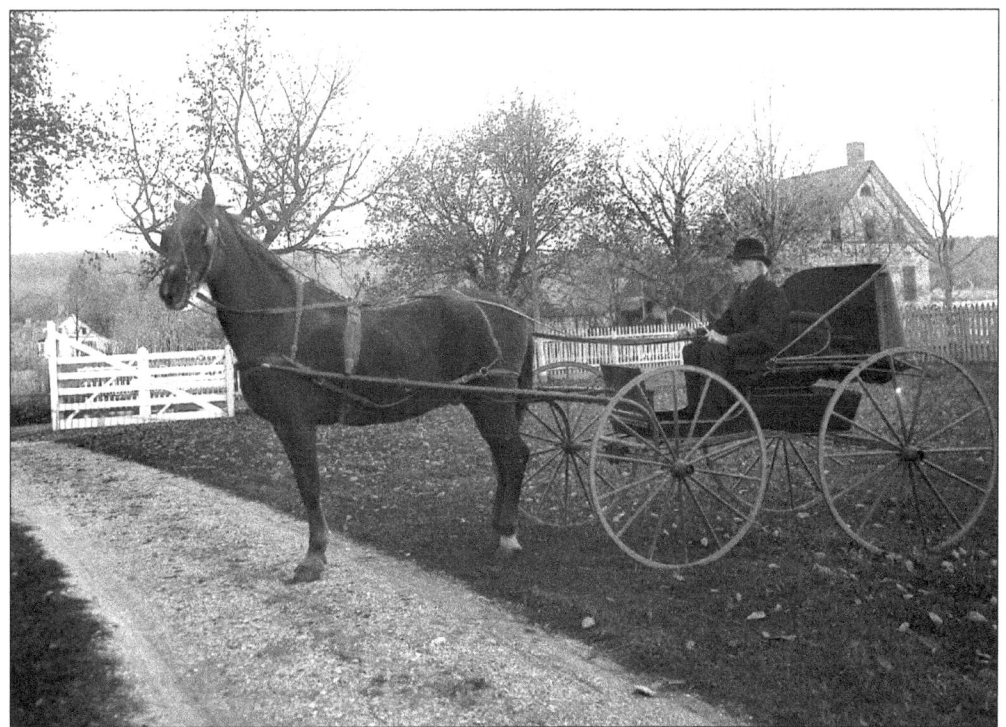

ABRAHAM I. AURYANSEN. Auryansen is out for a buggy ride on Hickory Lane. The stone house in the background is 119 Hickory Lane. This image was taken from a 19th-century glass negative by Harvey Conklin.

THE JOHN A. HARING HOUSE, 5 PIERMONT ROAD, ROCKLEIGH. This well-maintained complex along the old Closter Road, which connected Sneden's Landing or Dobbs Ferry on the Hudson River to points south and southwest, was built c. 1805. The main sections are the two attached stone buildings. The west one is a one-and-a-half-story, gambrel-roofed addition with side hall construction. It is two rooms deep and has a three-bay facade. The east stone house is larger and has a large front room with fireplace, two smaller rear rooms, and a split-leafed door with a rectangular transom. The old kitchen is a one-room stone addition probably of the same date. Several small frame additions were added to the old kitchen later. (HABS photograph, 1937; courtesy John Heslin.)

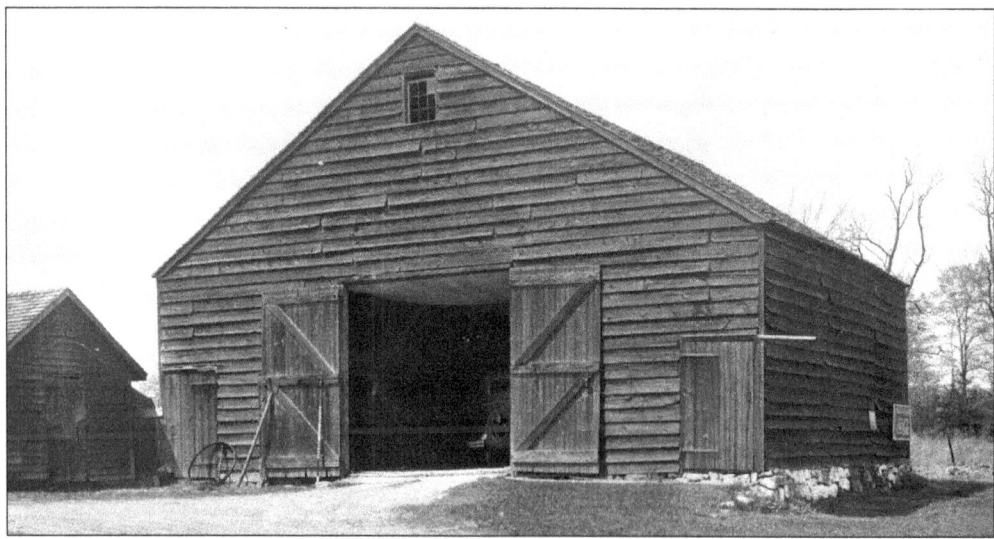

THE JOHN A. HARING BARN, 5 PIERMONT ROAD. The Haring barn is one of six surviving examples of the New World Dutch barn in Bergen County and illustrates the standard features of this barn type. They all are rather square, wider than they are tall or long, with a broad, gable roof, low side walls, and large entrances for wagons in both the gable ends. This is the oldest style of barn in the United States. They are found only in areas settled by the Dutch. (HABS photograph, 1937; courtesy John Heslin.)

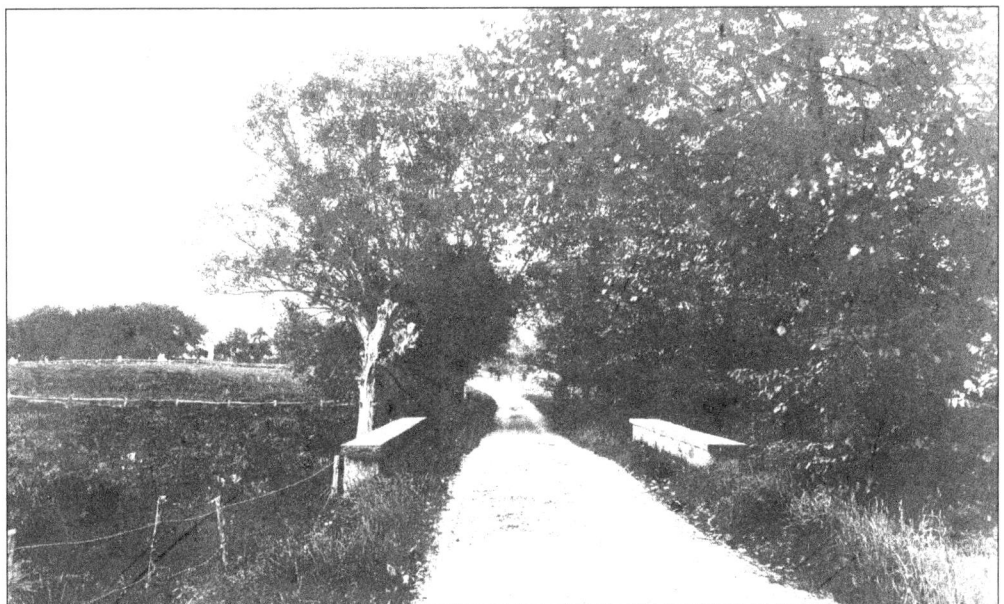

PIERMONT ROAD, VIEW NORTH. This late-19th-century view shows a small bridge along Piermont Road and, on the left, the Haring property, which is in present-day Rockleigh. (Courtesy John Heslin.)

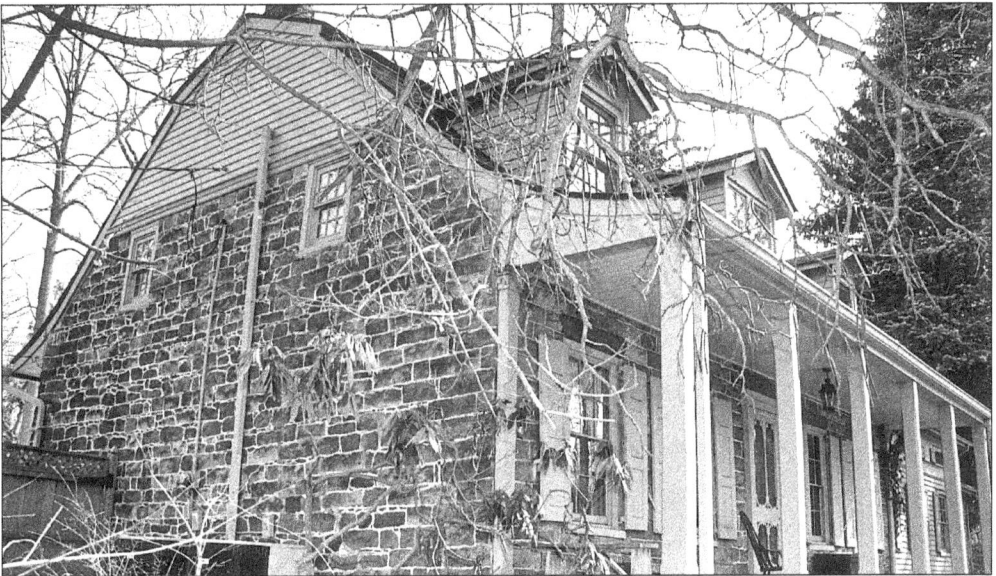

THE DAVID AND CORNELIUS VAN HORN HOUSE, 11 CEDAR LANE. David originally owned a large tract of land between the Tenakill Brook and Schraalenburg Road. Unfortunately, as a loyalist during the American Revolution he lost the property c. 1779. By March 1800, Christian Van Horn, who was trying to reclaim the family lands, purchased a portion of the land for his son David. David married in the same year, but it is believed that the present house was built later, when Cedar Lane was straightened. The stone house is an example of a center hall plan with two rooms on either side, a five-bay facade, one and a half stories, and a gambrel roof. An unusual feature of this house is the use of coursed stone well up into the gable ends. (Photograph by Uma Reddy.)

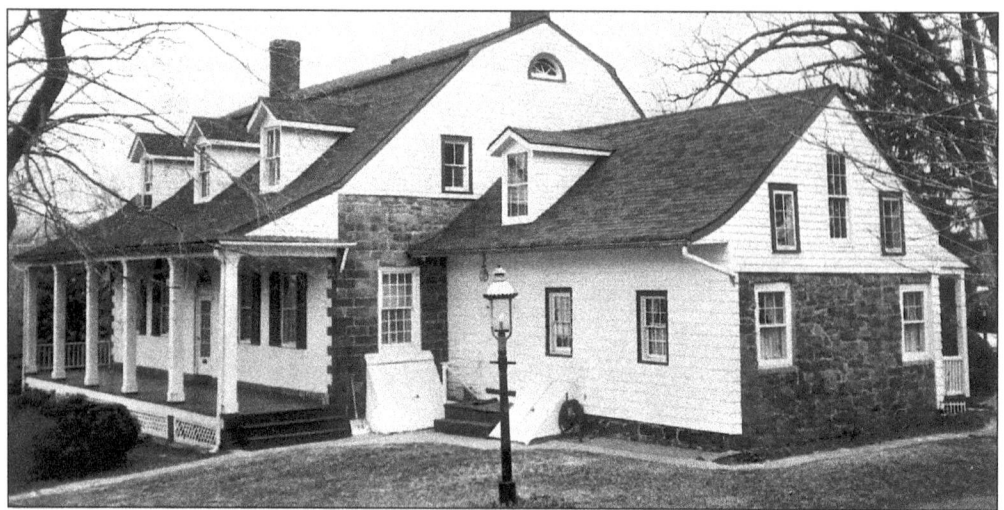

THE DURIE-TERNURE HOUSE, 257 SCHRAALENBURG ROAD. The Durie and Demaree families were French Huguenots. The land they settled on in this area of Closter was originally part of the French Patent. Erected c. 1800, this house illustrates an aristocratic blend of proportions and design combining traditional forms of the early stone house tradition with design elements of the Federal or Adamesque styles. The main block is large and has five bays with a center door and a graceful, low, gambrel roof with kick eaves. The roof is extended on the facade to form a porch. The finely tooled sandstone blocks on the sides are extended to form corner quoins, and the facade is brick. A smaller attached, one-and-a-half-story frame wing with east stone wall has a low pitched gable roof with kick eaves. Federal details include the lunette window and fanlight transom over the entrance door. (Courtesy Bergen County DC&HA.)

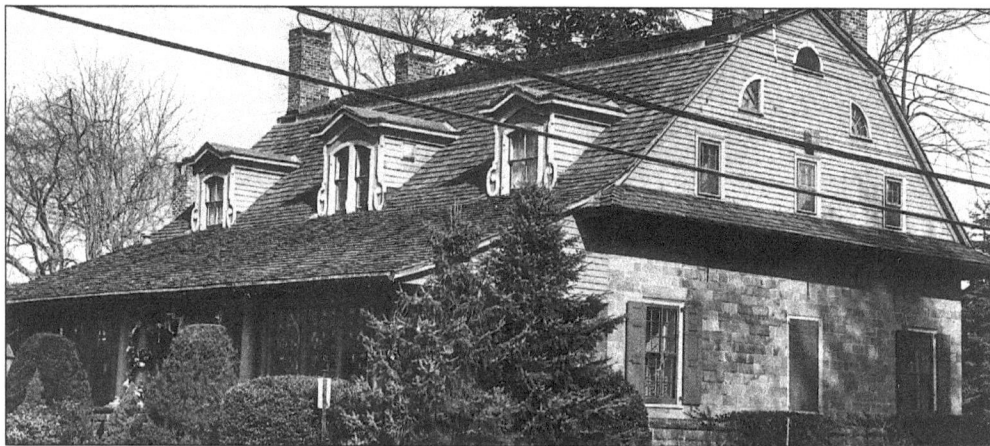

THE ABRAM AND DAVID A. DEMAREE HOUSE, 110 SCHRAALENBURGH ROAD. A second example of the marriage of the local stone tradition and popular architecture of the early 19th century is found in this landmark house at the juncture of Schraalenburg and Old Hook Roads near the Harrington Park border. It was the latest of the stone houses built in Closter between c. 1810 and 1830. It replaced the original homestead built by Abram Demaree a few years before the American Revolution. The graceful slope of the gambrel arch rests on very finely cut sandstone walls. The facade stones exhibit superb craftsmanship. The sides are less dressed, and the rear stones are cruder. The Federal-style entrance door has a fanlight with side lights and attractive molding around the door. Lunette windows, elaborate interior moldings, and fireplace mantels are additional elegant features of this style. (Photograph by Uma Reddy.)

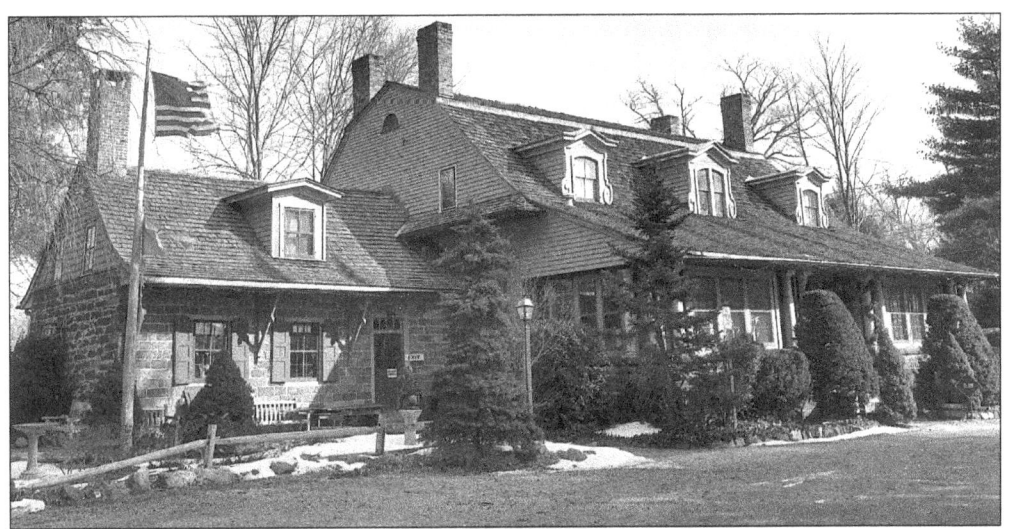

THE DEMAREE HOUSE, 110 SCHRAALENBURG ROAD. This photograph shows the west elevation with an attached kitchen wing. Although it has rougher stone walls and appears more primitive, it was added at a later date. It has a gable roof and a jambless fireplace in the west end. In her book, *Pre-Revolutionary Dutch Houses and Families*, Rosalee Bailey appropriately notes that the fine craftsmanship in stonework and the stone house tradition ends *c.* 1850 and parallels the demise of slavery in Bergen County. (Photograph by Uma Reddy.)

THE JOHN FERDON HOUSE, 102 BLANCHE AVENUE. The original 500-acre tract of land upon which this frame house sits was purchased by William Ferdon (Wilhelmus Verdon) in 1749. The land was located a half mile west of the Naugle homesteads on the east side of the Tenakill brook. This handsome frame dwelling erected in 1817 duplicates the large, five-bay, center hall plan and gambrel roof of the stone houses. The Robert Adam–style entrance doorway, with its elaborate tracery in fanlight and side transoms, is very refined and derived from English pattern books. By contrast, the door is double-leafed and more Dutch in character. John Ferdon was a leading civic and political citizen in Closter and Bergen County. He served two terms as a Chosen Freeholder of Harrington Township: 1812–1817 and 1822–1825. Blanche Avenue was cut through as a county road in 1795. (Photograph by Uma Reddy.)

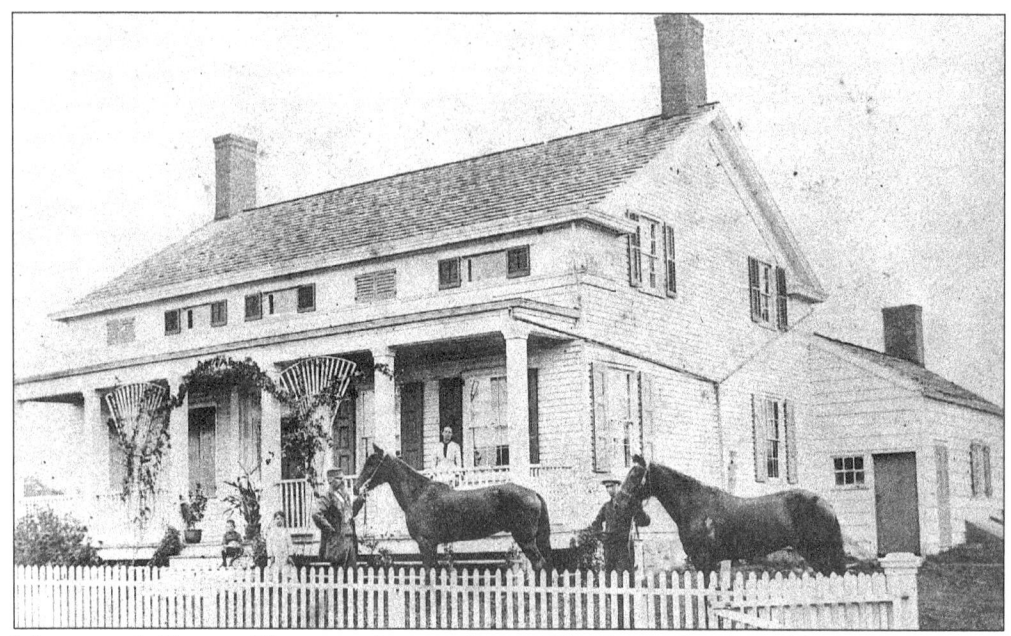

MATTHEW S. BOGERT HOUSE, 1 COUNTY ROAD. The Bogert family and horses gathered for this portrait in front of their handsome five-bay, Greek Revival–style, vernacular farmhouse c. 1900. Matthew S. Bogert was descended from a distinguished family with pre-Revolutionary roots in nearby Demarest on County Road. He built this one-and-a-half-story, gable-roofed house with end chimneys in 1852. Greek Revival features include a stoic symmetry of proportions, the frieze at the half-story level punctuated by small eyebrow windows, the entrance door, and returned eaves of the roof. Matthew was a leading citizen in Closter and served as Chosen Freeholder of Harrington Township from 1834 to 1836. (Courtesy Harvey Conklin Studios.)

JOHN AND JANE BOGERT. This c. 1910 photograph shows a husband and wife inside their home at 1 County Road. The photograph was taken by Harvey Conklin, a Closter resident and butcher who took many of the images in this book.

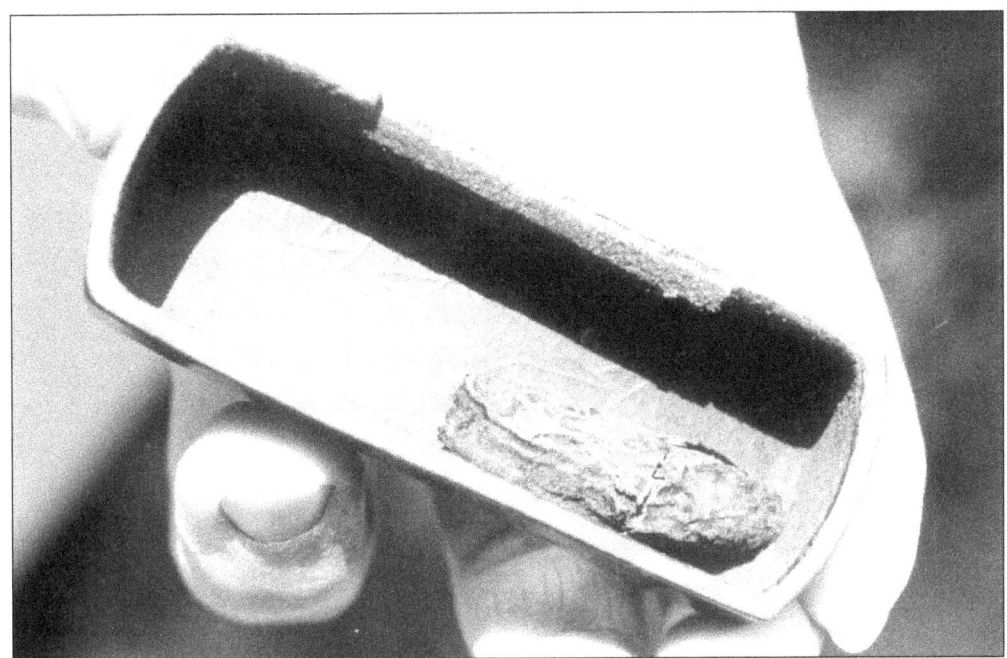

MAJOR ANDRE'S TOE BONE. British major John Andre was captured and then executed and buried in Tappan, New York, in 1780. Forty years later, his body was exhumed to be returned to Westminister Abbey in London for proper burial. David Doremus, a young Closter cabinet maker, built the casket and loaned a wagon to transport Andre's remains to the frigate waiting on the Hudson River. As he was removing the body, Doremus recovered Andre's toe bone and eventually built a small coffin for it. This keepsake has been passed down to family descendants.

THE DAVID D. DOREMUS HOUSE, 269 PIERMONT ROAD. An earlier Greek Revival–style vernacular house in town was erected by carpenter David Doremus c. 1843. In addition to the characteristic features of this house type with entrance door, frieze, and eyebrow windows, he also built a one-bay Greek Revival portico with a pediment. Doremus was a Chosen Freeholder (1851–1853) in old Harrington Township. (Courtesy Bergen County DC&HA.)

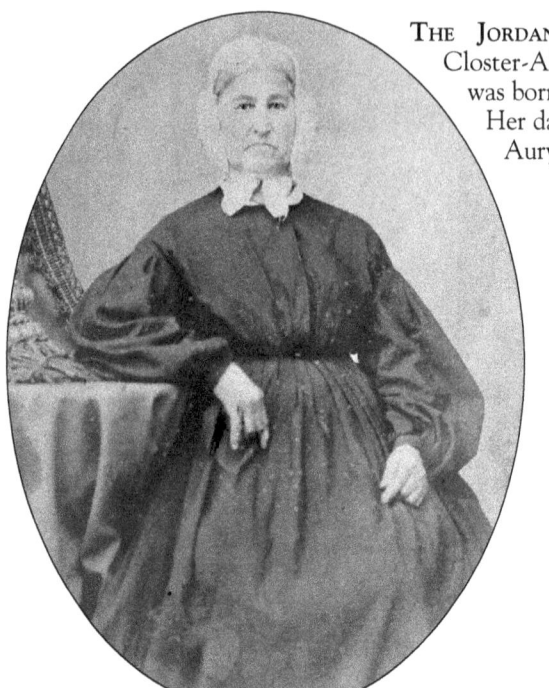

THE JORDANS. The Jordan family settled in the Closter-Alpine area in the late 1700s. Mrs. Jordan was born in 1790, probably in present-day Closter. Her daughter Mary Jane Jordan married into the Auryansen family. (Courtesy Tim Adriance.)

THE J. JORDAN HOUSE, 20 PIERMONT ROAD. This house was originally a Greek Revival–style home and dates from the mid-19th century. Although not recorded on the 1840 Coast Survey Map, it is shown on the Hopkins-Corey wall map of 1861 as the property of J. Jordan. In 1891, J. Jordan still owned the property. A two-story, front addition in the Neoclassical Revival style was added around the beginning of the 1900s. (Photograph by Uma Reddy.)

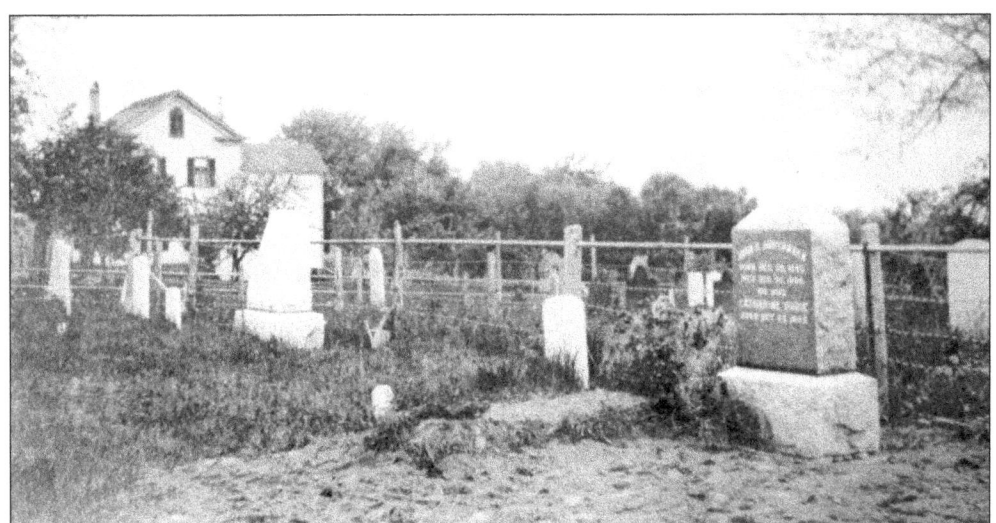

THE NAUGLE-AURYANSEN CEMETERY, HICKORY LANE. This Colonial family's burial ground is shown in an older photograph looking south, with the Doremus House in the background. Once simply known as the Burying Place, it was part of the original lands purchased by the Naugle brothers. The first documented burials date from c. 1722 and include Dutch, German, and French pioneering families with names like Vervalen, Naugle (Nagle), De Clark, Ferdon, Parsells, Auryansen, Demarest, Haring, Cole, Kearney, Montague, and Bogert. Seven soldiers, all Closter farmers, who served in the Bergen County Militia during the American Revolution and one veteran from the War of 1812 are known to be among the interred. (Courtesy Tim Adriance.)

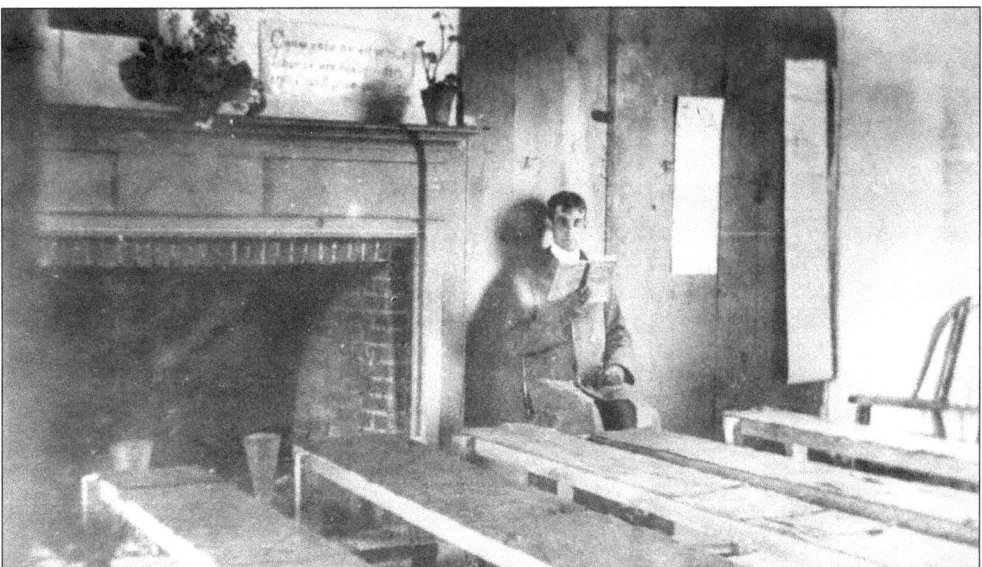

THE CLOSTER SCHOOLROOM AND TEACHER. This is the interior of the Barent Naugle house on Harvard Street when it was used as a schoolhouse in the 19th century. It was a private school at a time when boys were the only students. The first school teacher, Benjamin Blackledge, came to Closter from Elizabeth, New Jersey, in 1770. His mission was to teach the Queen's English and British customs. He married Cathelyntie Tallman in the same year, and for 40 years earned a living drawing up local deeds. (Courtesy Palisades Library.)

GARRET AURYANSEN'S SCHOOL MATH NOTEBOOK, 1830. Garret grew up in the sandstone house at 377 Piermont Road in Closter. According to Tim Adriance, he was 13 years old in 1830 and attended the oldest schoolhouse on Harvard Street. There are about 85 pages of wonderful, hand-written math problems in sentences and clerical script in this book. Sometimes monetary calculations are done in British sterling, and there is no hint of algebra. (Courtesy Closter Historical Society.)

EEL FISHING. An unidentified angler, John J. Auryansen, and Garret Iseman, all Closter residents, were photographed in the salt meadows in Piermont, New York. During the 18th and 19th centuries, residents of Closter owned portions of the marshy meadows here so that they could harvest winter feed (salt hay) for their livestock and cattle. The arrangement persisted until after the Civil War. At that time, Closter began to import beef from the western United States by rail. (Courtesy Tim Adriance.)

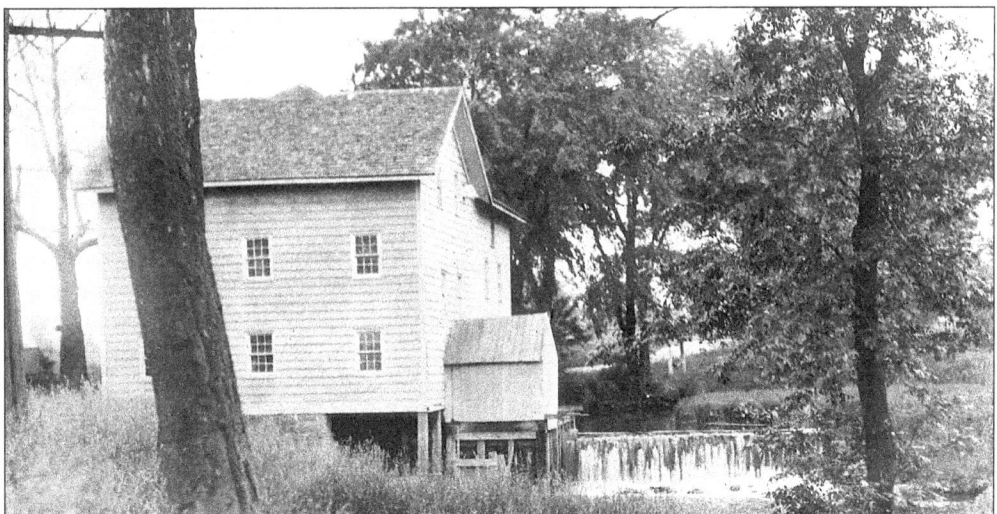

THE MYERS-BOGERT GRISTMILL. Area farmers took their grain to be ground at this gristmill on Harriot Avenue in Harrington Park from the mid-18th century until the 20th century. When the mill site and building were demolished in 1932 to create the Oradell Reservoir, it had the distinction of being the last water-powered gristmill in the Northern Valley. Originally Abraham Meyers established the mill on the Hackensack River prior to 1765. The business was continued by his son John and son-in-law James Bogert. For three generations, the Bogert family continued ownership and it was popularly known as just Bogert's Mill. (Walter Mall Collection.)

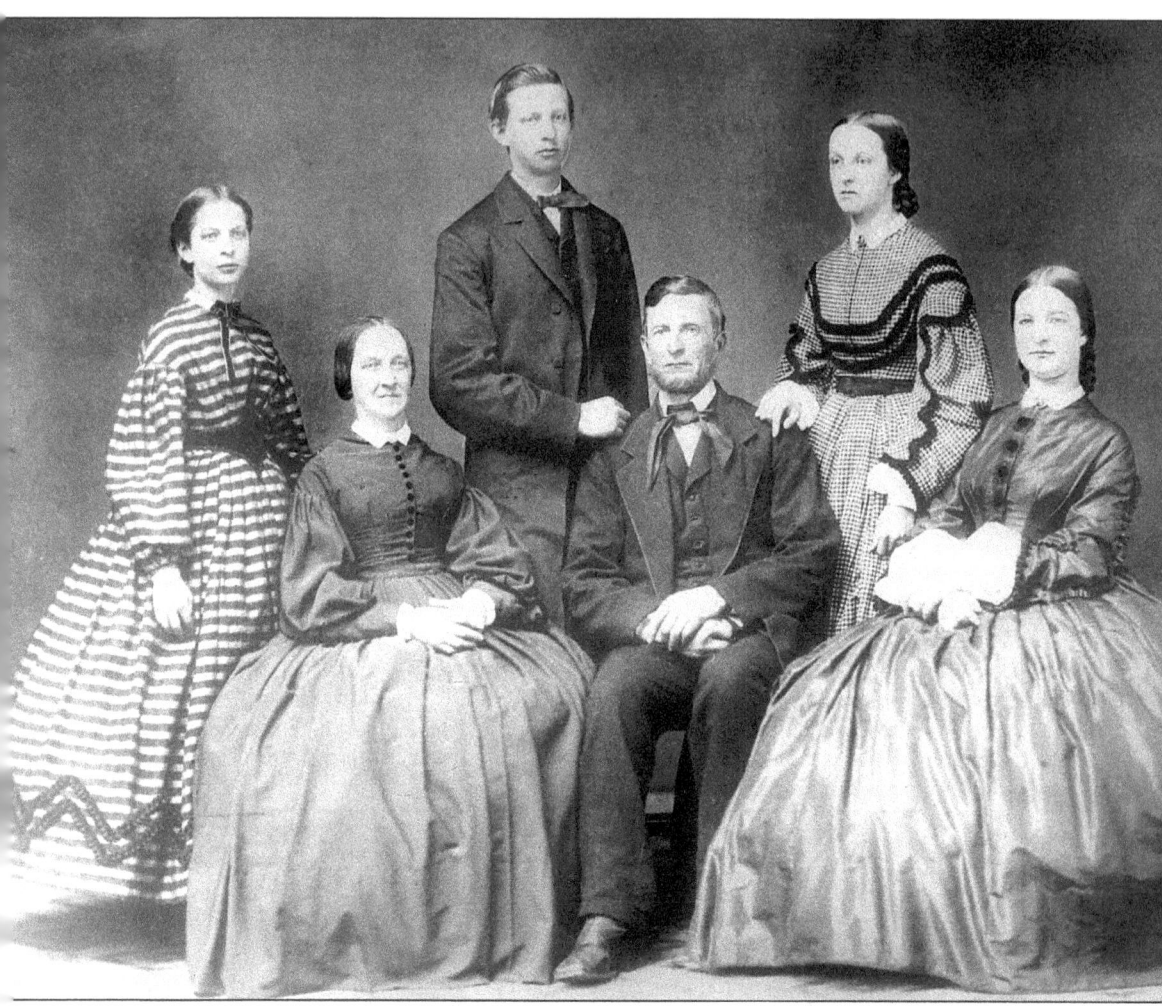

PORTRAIT OF JOHN BOGERT'S FAMILY. Members of this family photographed in 1854 are, from left to right, Elma Clark Bogert (daughter), Margaret Blauvelt Bogert (mother), John Jacob Bogert (son), John Bogert (miller), Jane Bogert (daughter), and Lee Ann (daughter). John was son of James Bogert. The family lived in the house across from the mill on Harriot Avenue in Harrington Park. (Courtesy Harvey Conklin Studios.)

Three
THE AMERICAN REVOLUTION

The New York Campaign of 1776 was watched throughout the world as Great Britain mounted all its forces to crush the American rebellion once and for all. The New Jersey portion of the campaign began a six-month saga that was to shape the birth and destiny of the United States. After months of losses in New York and the Battle of Brooklyn, Gen. George Washington's army escaped from New York in November 1776 and set up temporary headquarters in the Zabriskie House in Hackensack. Maj. Gen. Lord Cornwallis soon organized a flotilla in Kingsbridge, New York, to cross the Hudson River. On the morning of November 20, 1776, he arrived at the Lower Closter Landing (Huyler Landing) with 5,000 British and Hessian troops. They scaled the Palisades cliffs and marched south to capture the fort at Fort Lee. Thus began the events of Washington's retreat to winter quarters in Morristown and some of the darkest hours in the fight for America's independence. "These are the times that try men's souls" was the phrase appropriately penned by Thomas Paine soon after the fall of Fort Lee. The only ray of light in 1776 was the surprise Christmas-day attack on Hessian troops stationed in Trenton. The hope generated by this campaign provided some comfort for Washington and the Continental army.

During the American Revolution, Closter, as well as the nearby settlements of Tappan and Schraalenburgh, became known as the neutral ground. Politically, the area contained a large number of patriots balanced by almost an equal number of loyalist, or Tory, sympathizers. Many residents chose to profess their neutrality. The hostility of the situation, which often split families, is emphasized by historian Adrian C. Leiby, noting that Closter residents hung papers on their doors reading, "No Quarter Shall Be Given to Refugees [loyalists]." Even seasoned Hessian soldiers were repulsed by the level of bitterness and retaliatory attack by former neighbors. The story of the rotting corpse of loyalist soldier Ens. Peter Meyer, killed by patriots in the March 29, 1779 raid, hanging from a tree limb as a warning to others, confirmed their opinions. Religion also played a role in the sides that neighbors might take against one another.

The Closter farms were close to New York markets, where the thrifty, hardworking Dutch farmers grew plentiful amounts of crops and raised cattle and sheep. The neutral ground

represented a prime area for a series of campaigns that focused on procuring supplies for British troops in New York. Both loyalists and former slaves from this area played a major role in organizing and leading these brutal raids. The May 9, 1779 raid on Closter is the best documented of these events and describes the savage and murderous nature of neighborly retaliation. Detailed accounts of events come from letters by teacher Benjamin Blackledge, newspaper stories, tombstone inscriptions, and damage claims submitted after the raid.

The largest loss of patriot soldier's lives occurred the night of September 27, 1778, when a surprise attack by British general Gray killed 64 of Col. Baylor's Dragoons as they slept in barns owned by the Haring family in present-day River Vale. This site is commemorated today by the Baylor Massacre Memorial, a burial site near the Old Tappan border on the Hackensack River.

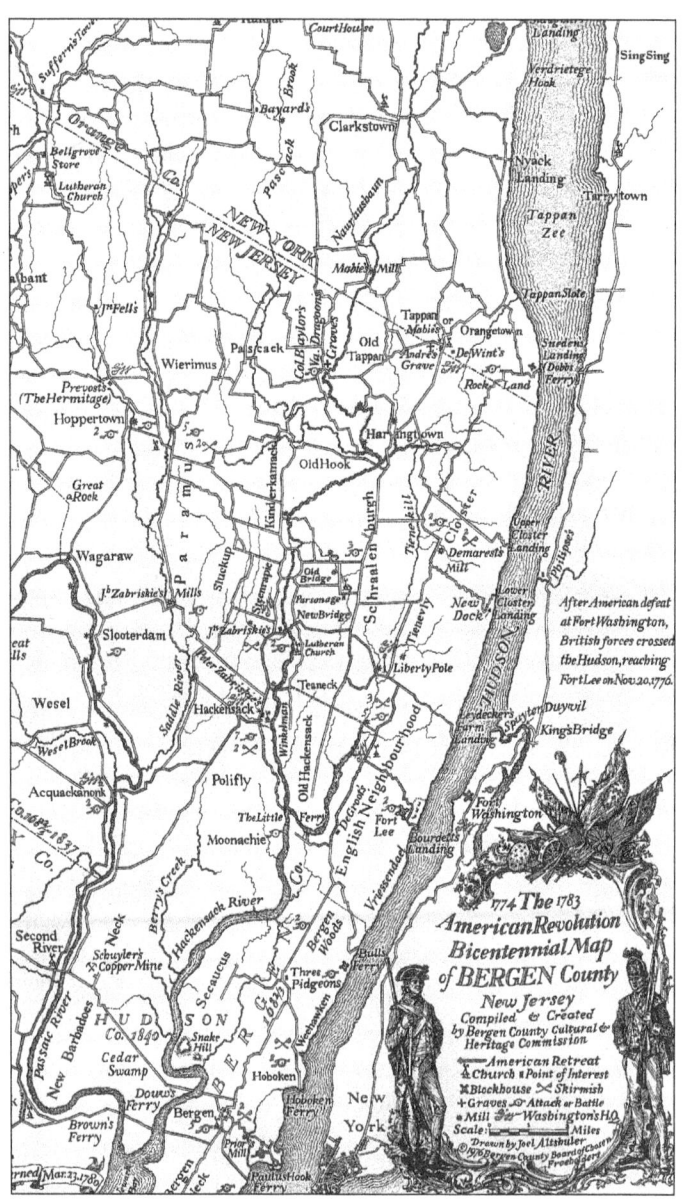

THE AMERICAN REVOLUTION BICENTENNIAL MAP. This detail shows the New Dock, the Huyler or Lower Closter Landing site used by Maj. Gen. Lord Cornwallis to invade New Jersey, the land route to Fort Lee, and the settlements of Closter, Schraalenburgh, and Tappan, New York. It also includes area roads, such as the New Dock (Huyler) Road, County Road, and Old Closter (or Rockleigh) Road leading to Sneden's Landing (Dobbs Ferry). Schraalenburg Road, which passes through western Closter, connected the English neighborhood in Englewood to Tappan, New York. (Compiled by the Bergen County Cultural and Heritage Commission; courtesy Bergen County.)

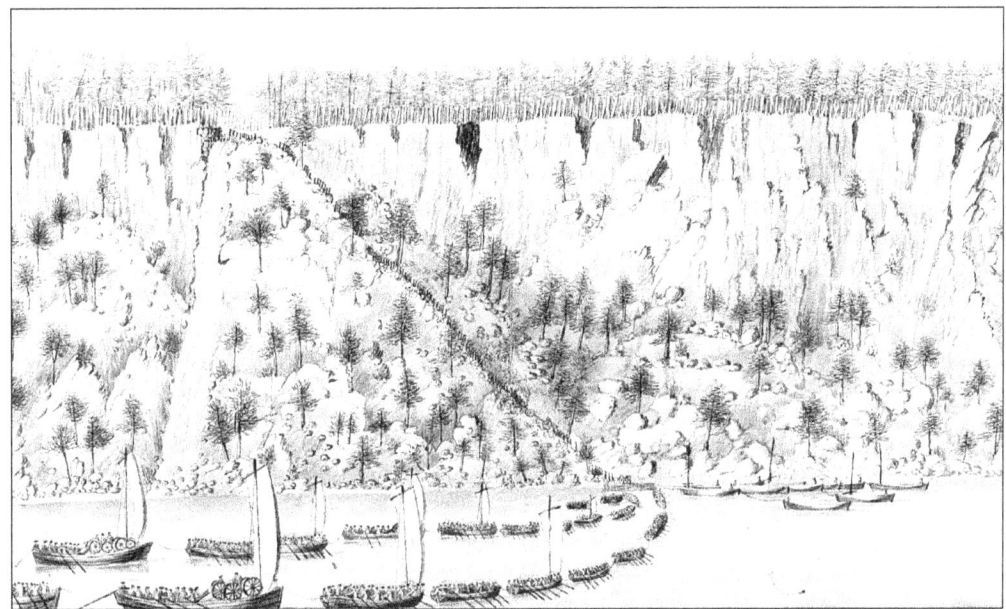

THE BRITISH INVASION AT LOWER CLOSTER LANDING. After Washington left New York and set up Revolutionary headquarters in New Jersey, Maj. Gen. Lord Cornwallis captured Fort Washington in New York. He then set his sights on capturing Fort Lee, which he did within 48 hours after the New York fort. The goal was then to pursue Washington and finally squelch the rebellious insurrection. This c. 1776 painting by Thomas Davies, a British officer, illustrates what the challenge of moving 5,000 troops and light artillery up the Palisades cliffs entailed. (Courtesy New York Public Library.)

HUYLER LANDING ROAD. This 20th-century photograph shows the New Closter Dock Road above the Lower Closter Landing (also called Hyler's Landing Road) as it extends westward from the crest of the Palisades cliff. The road led directly to the settlement of Closter via present-day County Road. The loyalist raiding parties from New York used this route repeatedly to plunder the area farmers and murder and abuse patriot residents. (Courtesy John Spring.)

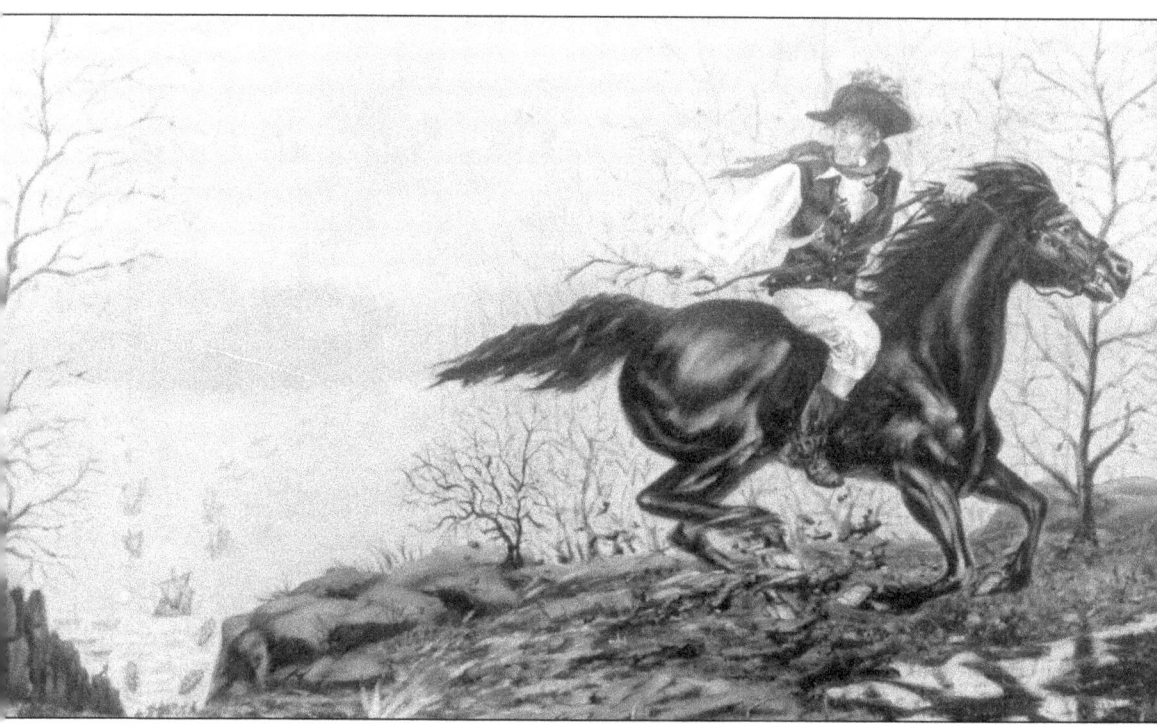

THE LONE HORSEMAN. This painting by Dr. John Pagano shows the Closter sentry, probably a local farmer and militia man, spotting the British landing at Lower Closter or New Dock and racing to warn the soldiers at Fort Lee. The warning gave Washington enough time to order General Green to evacuate the fort and escape to regroup at New Bridge on the Hackensack River. The racing horseman with tri-pointed hat, Closter's Paul Revere, has been the borough seal since 1976. The original painting measures three by four feet and is on permanent display at the Museum in Fort Lee Historic Park. (Courtesy Dr. John Pagano.)

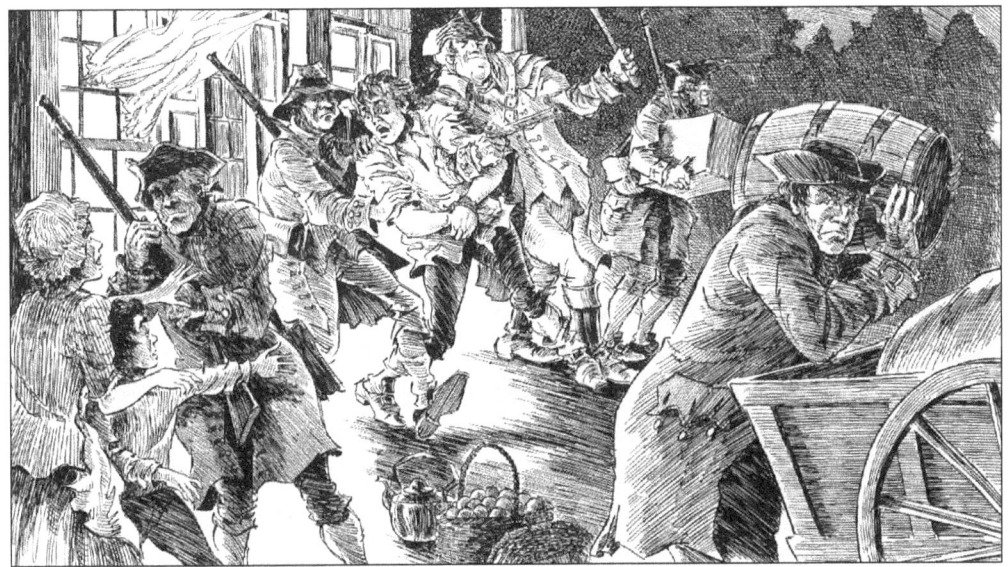

TORY RAIDS AND FORAGING PARTIES IN CLOSTER. The drawing illustrates a common occurrence in Closter during the American Revolution. The raids of March 1779 and May 9, 1779—pitting Tory and patriot, former neighbors, against one another—were particularly brutal. A letter written on May 10 after the second raid notes that "about 100 of the enemy came by way of the New Dock. . . . They were of Buskirk's troops, some of our old Closter and Old Tappan neighbors joined by a part of a party of negroes." Detailed accounts of events come from letters by teacher Benjamin Blackledge, newspaper stories, tombstone inscriptions, and damage claims submitted after the raids. (Courtesy Bergen County.)

WESTERVELT-MEYERHOFF HOUSE. This pre-Revolutionary stone house at 279 County Road was owned jointly by brothers John and Cornelius Huyler in 1779. Following the May 9 raid, they submitted damages. This house was burned together with the houses of Cornelius Demarest and Mathias Bogert during the raid. Samuel Demarest and John Banta lost their houses and barns; Cornelius Bogert and John Westervelt lost only barns. The troops set fire to everything (though some were extinguished), broke all the furniture, and abused many of the women. (Courtesy Mary Ann Clarke.)

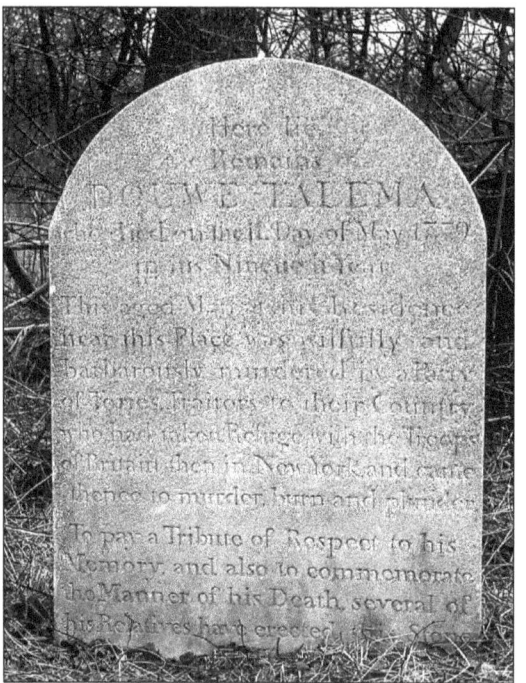

DOUWE TALLMAN TOMBSTONE. Located in Sautjes Tave's Begraven Ground, a small cemetery in present-day Demarest, this stone marks the burial of Douwe (or Dow) Tallman, a 90-year-old defenseless and nearly deaf Closter resident who was brutally murdered in the May 9 raid. The inscription was dedicated by family members: "Here lies the remains of Douve Talema, who died on the 11th day of May, 1779, in his ninetieth year. This aged Man at his residence near this place was wilfully and barbarously murdered by a party of Tories. Traitors to their country who had taken refuge with the Troops of Britian then in New York and came thence to murder and plunder. To pay a Tribute of Respect to his memory and also to commemorate the manner of his death, several of his relatives have erected this Stone." (Courtesy Mary Ann Clarke.)

The following is an account of the murder of the old man by Wildred B. Tallman, a descendant of Douwe:

> He was fat and heavy, and stone deaf and totally blind from age, so the story goes. He neither saw nor heeded the cutthroats who told him to go get up and let them have the contents of the chest. By tradition, the chest contained gold and silver. Perhaps tradition stretched a point, but it is quite possible that this small compartment was the household hiding place for the doubloons and pistoles of gold and the silver crowns and pieces of eight that passed for money in those days.
>
> When the old man did not rise—and the report says he resisted entirely from stubbornness—a member of the band identified as Van Wagoner of Ramapo disemboweled him with a bayonet. The raiders then pried open the lock of the chest as well as that of a desk nearby and helped themselves to whatever was inside.
>
> When they had gone, the old man's granddaughter, Cathalyntje Blackledge, wife of Benjamin Blackledge the schoolmaster, took him to her home, and there he died the next day.

A second newspaper account written for the *Bergen County Journal* in 1858 states that Tallman did talk to the Tories and reports the following:

> [Tallman said] "I am an old man—I cannot injure you—you will not hurt me." The reply was "no," and instantly they knocked him down on his trunk and ran a bayonet through his body. Then they took him by the feet and dragged him out of the door, and down the stone steps, (his head striking every step as they went down,) and threw his body into the yard before the house; then they set fire to both the house and barn; the militia were away at this time on duty elsewhere.
>
> —From "Raid!: The Tory Raid on Closter—May 9, 1779." Bicentennial Raid Committee, 1979. Reprinted by the Closter Historical Society, 1999.

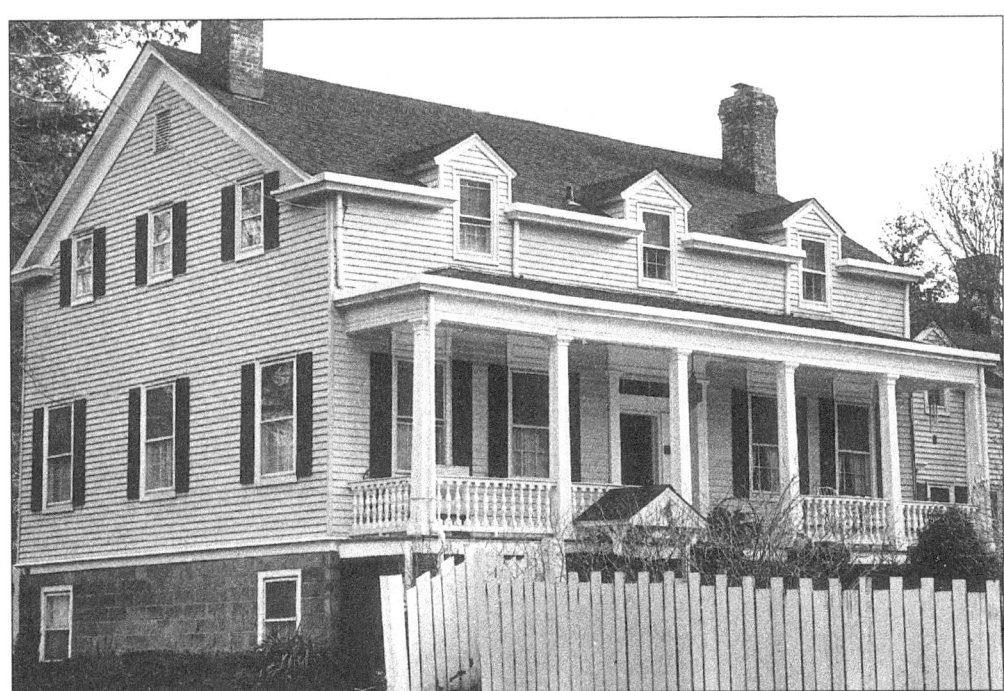

THE SAMUEL DEMAREST HOUSE, 60 COUNTY ROAD, DEMAREST. The greatest tragedy of the raid occurred here at the Demarest family home. Sammy "the Miller" Demarest, a patriotic man, staunchly defended his home and family and fired numerous shots at the intruders as they marched up the road. Sammy was carried off as prisoner to New York because he regularly supplied grain to the Continental troops in Tappan. Among the dead was his son Cornelius Demarest. Son Hendrick would have been killed were it not for a woman in the household who threw herself over him to defend him from the raiders. The house and mill were burned. The house now on the site incorporates the foundation of the pre-Revolutionary residence. (Photograph by Uma Reddy.)

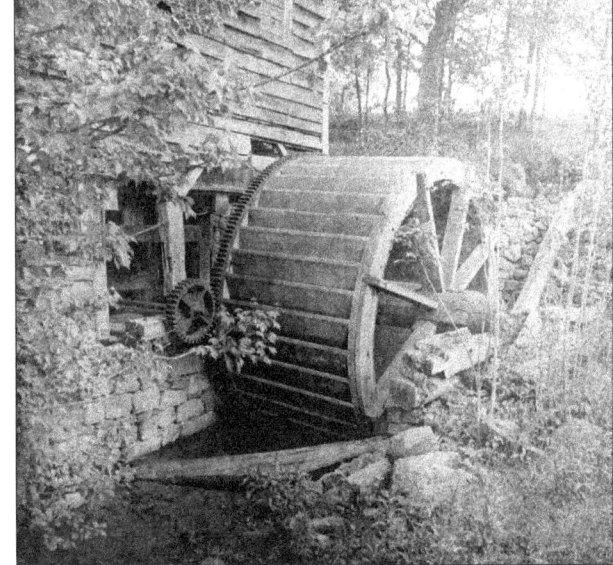

DEMAREST MILL, COUNTY ROAD. This mid-19th century photograph shows the mill that was rebuilt on the site of Sammy Demarest's land after the original had been burned down by Tory raiders. It was demolished in the early 1930s.

The M. Bogert House, 324 County Road, Demarest. Mathias Bogert purchased the land upon which this house sits in 1740. The Bogert family was particularly hard hit in the May 9 raid. In addition to losing an assortment of livestock, clothing, and eating utensils, the loyalists also burned Bogert's dwelling to the ground. Damage claims for the house totaled 150 pounds. The family—away at church in Tappan, New York—was unharmed. The stone part of the present house was probably built by Matthew Bogert II, a descendant of Mathias, just after 1800. Because the raid took place on a Sunday morning few residents were home to fend off the intruders. (Courtesy Mary Ann Clarke.)

Four

THE RAILROAD SUBURB

In 1859, the first wood-burning steam locomotive of the Northern Railroad chugged through Closter and the Northern Valley, transforming an area of Colonial farms and mills into a commuter suburb. The line made the connection between New York City and Piermont, New York. It allowed Closter residents to commute to Manhattan to work and city dwellers to vacation in the fresh air of the New Jersey countryside.

A community, Closter City, grew up almost overnight around the railroad depot. During the late 19th century and early 20th century, it was the largest population center in the Northern Valley. A 1903 chamber of commerce publication stated that "the population is about 1200; two-thirds of the male citizens are commuters and have their business in New York City: the rest are merchants and business and professional men who make a livelihood in this village and in neighboring towns."

Today this hub center of concentrated settlement, dating from 1859 to the 1930s, includes more than 200 historic buildings ranging from commercial, industrial, residential, churches, schools, and civic examples of American vernacular architecture. This historic district was first described by the Bergen County Historic Sites Survey in 1982, and the boundaries were expanded by the Closter Preservation Commission in 1999.

A second area of residential building at the intersection of Durie Avenue and Knickerbocker Road dates from the same time period. These stately homes were built by wealthy residents. The area was advertised in a local chamber of commerce bulletin as an upper-middle-class suburban neighborhood located up on a hill away from the noise and soot of the railroad.

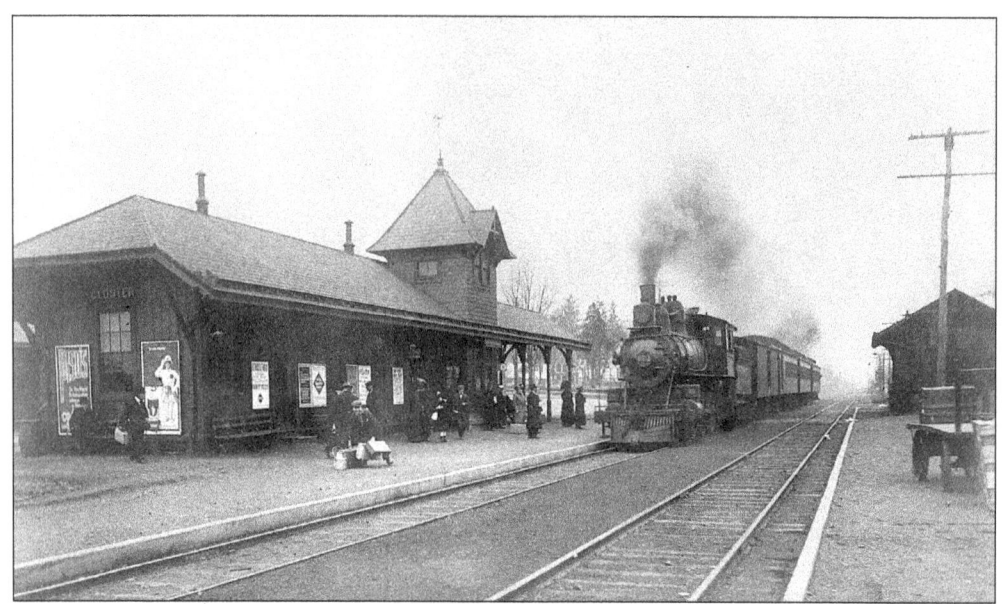

DEPOT AND TRAIN, 1 STATION SQUARE. In 1859, Closter was one of three original stops on the Northern line (the others were Englewood and Piermont, New York). Closter City soon became the business, population, and education center of the valley area: the hub of the Northern Valley. There were 18 trains going each way for a total of 36 by the beginning of the 20th century. By 1881, the town was already so clogged with rail traffic that the station was removed farther out of town to its present location.

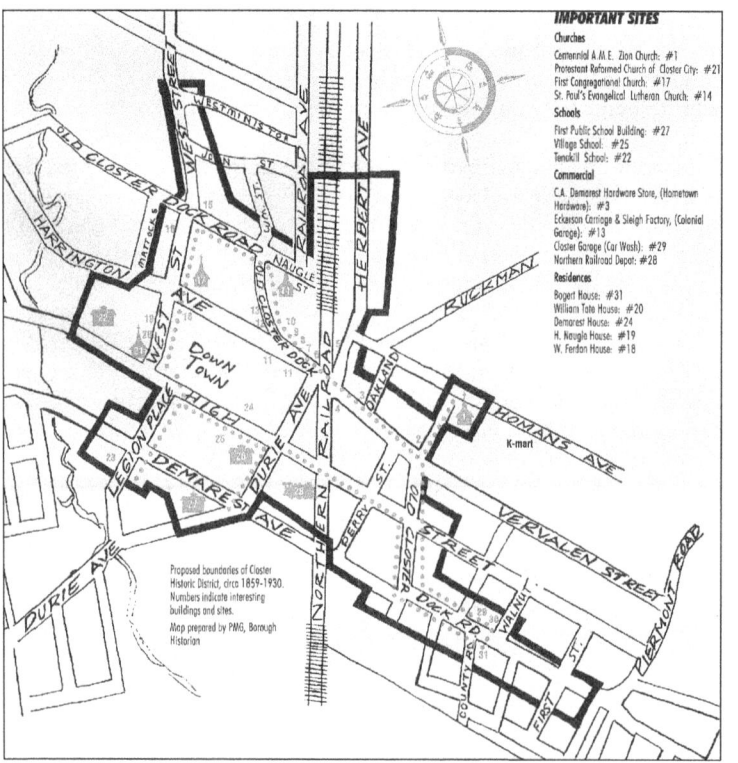

A MAP OF CLOSTER CITY HISTORIC DISTRICT. This map comes from a walking tour brochure prepared by the Closter Historical Society. In addition to a commercial downtown and a large residential section, this pre-automobile railroad suburb included four churches, three schools, three hotels, and a train depot.

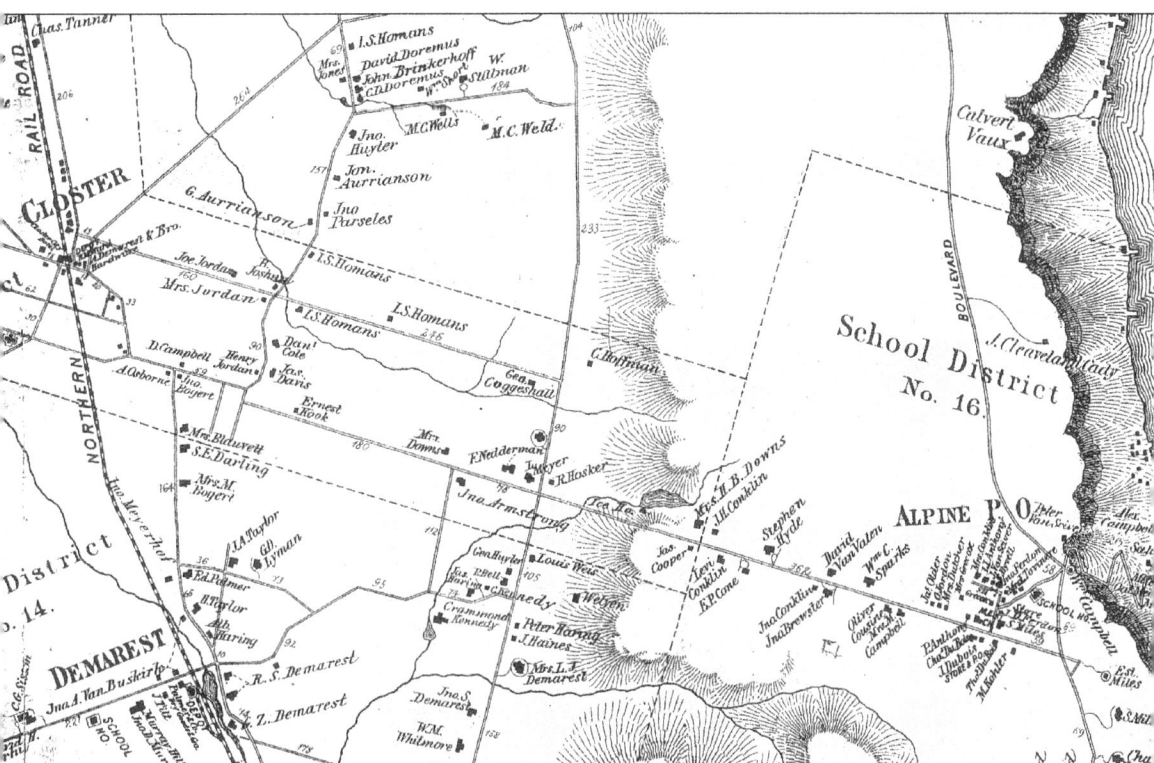

MAP OF CLOSTER AND ALPINE, 1876. Walker's 1876 *Atlas* shows some of the main areas of settlement in the region in the late 19th century. They include the Alpine hamlet, above the cliffs, and Closter City and Demarest, located farther inland and to the west. Alpine and Closter are connected by Closter Dock Road. Other early roadways shown are Blanche Avenue and County, Piermont, and Ruckman Roads.

NORTHERN R. R. TIME TABLE.

JANUARY 4, 1903.

Leave Closter For N.Y.	LEAVE NEW YORK. 23d St.	LEAVE NEW YORK. Ch'bers St.	Arrive Closter Fr'm N.Y.
A. M.	A. M.	A. M.	A. M.
5 22	*5 40	*5 45	6 54
6 23	6 55	7 08	8 08
6 43	8 10	8 15	9 17
7 00	9 55	10 00	11 01
*7 20	11 25	11 30	P. M.
*7 49			12 34
8 07	P. M.	P. M.	1 32
8 46	†12 25	†12 40	2 25
9 31	1 10	1 20	3 38
11 06	†2 25	†2 30	4 17
	3 25	3 30	4 56
P. M.	3 40	3 53	5 46
12 38	*4 38	*4 53	6 34
1 52	*5 23	*5 36	7 09
3 43	5 53	6 06	7 51
4 10	6 38	6 43	9 03
5 36	7 55	8 00	10 00
6 42	8 40	9 00	11 33
8 32	10 25	10 30	A. M.
11 03	11 55	12 00	1 01

SUNDAY TIME TABLE.

A. M.	A. M.	A. M.	A. M.
7 39	8 25	8 30	9 34
9 04	9 25	9 30	10 42
P. M.	P. M.	P. M.	P. M.
1 33	1 25	1 30	2 37
5 31	3 53	4 00	5 04
6 51	6 53	6 58	8 00
8 06	7 55	8 15	9 18
9 36	9 55	10 00	11 08

*Except Holidays. †Saturdays Only.

THE NORTHERN RAILROAD SCHEDULE. In 1903, 18 trains were running each way between Closter and New York City. The train hooked up with a ferry connection in Jersey City. In Tillotson's *Directory of the Northern Valley* (1900), most Closterites who commuted listed their offices as being in lower Manhattan in the Wall Street area.

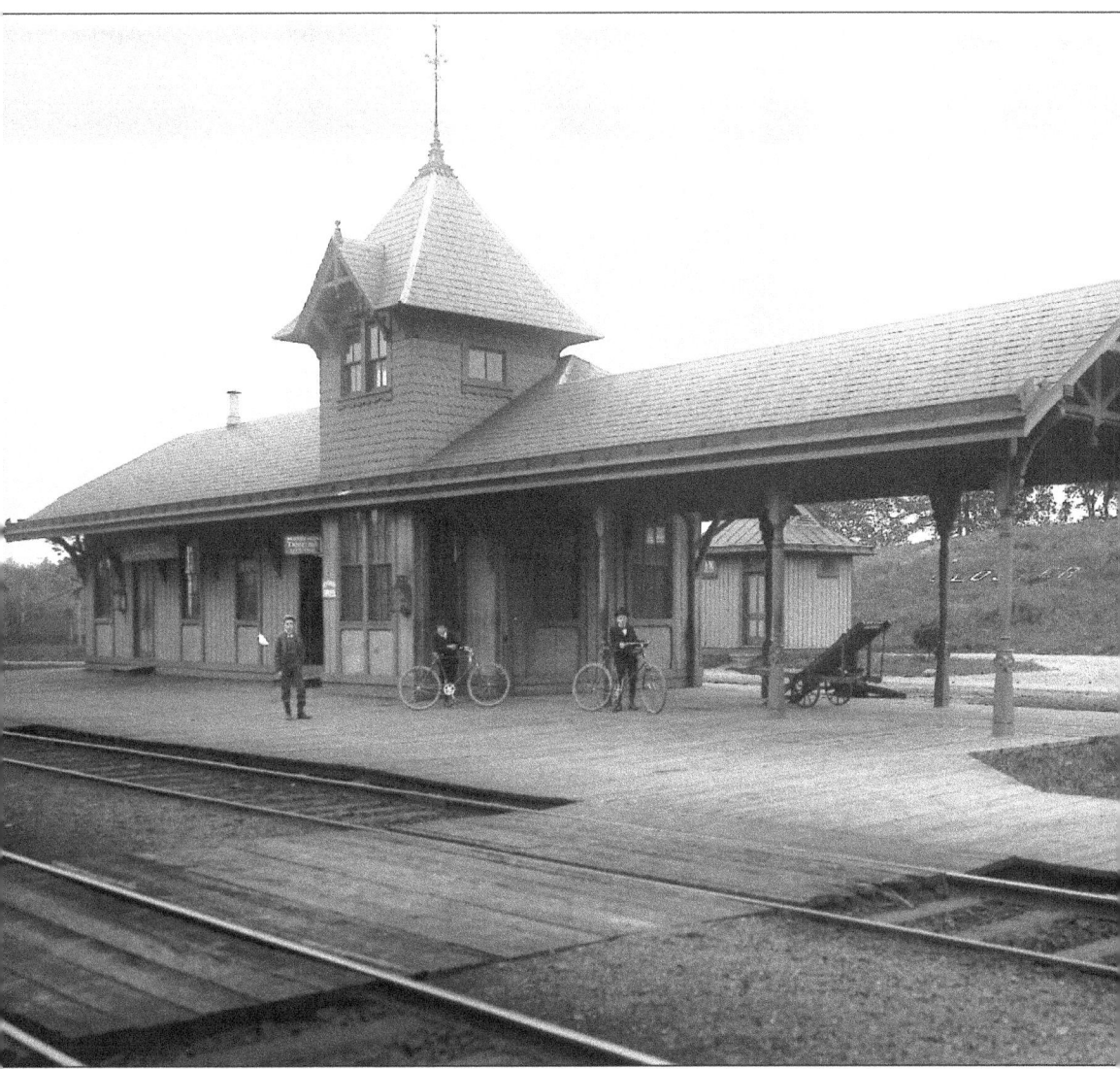

THE CLOSTER DEPOT. This station was built in 1875 in the Victorian Stick style and was moved to its present site in 1881. For decades it had the only telegraph in the area and was a communication center for the town. It was also used by estate owners on the Alpine cliffs; daily visitors included Wall Street barons and the Ringling brothers when they were in summer residence. A potbellied stove was the center of news and social activity. Before the depot was built, the *Hand-Book of the Northern Railroad* said the first station consisted of a tin box, ticket sales, and a hat that contained U.S. mail. This concession was owned and administered by John Henry Stephens. (Courtesy Harvey Conklin Studios.)

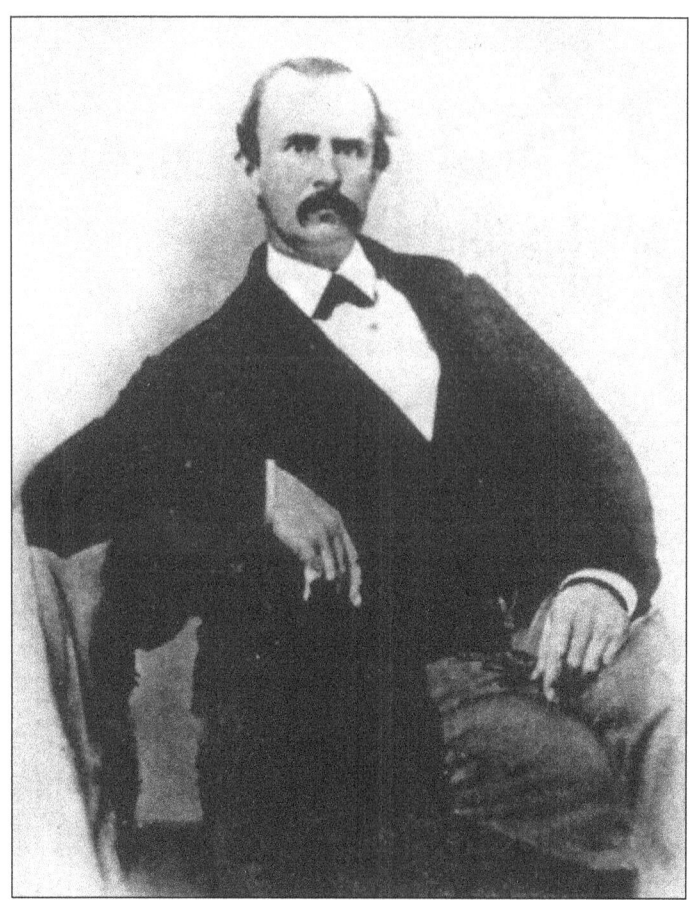

JOHN HENRY STEPHENS. A successful businessman, Stephens erected an Italianate commercial building, with huge wraparound porch and copula, in 1857, two years before the railroad started running trains.

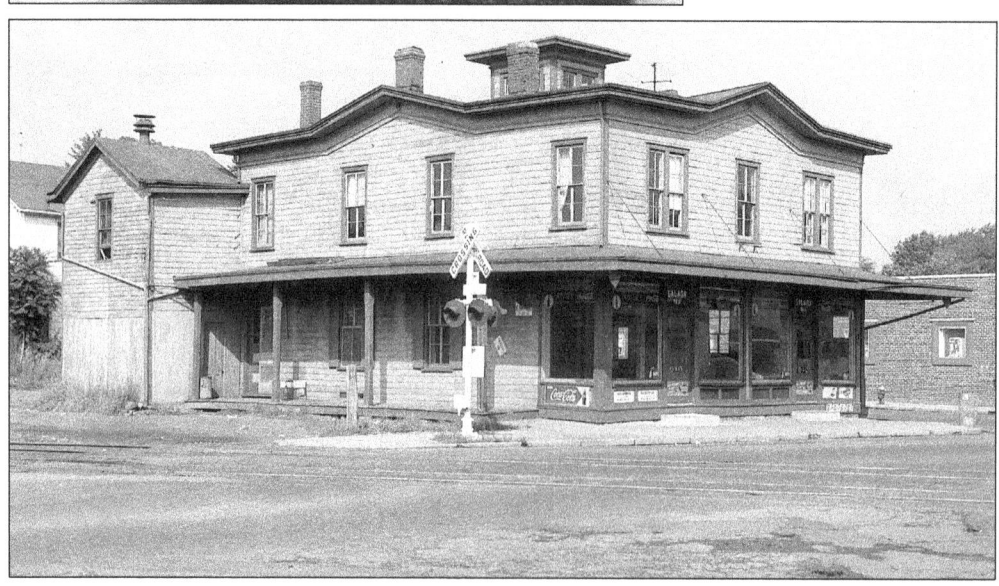

THE JOHN HENRY STEPHENS STORE, 230 CLOSTER DOCK ROAD. Stephens's store was the first commercial building in town. Unfortunately this landmark building was demolished in 1957. The Closter Bootery is on the site today. (Courtesy Walter Mall Collection.)

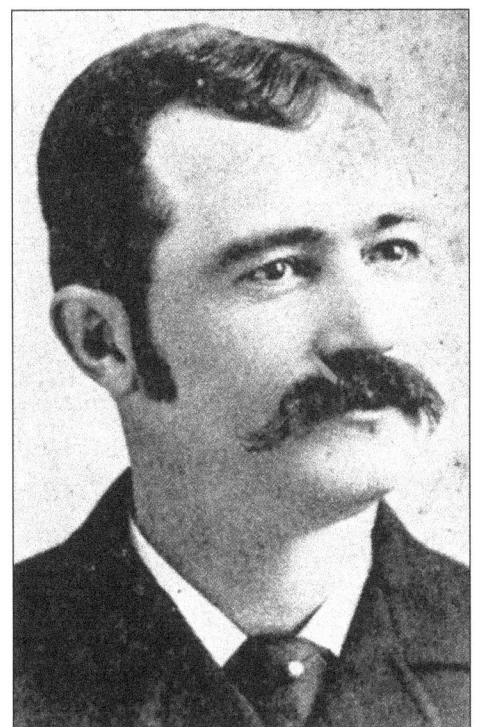 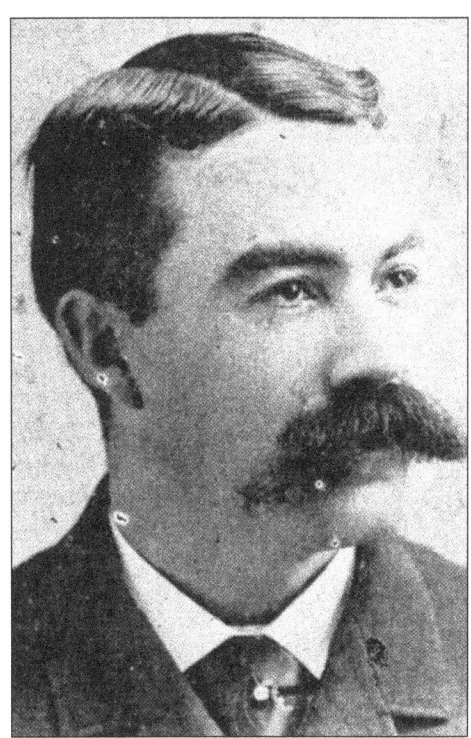

JAMES TAVENIERE (LEFT) AND DARIUS JOHNSON. In 1882, John Johnson's son James and Darius Taveniere, who had been working for the elder Johnson, forged a lifelong partnership and took over the livery business. Both men were very active in town affairs and introduced running water and electricity in Closter. (Courtesy Charles Lyons.)

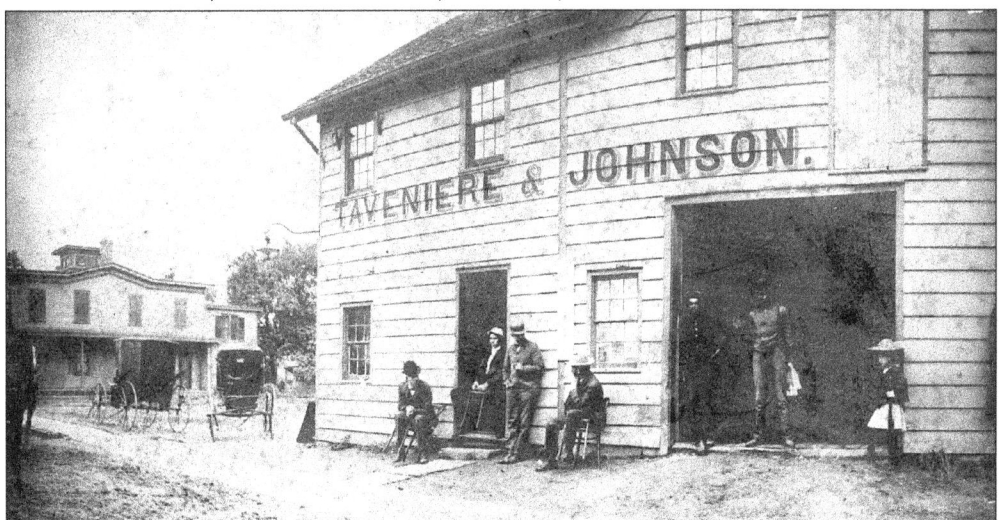

TAVENIERE & JOHNSON LIVERY STABLES. Closter was a rail transfer station for mail. In 1872, a stagecoach line connected the Pascack Valley area, now Woodcliff Lake, to Closter; this led to the creation of this livery and stable business. John P. Johnson first organized a travel service with the old Main Street stable as the Closter terminal. The general livery business grew with the sale of horses. The building was demolished in the late 1920s. It was located a 226 Closter Dock Road, where Morses's pharmacy was for many years. (Courtesy Charles Lyons.)

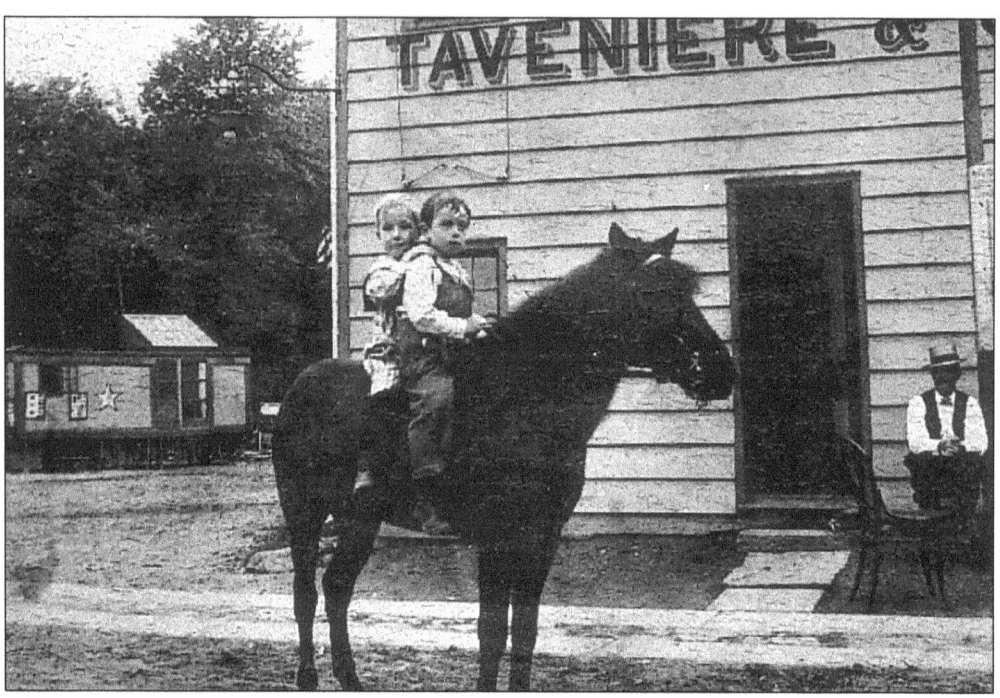

STANLEY AND JAMES TAVENIERE. The boys are shown on a horse in front of their family's business. (Courtesy Charles Lyons.)

THE FIRST CLOSTER POST OFFICE BUILDING. Located on the south side of Main Street at present-day 218 Closter Dock Road, William Tate is shown c. 1905 with his children Buelah and Clifford. Tate was in the insurance business. He erected this building for a post office when, after many years, the postal department decided to separate from the Stephens's country store building. Tate was the first postmaster and served a six-year term. At that time the rating of the post office was fourth class. When it graduated to third class, the postmaster's appointment became a four-year term. Tate served three more consecutive terms. (Courtesy Harvey Conklin Studios.)

THE TELEGRAPH. For many decades during the early 20th century, Ralph W. Tracy was the agent for the railroad and operated the telegraph system from the railroad depot. He was also in charge of collecting the mail and freight. Ed Oliver transferred the mail to the Main Street post office. Tracy is shown at his station c. 1910.

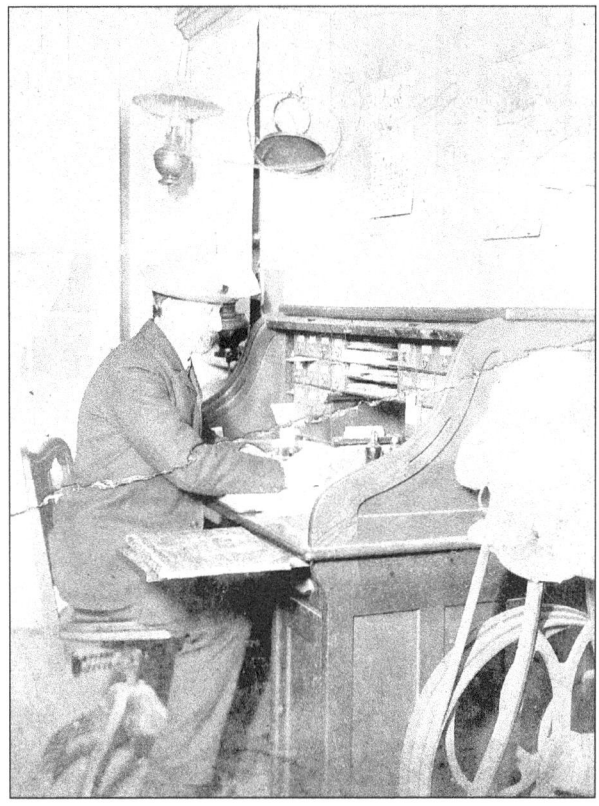

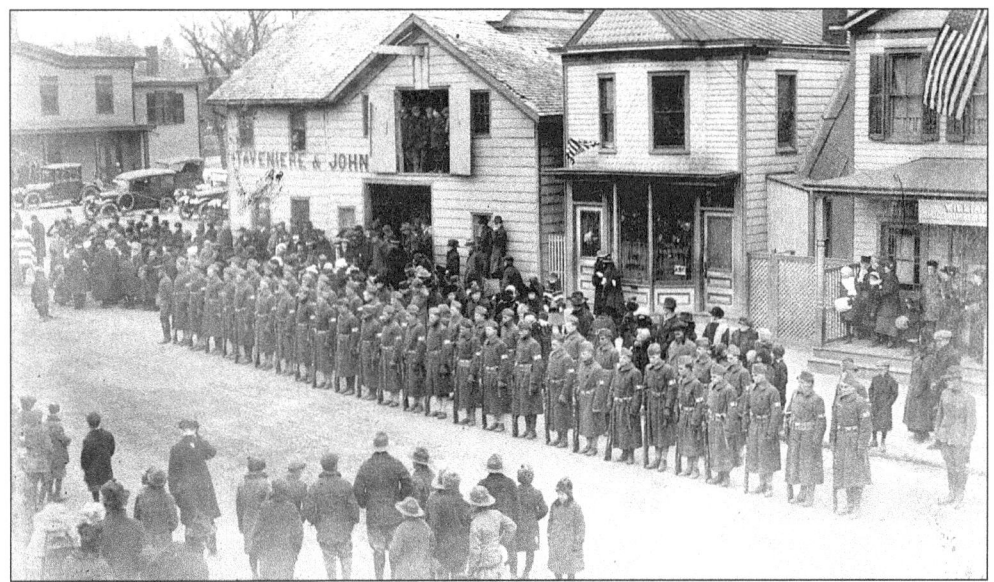

THE ARMISTICE DAY PARADE, C. 1918. This view of a downtown parade includes the dough boys, the post office, the livery stable, and the Stephens building. The numerous soldiers came from nearby Camp Merritt in Cresskill.

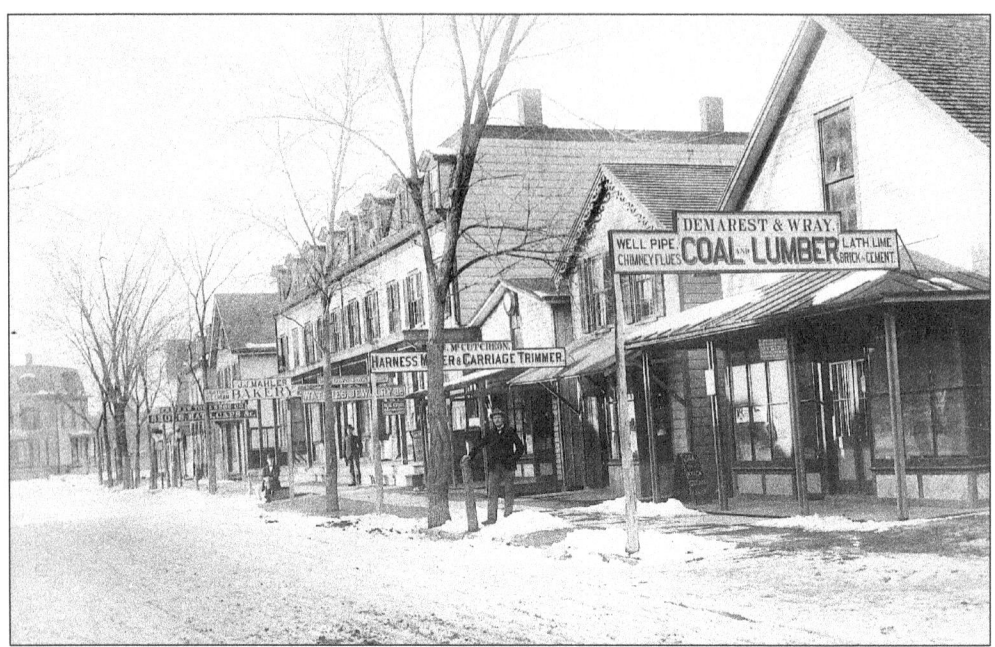

MAIN STREET, NORTH SIDE, LOOKING WEST. The three-story, Second Empire–style, commercial-row building with a mansard roof was built by William Lindemann, a farmer who became a real estate agent and builder. It is known as Lindemann Row. Lindemann was probably the second most important person in the early development of the town and built many of the homes in the residential section of the district. As a politician, he served as freeholder for Harrington Township from 1886 to 1890 and served on the first council when the borough incorporated in 1904. (Courtesy Walter Mall Collection.)

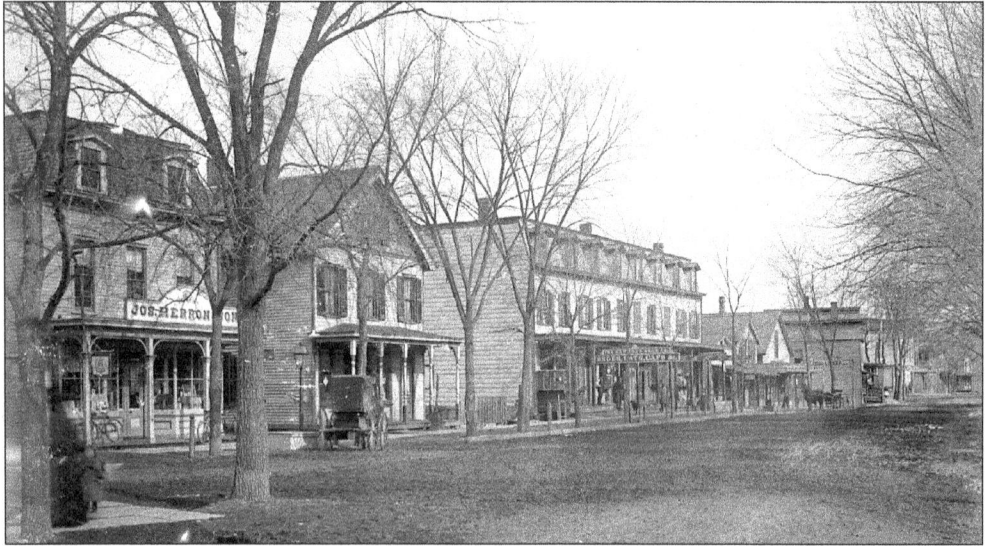

MAIN STREET, LOOKING EAST. The 1870 *Hand-Book of the Northern Railroad* on New Jersey listed the variety of businesses on Main Street: "commercial enterprises in the town including three hotels, blacksmiths, boots and shoes, coach trimmings, carriage and sleigh manufacturers, dry goods, flour and feed, general store, hardware and stoves, livery stable, merchant tailor, restaurant, stair builder, and wheelwrights."

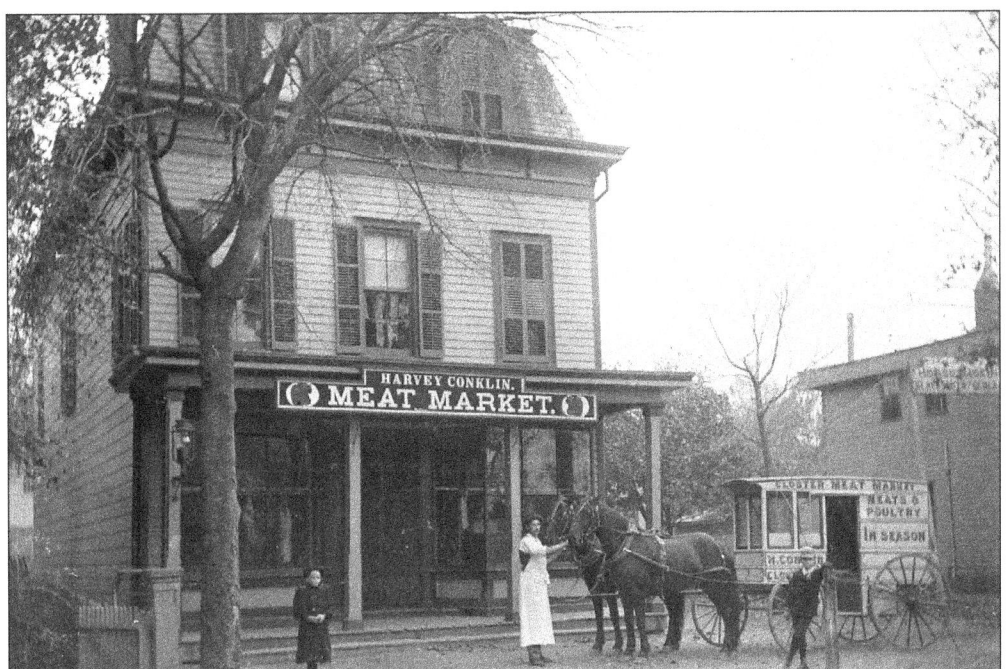

THE HARVEY CONKLIN MEAT MARKET, MAIN STREET. This store was the main butcher shop during the 19th century. Conklin traveled in his horse-drawn wagon between Snedens Landing, New York, to the north and south of Closter delivering fresh meats. (Courtesy Harvey Conklin Studios.)

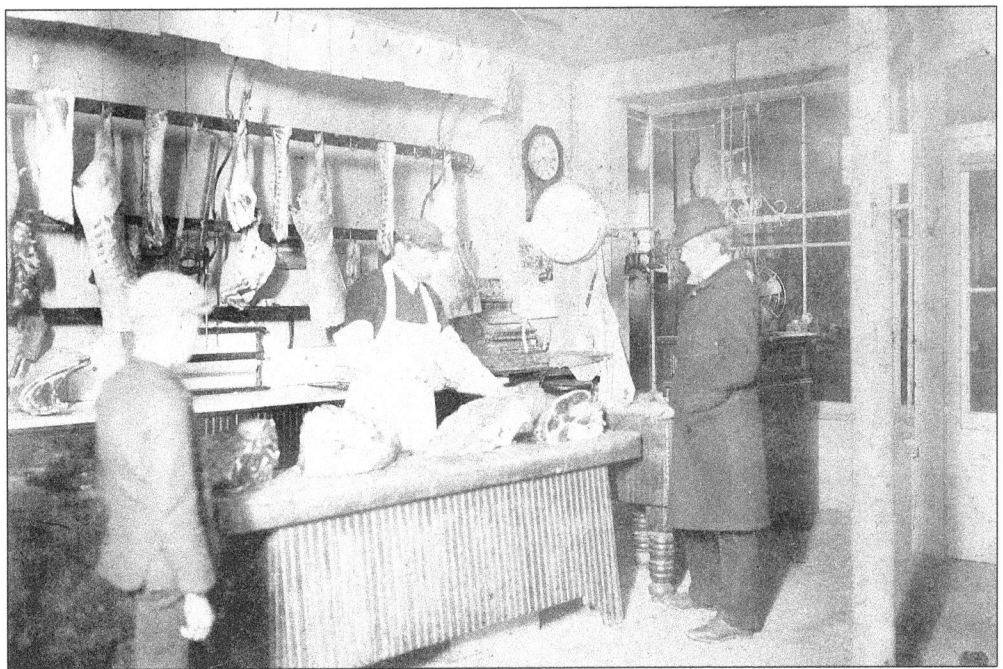

HARVEY CONKLIN. In this view, Conklin waits on customers inside the shop. (Courtesy Harvey Conklin Studios.)

55

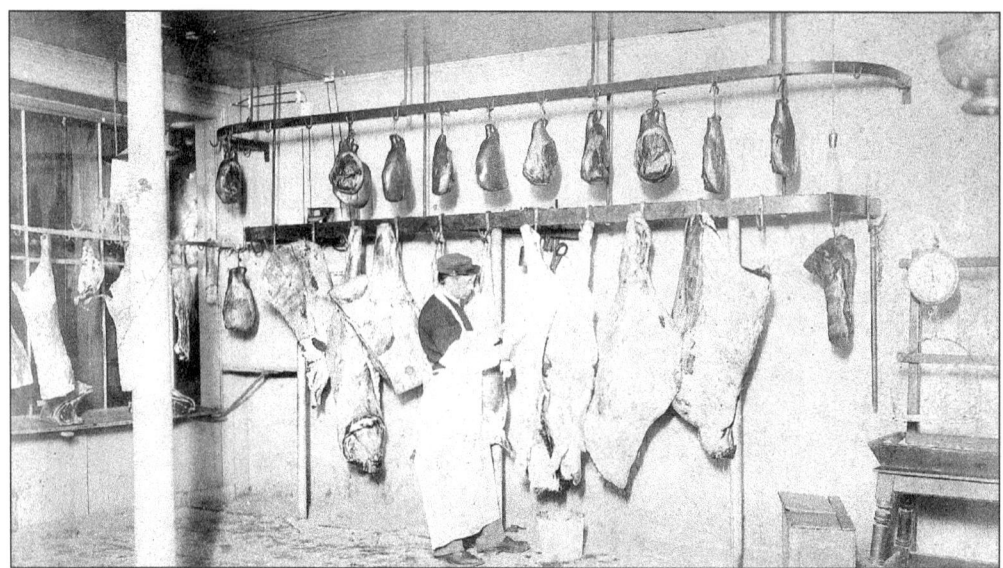

CONKLIN MEAT MARKET INTERIOR. The store was well stocked. For over half a century, Conklin traveled the northern valley selling his meats and taking photographs of his customers. Many of the older photographs in this book were taken from his glass negatives.

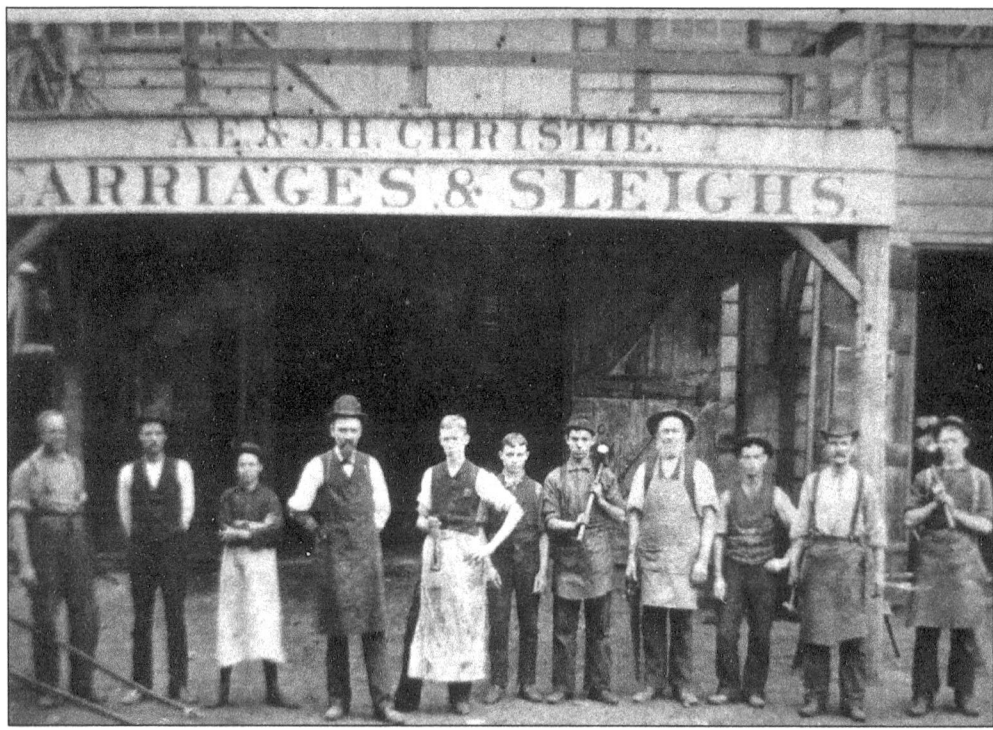

A.E. & J.H. CHRISTIE CARRIAGES & SLEIGHS. This late-19th-century photograph shows wheelwrights, blacksmiths, and other workers in front of the shop. (Courtesy Mark Wright.)

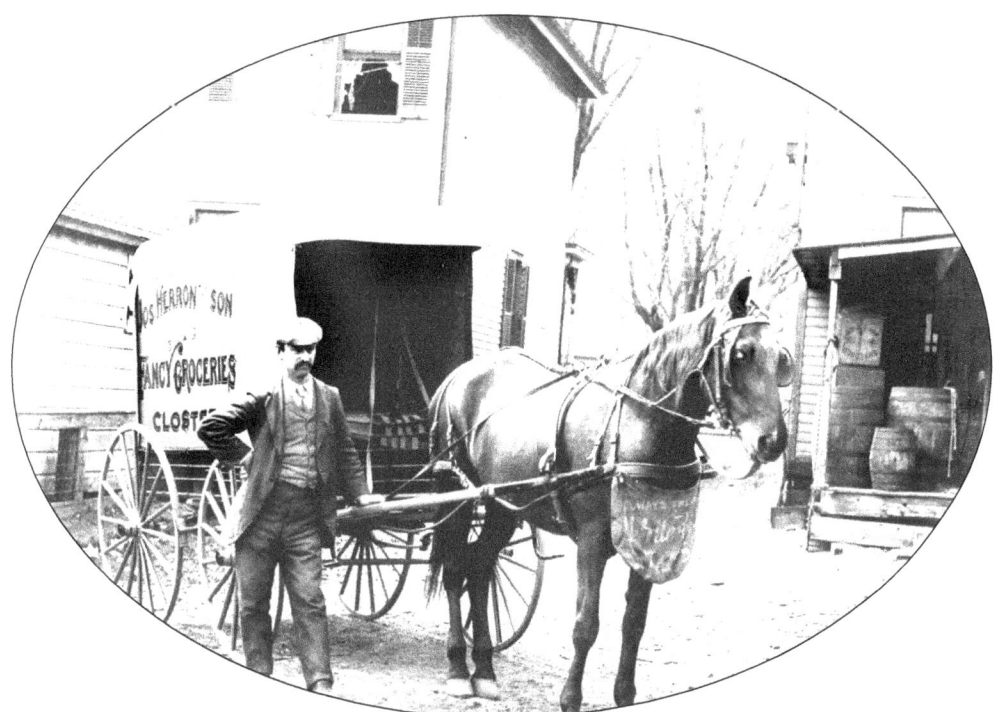

JOSEPH HERRON WITH A GROCERY STORE DELIVERY WAGON. This c. 1900 photograph was taken in back of a grocery store on Main Street, between 217 (Herron Store) and 219 Closter Dock Road in an alleyway that still exists. (Courtesy Red Maple Luncheonette.)

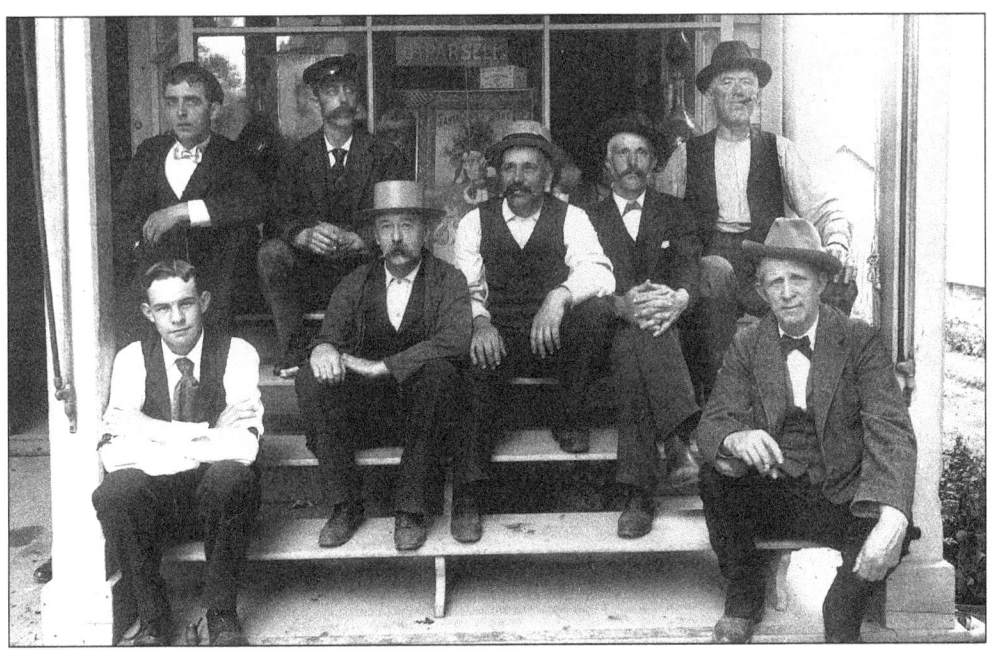

TOWNSMEN IN FRONT OF HERRON STORE. The only man identified in this c. 1905 photograph is William Wray, far right. (Courtesy Harvey Conklin Studios.)

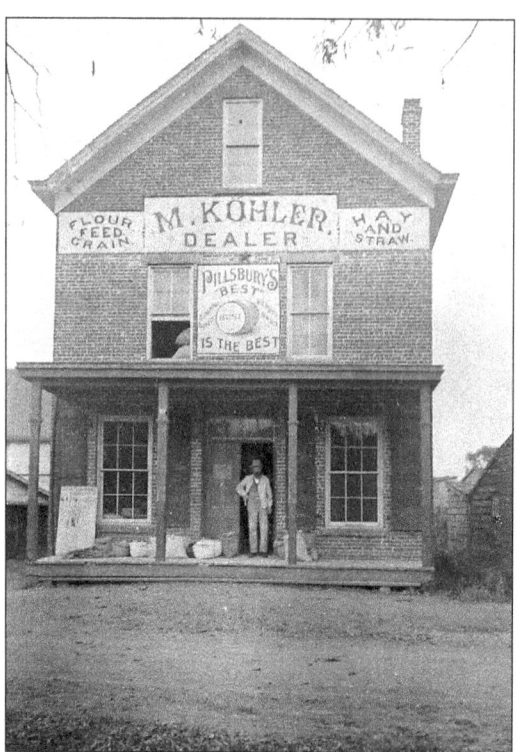

THE H & M KOHLER COMPANY. Currently at 211 Closter Dock Road, this early brick building was one of the original feed, grain, hay, and straw shops in 19th-century downtown Closter. (Courtesy Charles Lyons.)

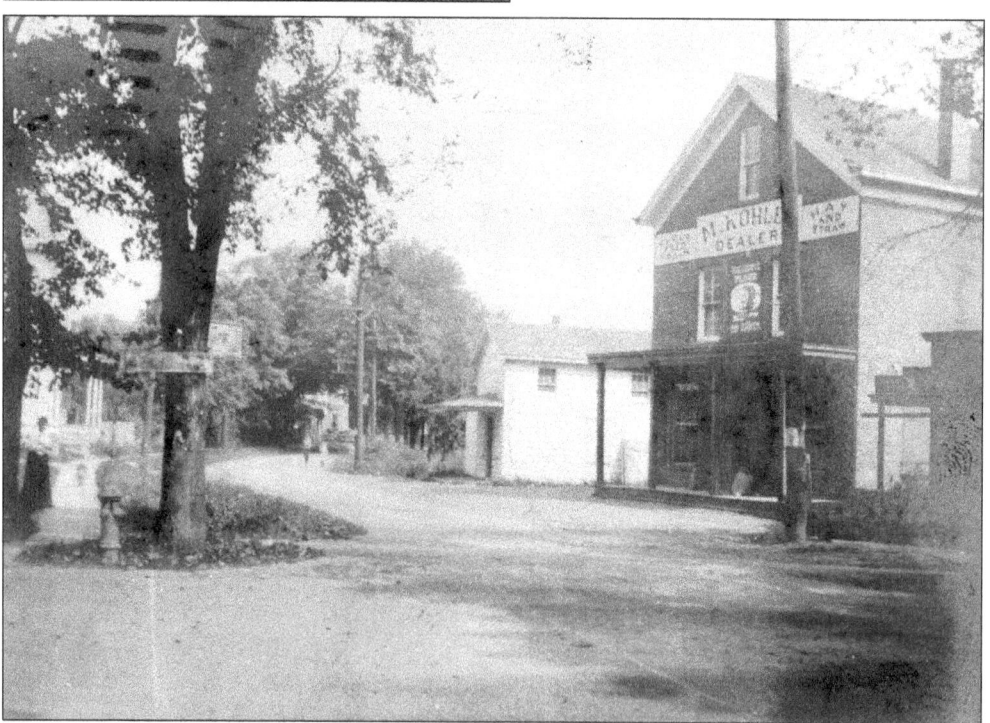

OLD CLOSTER DOCK ROAD, LOOKING NORTH. Taken from the juncture with present-day Harrington Avenue, this photograph looks north toward the residential section of town and the Kohler store. (Courtesy Charles Lyons.)

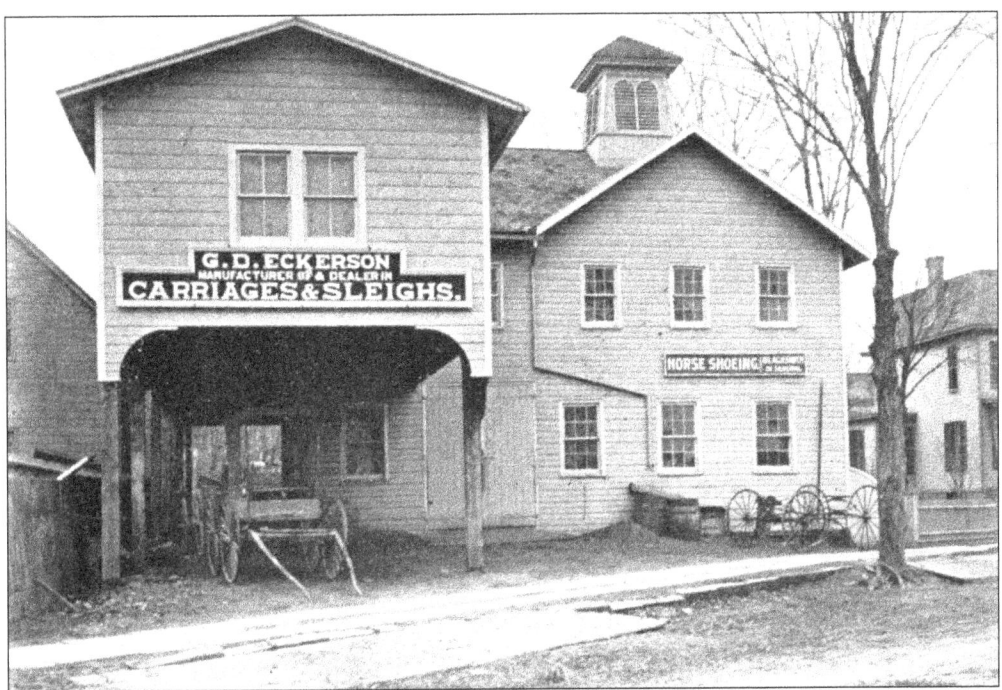

THE ECKERSON AND BROTHERS CARRIAGE & SLEIGH MANUFACTORY. Located at 170 Closter Dock Road, this is one of the oldest industrial concerns in Closter City and the historic district. Established in 1870 by G.D. Eckerson, it was noted for high-quality workmanship and fine products. It included blacksmithing services and became an automobile garage in 1912. It continued to function as a garage until 1999. Garret Demarest Eckerson, proprietor, was born in 1846 and Married Margaret Hammond in 1873. He died in 1924.

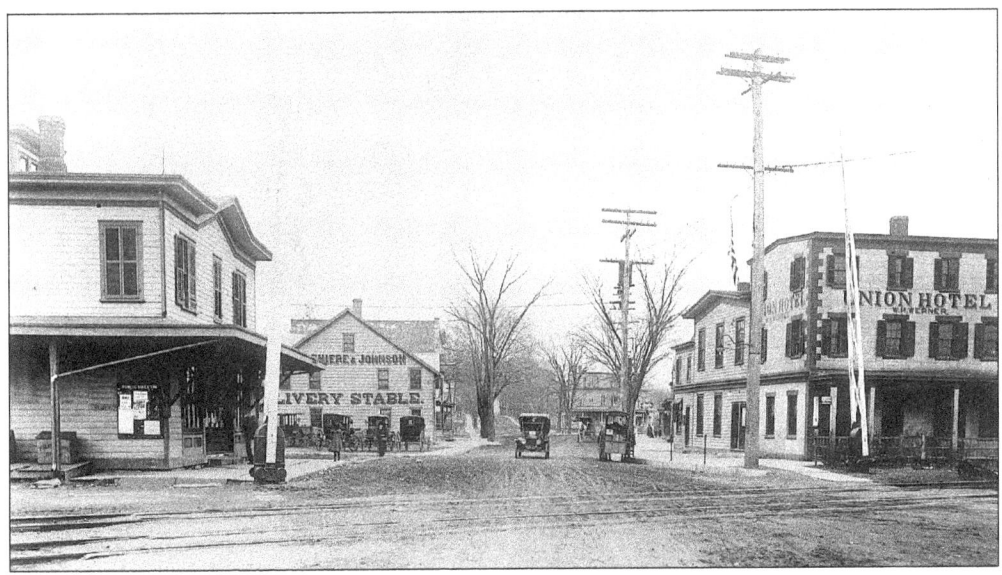

MAIN STREET, WEST OF THE RAILROAD TRACKS AND UNION HOTEL. The Union Hotel was originally the Closter City Hotel and was one of three hotels in the downtown area.

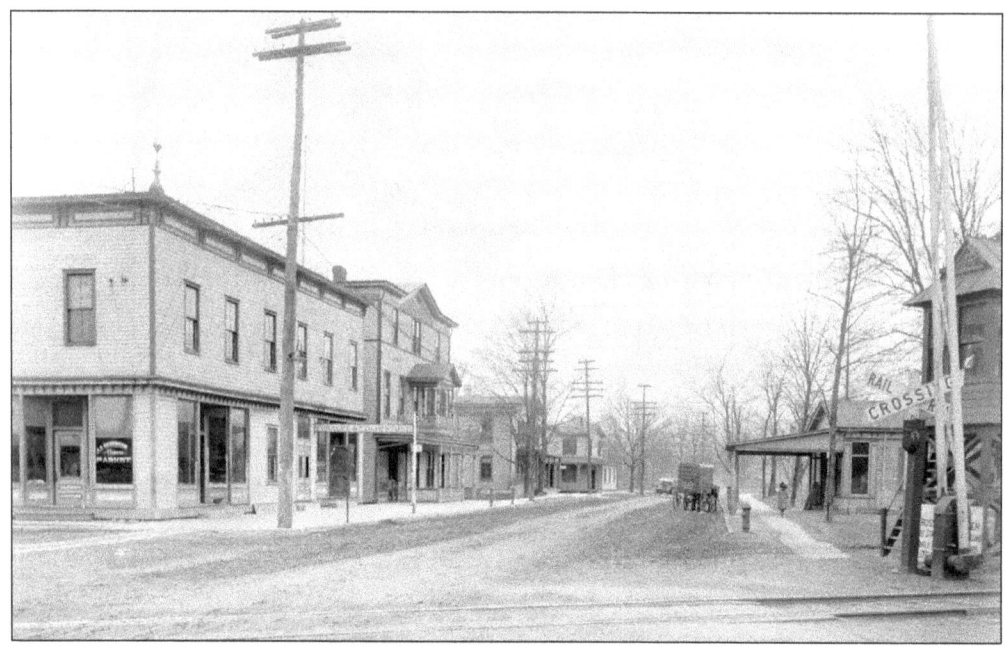

MAIN STREET, EAST OF THE RAILROAD TRACKS. This photograph shows what early residents knew as the Stephens Block. Following John Henry Stephens's death in 1888, his relatives built this block. Percy Stephens operated the corner store for many years. The second building on the left is the Ward's Hotel. All of these buildings have been demolished.

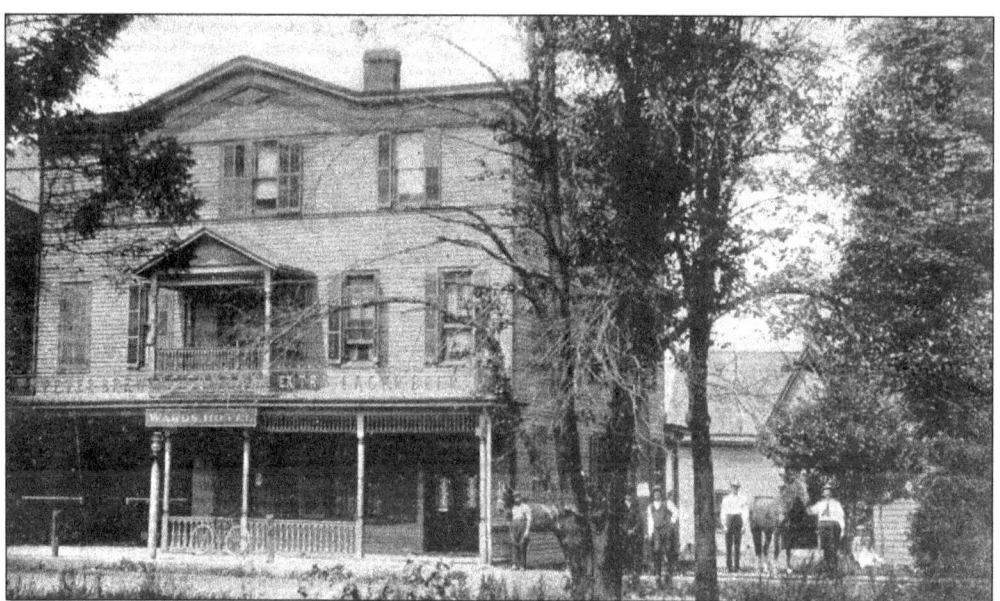

WARD'S HOTEL. Opened by N.M. Ward soon after the railroad opened, the hotel boasted first-class accommodations, a meeting hall, billiard hall, and bowling alleys. It was not uncommon for city dwellers to arrive at the beginning of the summer and remain for several months. Luxury hotels could be found on the northern line at the Norwood House to the north and at the Demarest Hotel to the south (Courtesy Charles Lyons.)

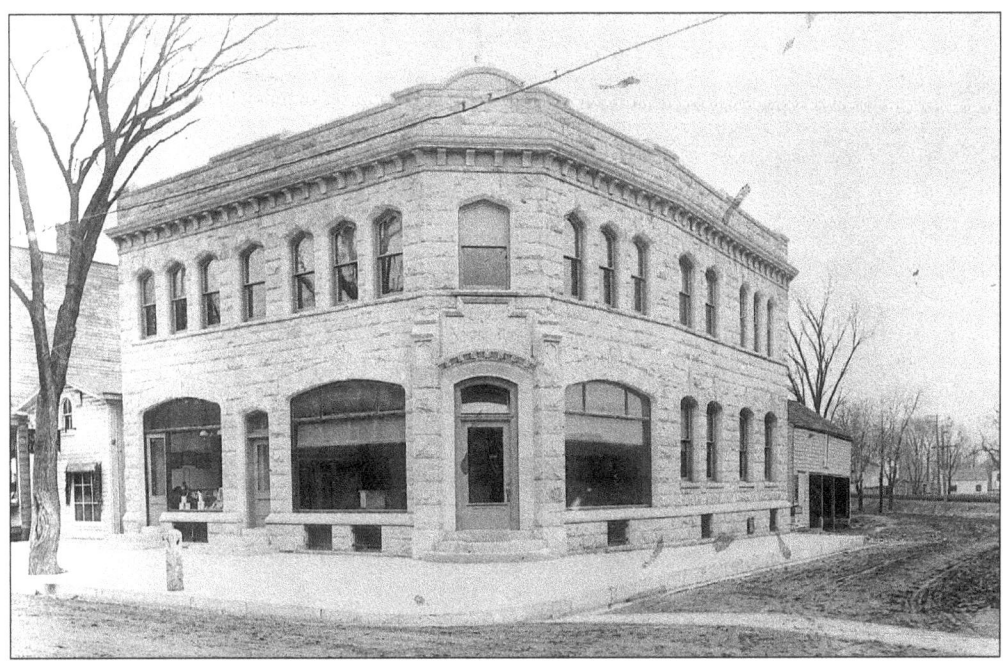

THE CLOSTER BANK BUILDING. This 1913 photograph shows the newly completed, handsome, Romanesque Revival–style bank building, which remains a landmark in the downtown landscape today. It is located at 235 Closter Dock Road, formerly the corner of Main Street and Railroad Avenue. (Courtesy Charles Lyons.)

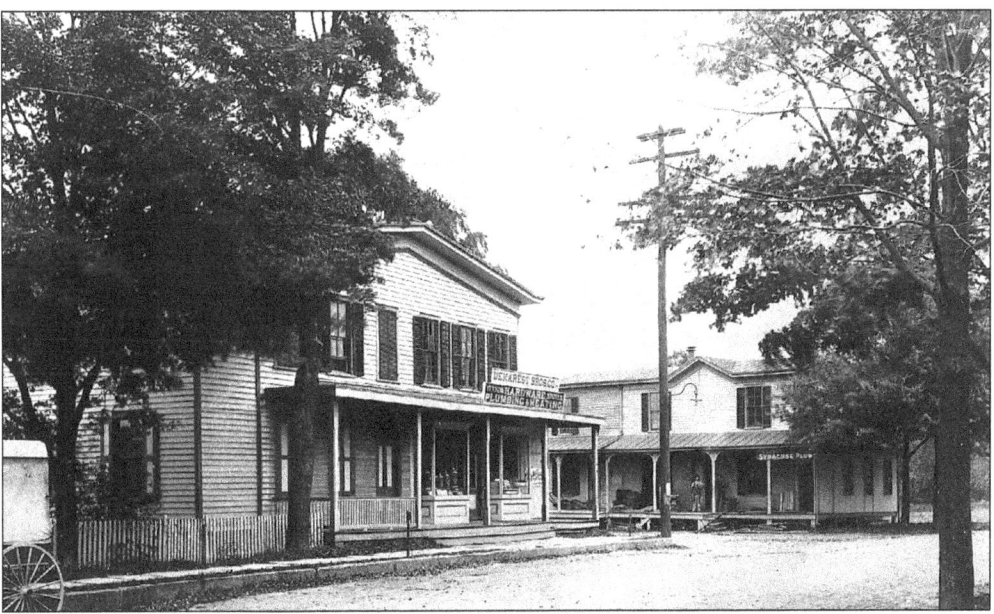

THE C.A. DEMAREST & BROTHERS HARDWARE STORE. The Demarest family established one of the first businesses around the old railroad depot and new town center. The business remained in the family for more than 100 years. This vernacular Italianate-style commercial building, erected in 1865, has recently been restored. The present building is located at 257 Closter Dock Road. (Courtesy Charles Lyons.)

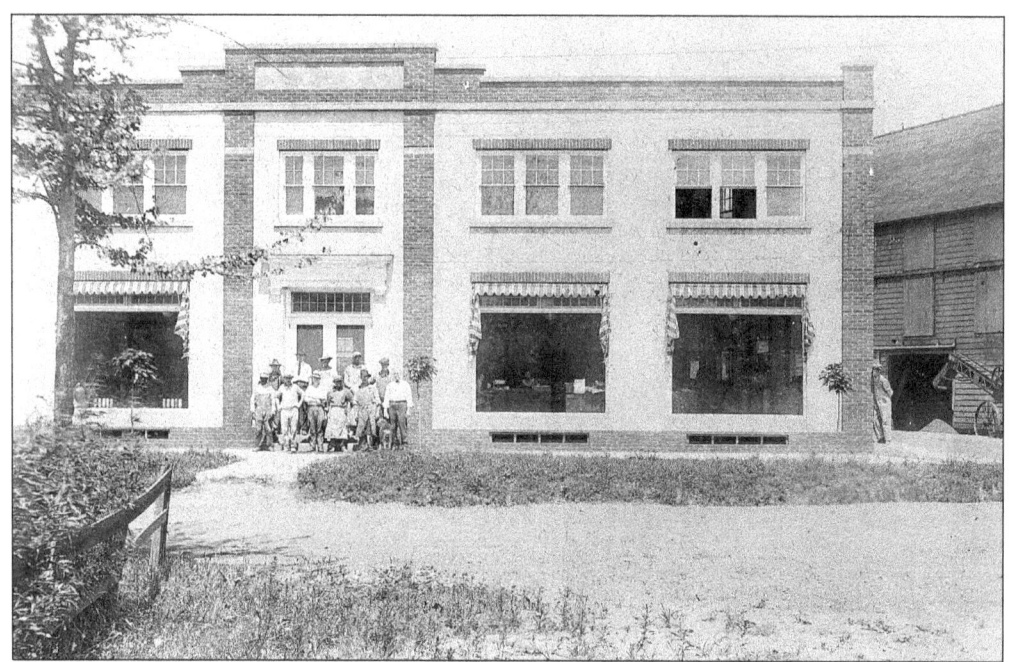

THE JOHN JAY DEMAREST HARDWARE STORE. This photograph shows employees in front of a second hardware store, which was originally established on Main Street and moved to Rail Road Avenue when the Closter Bank building was erected. The original firm was started by Tanner and Ferdon and was sold to John Demarest. His son John Jay Demarest took over and renamed the company after himself. In addition to regular hardware items, they prospered selling coal and lumber. (Courtesy Kenneth Thompson.)

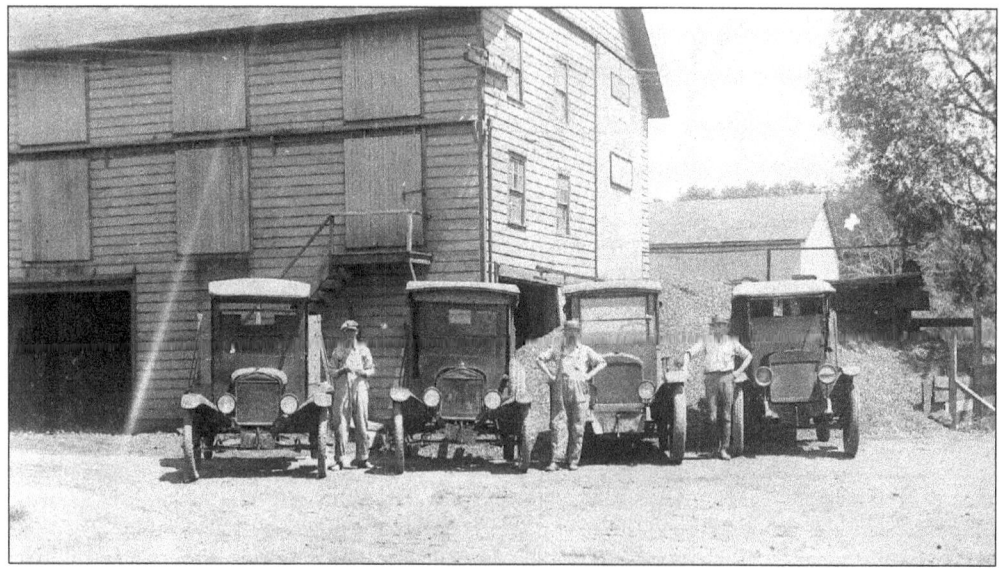

THE JOHN JAY DEMAREST HARDWARE STORE TRUCKS. As the 20th century progressed, delivery trucks replaced horse teams. (Courtesy Charles Lyons.)

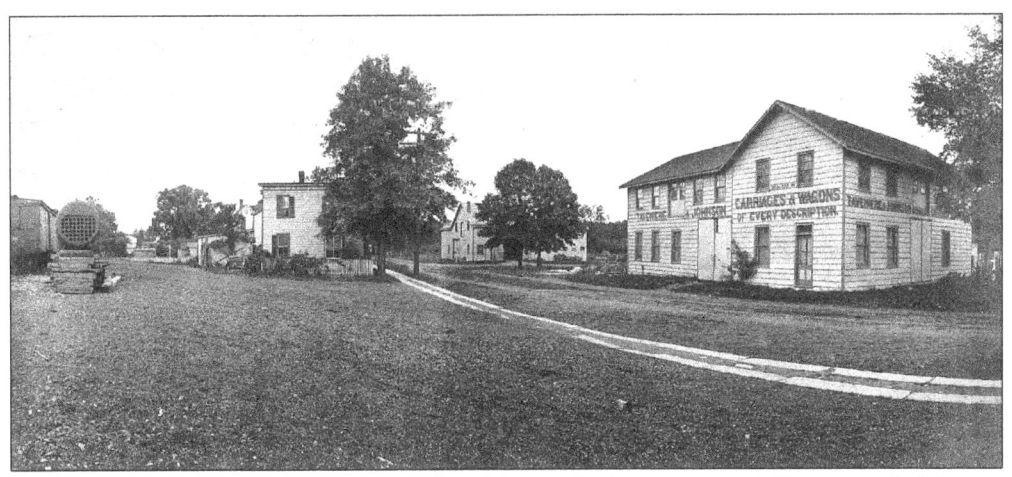

HERBERT AVENUE, LOOKING NORTH. This photograph shows a second Taveniere & Johnson stable. The small roadway that intersects with Herbert past the stable is Homans Avenue. (Courtesy Charles Lyons.)

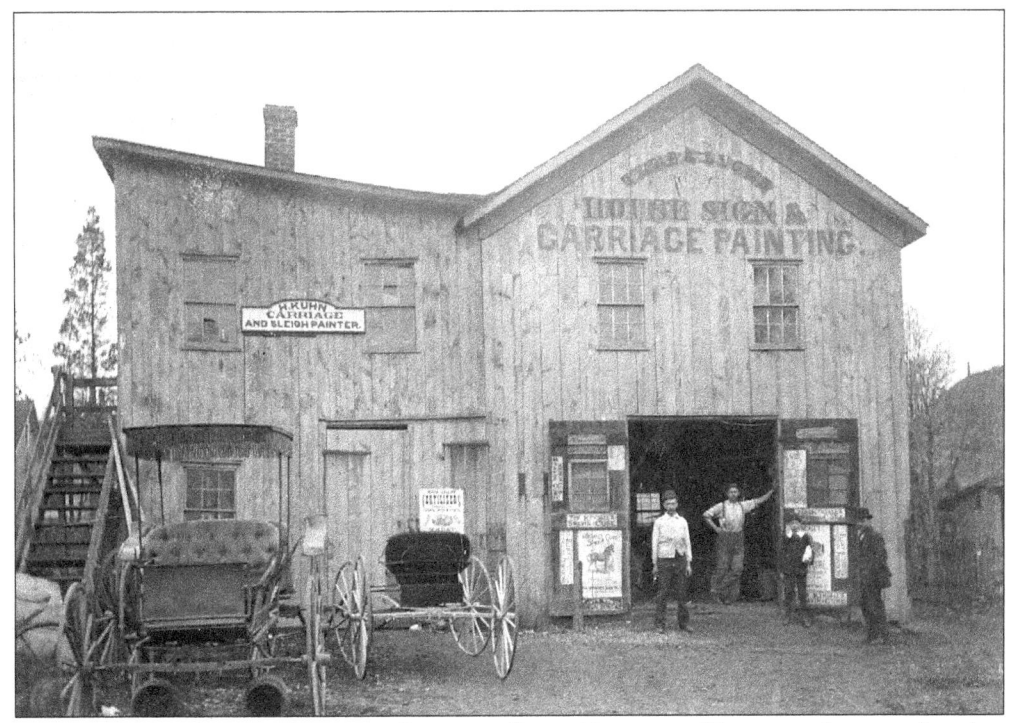

KUHN'S HOUSE, SIGN & CARRIAGE PAINTING SHOP. Numerous Closter residents are listed as sign painters in Tillotson's 1903 *Directory of the Northern Valley*.

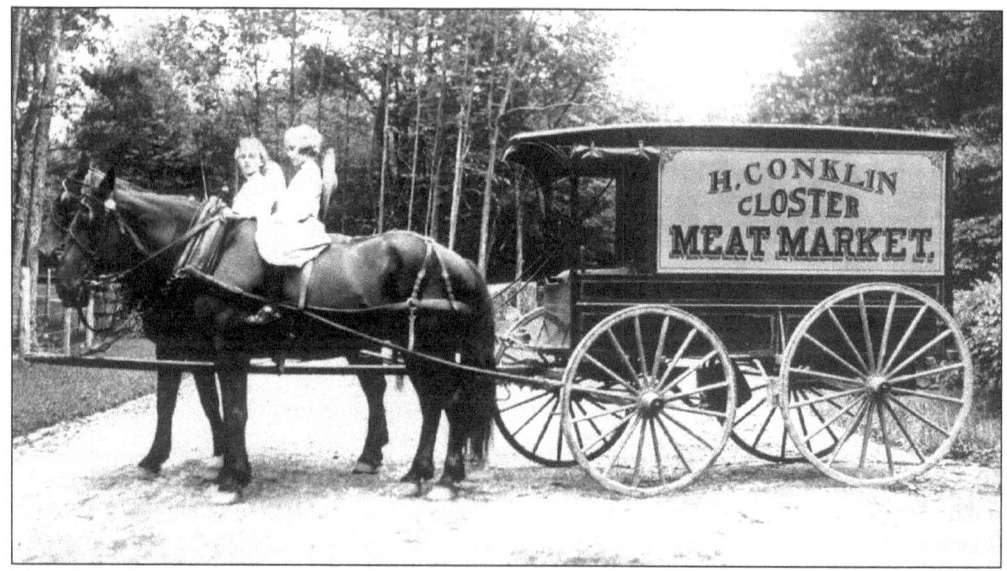

THE CONKLIN MEAT WAGON IN PALISADES, NEW YORK. The Park sisters, Marian and Helen, of Palisades pose on the horses of Harvey Conklin's traveling butcher store. According to Alice M. Haagensen's book *Palisades and Snedens Landing,* it was a great excitement for the children. A resident described it as follows: "A complete butcher shop where you opened the back, all cooled by great blocks of ice with beef, lamb, and pork all hanging and all his shining butcher tools. A team of strong bay horses brought it all the way from Closter. Conklin sliced calves liver expertly and would always slip me a small piece of raw meat." (Courtesy Palisades Library.)

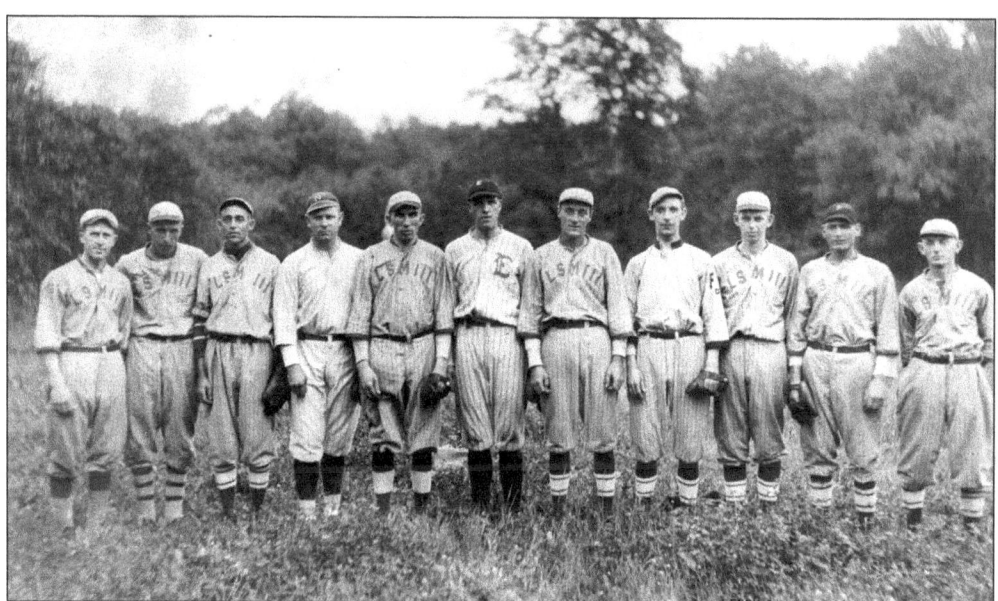

THE AMERICAN LEGION BASEBALL TEAM, 1920. Members of the team are, from left to right, an unidentified player, John Potterton, an unidentified player, Buck Short, an unidentified player, Wally Anker, two unidentified players, Ken Wray, an unidentified player, and George Vossler. This was the first team formed by the Leroy S. Mead Post of the American Legion. Mead was a Closter resident killed in World War I. (Courtesy George Potterton.)

CLOSTER DOCK ROAD, LOOKING WEST. This photograph shows Closter Dock Road where it intersects with County Road. The first house on the left is No. 388.

CLOSTER DOCK ROAD, LOOKING EAST. This photograph was taken from where Closter Dock Road intersects with Harrington Avenue. The first house on the left is No. 363.

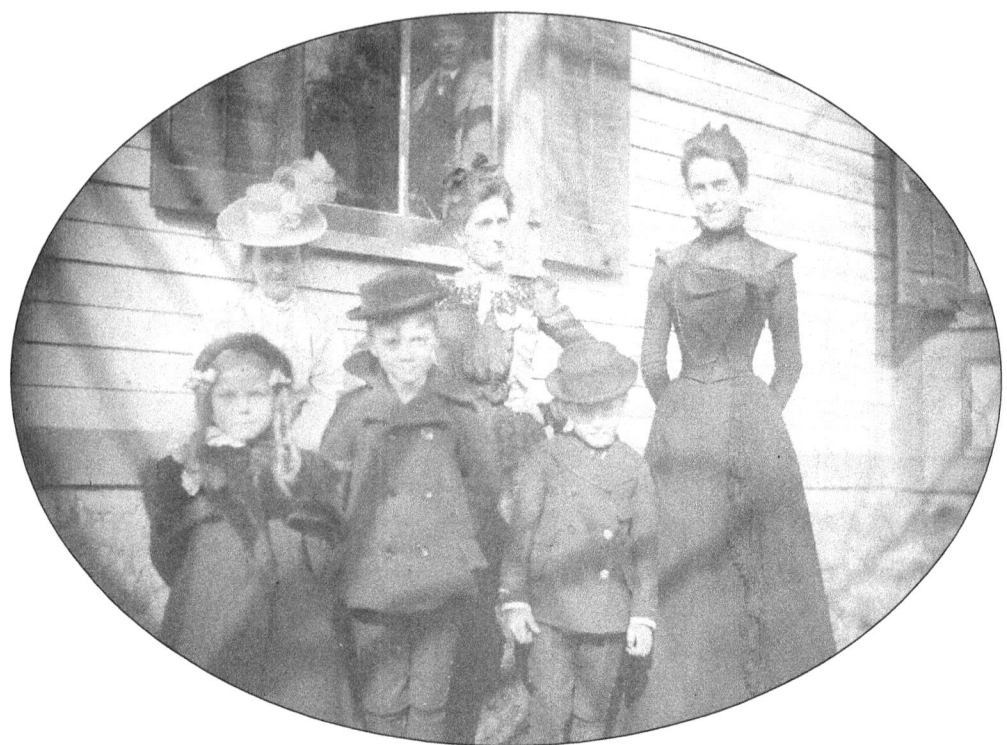

THE SHERMAN FAMILY, C. 1900. The Sherman family is pictured in front of their home at 460 Demarest Avenue on the corner where D'Amicos is today. Thomas Sherman (not pictured) was fire chief from 1920 to 1924 and served on the council in 1934 and 1935. (Courtesy J. Westervelt.)

CLOSTER DOCK ROAD, LOOKING EAST. This photograph is taken from where Closter Dock Road intersects with West Street. The first house is No. 127. It has been considerably stripped of its Queen Anne decorative details.

ABRAM DEMAREST HOUSE, 375 HIGH STREET. This c. 1900 photograph shows the handsome Queen Anne–style house with stickwork in gable ends, wraparound porch, and carriage house. The Demarest family owned the hardware store on Closter Dock Road.

THE CONKLIN HOUSE, DEMAREST AVENUE. The house is one of four small Queen Anne–style homes on the south side of the street. All are two and a half stories with scallop shingles in the gable end and three bay porches with attractive spindle frieze areas, turned posts, and brackets. At the time of Walker's 1876 *Atlas*, the house was owned by Charles H. Lyons. It was later occupied by the Conklin family. (Courtesy Charles Lyons.)

CONKLIN CHILDREN. Fred and Mabel Conklin (left) and a Conklin boy with a toy pony and cart (below) were photographed by Harvey Conklin. (Courtesy Charles Lyons.)

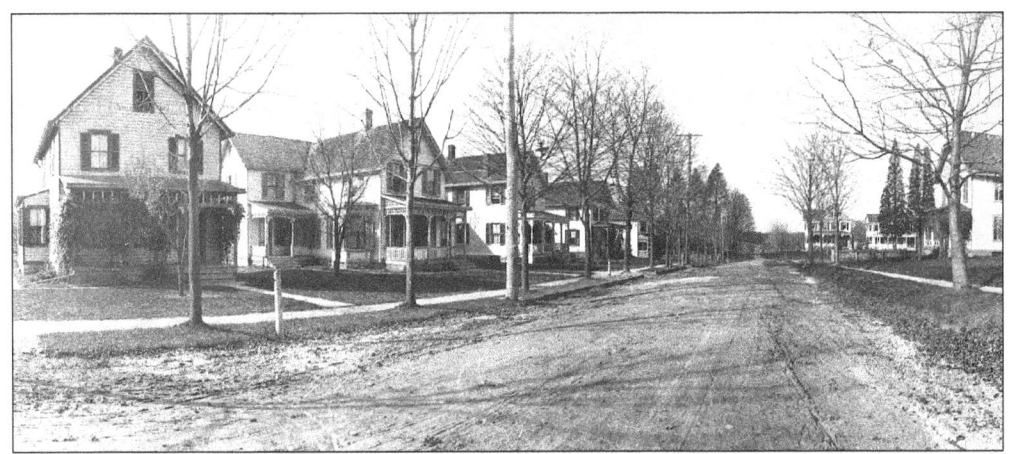

DEMAREST AVENUE, LOOKING WEST. This photograph was taken near the juncture of Durie Avenue, just west of the old School No. 2.

NOS. 422–410 HIGH STREET, LOOKING WEST. The view is from the railroad tracks. The houses are a group of four homes built by the Taveniere family. Probably constructed in the early 1880s, they are a group of four larger Queen Anne–style homes with large front porches.

No. 410 High Street, Looking East. This photograph, taken from the corner of Durie Avenue (formerly White Street), shows the corner Taveniere House and the family tennis court across the street. Several families owned and maintained tennis courts in the historic district. (Courtesy Charles Lyons.)

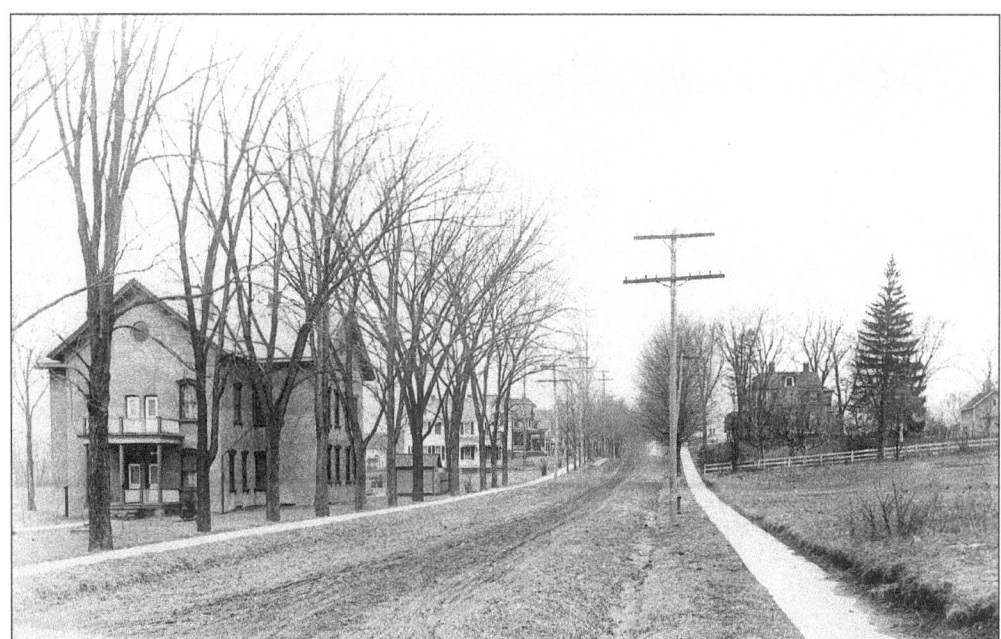

The Elms Apartment House, Demarest Avenue. This c. 1915 photograph shows the old School No. 2 building after it had been converted to apartments. It was called the Elms because of all the tall trees of that type around the property. All of the trees died in the blight in the 1960s, but the name remained.

TWO GIRLS IN A PONY BUGGY. Inez Taveniere Wray and Hazel Johnson Thomas were daughters of livery stable owners Taveniere and Johnson. (Courtesy Charles Lyons.)

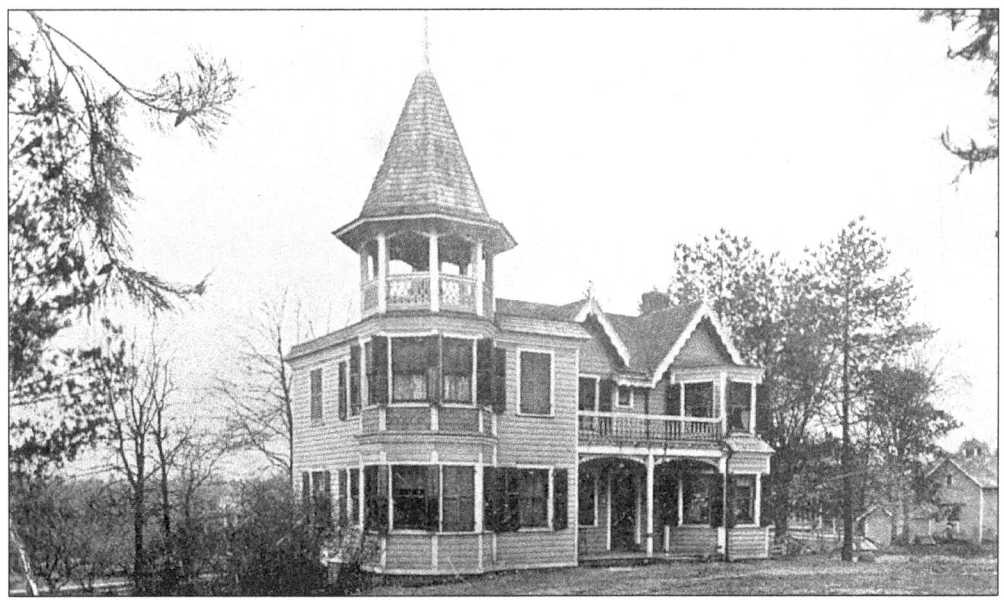

THE CASTLE, 382 HIGH STREET. This c. 1905 postcard illustrates a landmark in Closter that is still known as the Castle by older residents. Built in the 1880s in the Queen Anne style, the most distinctive feature is the two-story octagon belvedere tower with conical roof. The house had a commanding view of the valley below before the Closter School was erected in 1900.

THE VOSSLER FAMILY. Above, Edward Vossler Jr. (front center) and cousins pose for a photograph at 215 High Street. Below, Mr. Vossler takes members of the family out in 1913 in the new car. (Courtesy Lynn Holtzbach.)

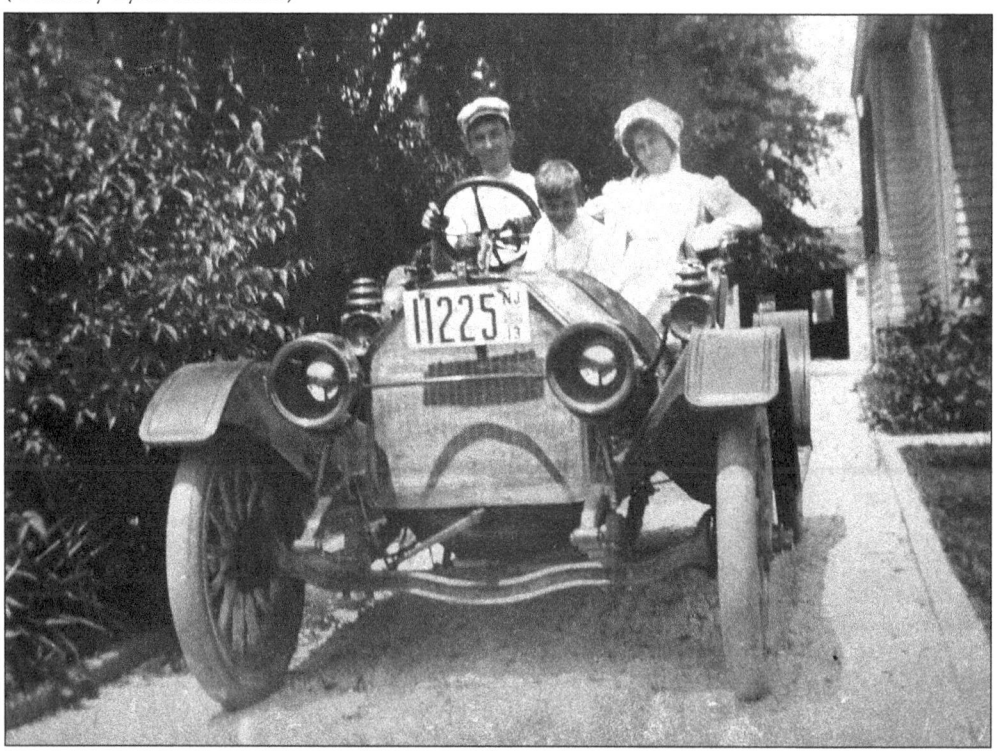

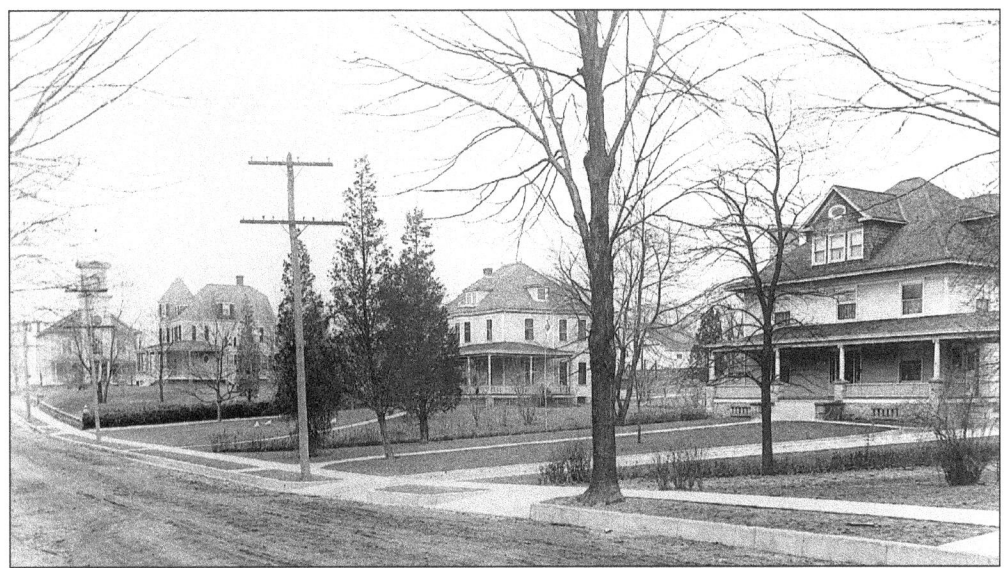

HIGH STREET, LOOKING WEST. This photograph shows a group of three c. 1900s Colonial Revival homes, Nos. 347 and 335 High Street. The homes have hip roofs, porte cocheres, and porches. The house on the corner has been demolished. The Dutch Reformed Church is in the background on West Street.

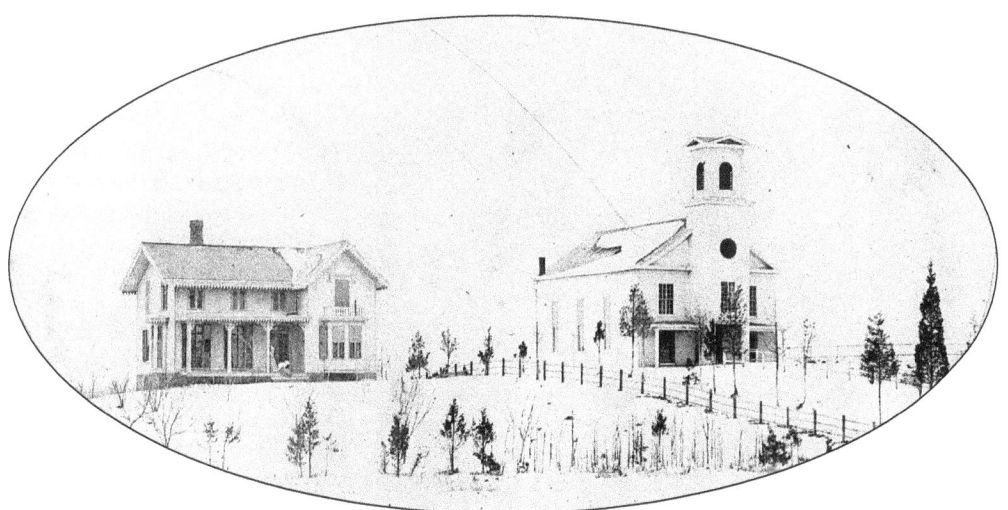

THE DUTCH REFORMED CHURCH AND ECKERSON HOUSE. This 1863 photograph shows the Reformed Church and the house occupied by Reverend Hammond and later by the Eckerson family. The house is a handsome vernacular farmhouse with attractive Gothic Revival–style, saw-toothed, verge board trim at the eaves of the roof and porch. Note the tall first-story windows of the facade. In the 20th century, the house was demolished. St. Mary's school is currently on the site of the house. (Courtesy Harvey Conklin Studios.)

WEST STREET, LOOKING NORTH. The house on the left is the Naugle House at 280 West Street. The view, taken from a 1905 postcard, shows Harrington Avenue ending at West Street. Later, when Harrington Avenue was extended west, the Tanner house (third on left) was rolled back down the hill and is today at 248 Harrington Avenue.

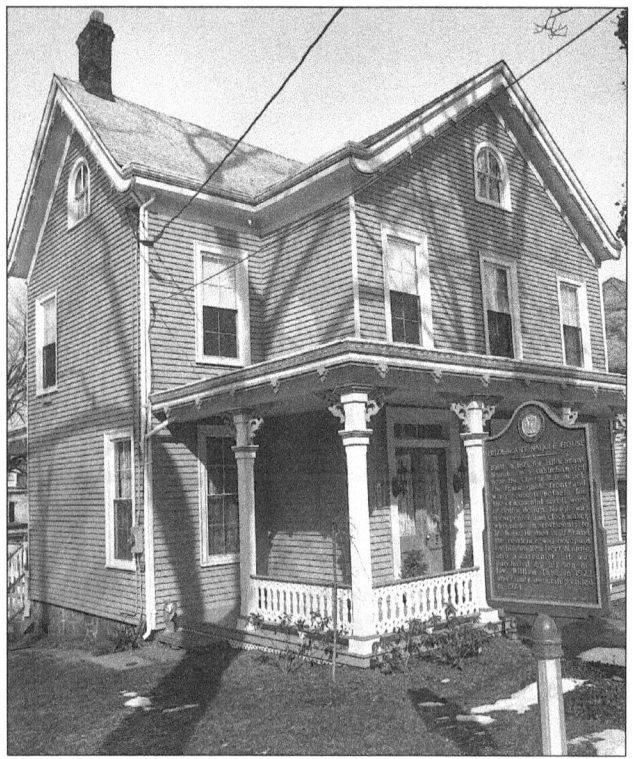

THE HILDEBRAND NAUGLE HOUSE, 280 WEST STREET. The house was built in 1864 by Hildebrand Naugle, a descendant of the Colonial-period Naugles from the east hill. Hildebrand is known to have worked as a carpenter and clockmaker. His daughter Debbie Naugle married Thomas Tate. The fanciful verge board trim and porch brackets are typical of the A.J. Downing or Gothic Revival styles of the day. Resolvent Naugle, son of Hildebrand, resided here in 1903. He is listed in Tillotson's 1903 *Directory* as a carpenter. (Photograph by Uma Reddy.)

THE WILLIAM TATE HOUSE, 292 WEST STREET. In 1913, William Tate built this handsome Colonial Revival–style home. Characteristic features of this style are the corner pilasters (engaged columns), return eaves of the cornices, dentil patterns, and the huge wraparound porch with Doric columns. Tate was an insurance broker, postmaster, and the first notary public in the borough. He also commuted for a time by rail to an office on Broadway in lower Manhattan. (Photograph by Uma Reddy.)

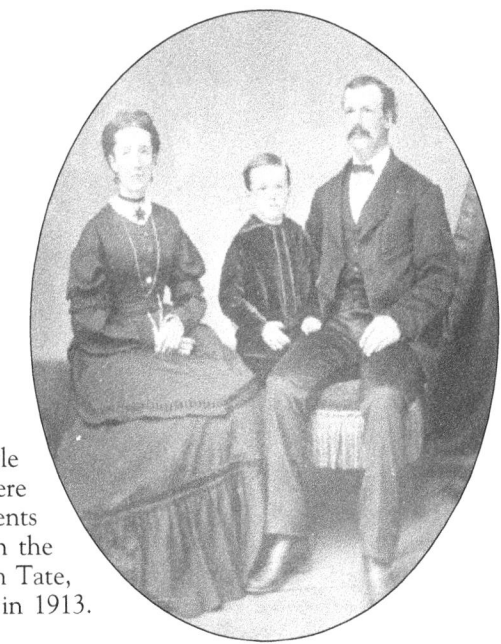

THE THOMAS TATE FAMILY. Debbie Naugle Tate, William Tate, and Thomas Tate were photographed in 1871. Debbie Tate's grandparents Hester Westerfeld and Henry Naugle lived in the stone homestead at 80 Hickory Lane. William Tate, her son, built the house at 292 West Street in 1913. (Courtesy Sally Tate Joslin.)

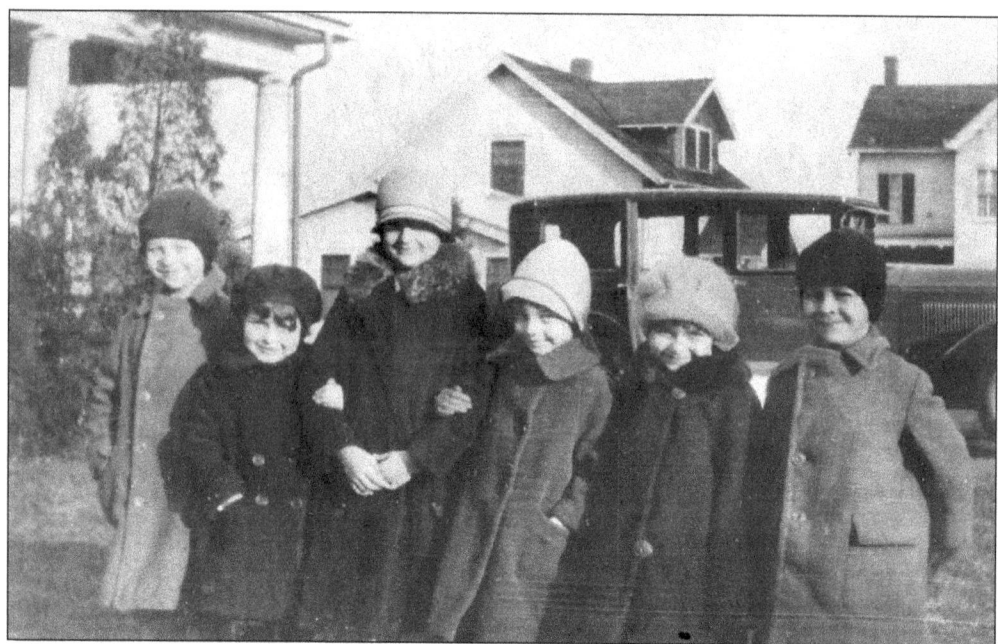

GROWING UP ON WEST STREET. Photographed on West Street are, from left to right, Andrew Maier, Jackie Telfer, Edith Maier Gordon, Sallie Tate Joslin, Marie Maier Humphryes, and Joseph Maier. (Courtesy S. Tate Joslin.)

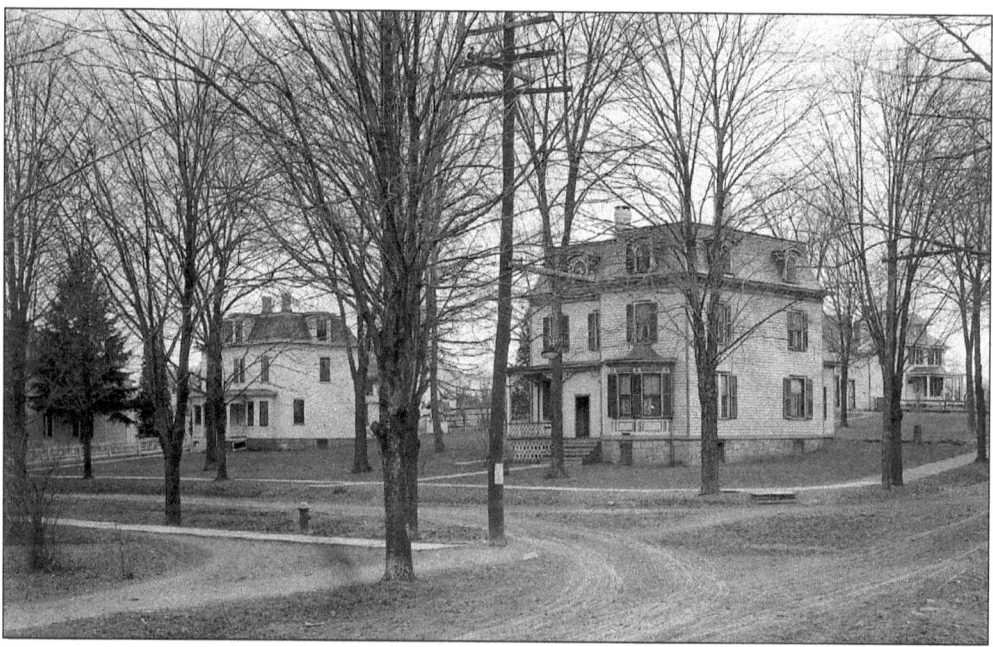

THE CORNER OF WEST STREET AND HARRINGTON AVENUE. The corner house at 270 Harrington Avenue was built by a member of the Ferdon family and occupied for many years by Dr. L.B. Parsells. Parsells practiced during the late 19th century and into the early 20th century. The photograph shows two of three Second Empire–style homes on this street. They are characterized by mansard roofs, heavy cornice brackets, and cubelike massing. (Courtesy Charles Lyons.)

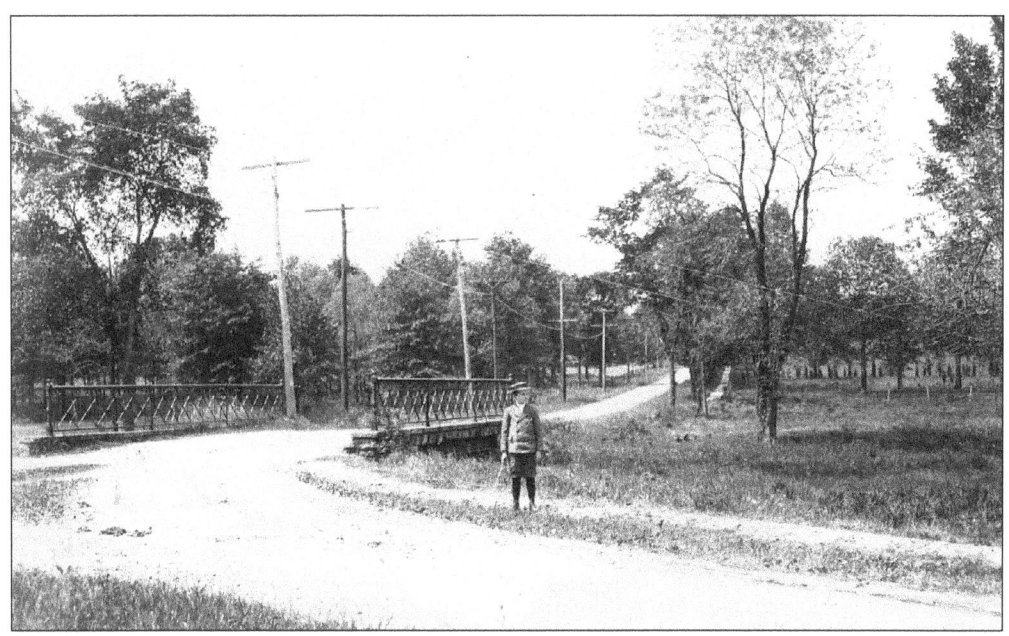

THE HIGH STREET BRIDGE. This c. 1900 view is looking west from where the library and Tenakill School are located today. (Courtesy Charles Lyons.)

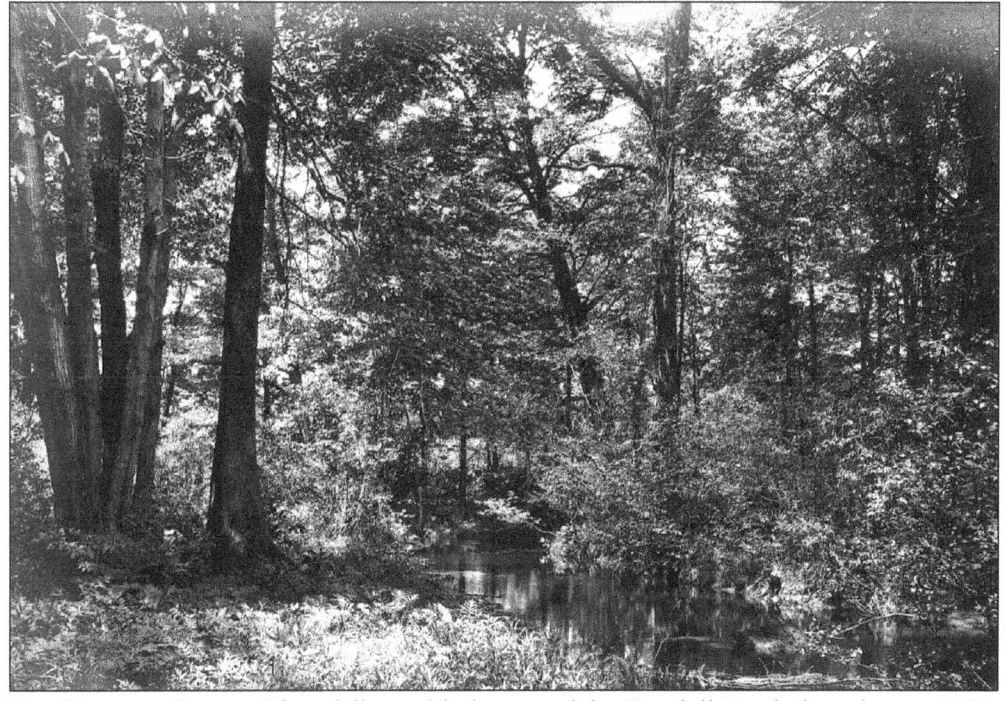

THE TENAKILL BROOK. This idyllic and lush view of the Tenakill Brook dates from c. 1900. (Courtesy Charles Lyons.)

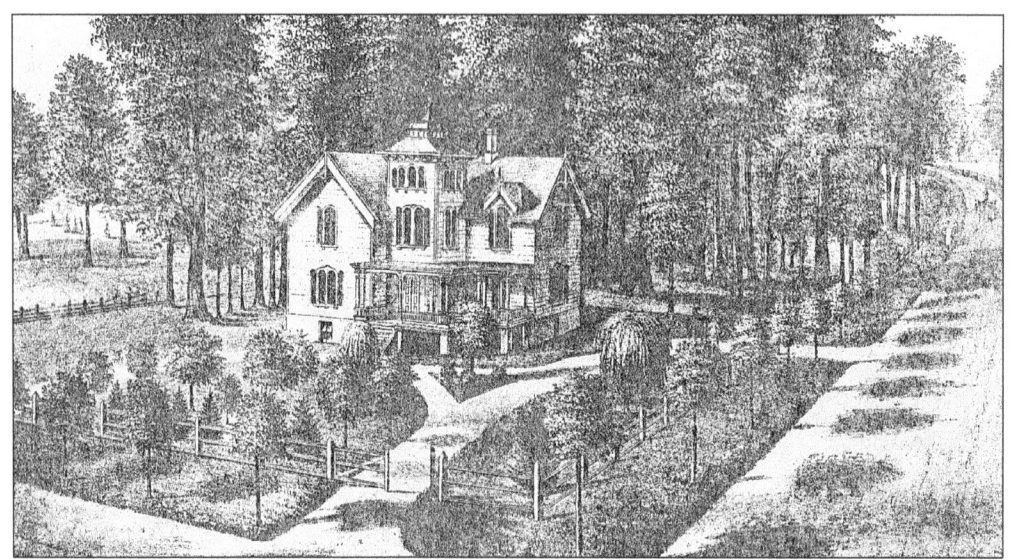

THE J.M. SERVISS HOUSE. The picturesque Serviss house at 390 Knickerbocker Road is an eclectic combination of styles but is primarily in the Gothic Revival tradition. It was designed by Closter architect John Henry Stephens for J.M. Serviss, who was listed in Walker's 1876 *Atlas* as a "civil engineer and surveyor." This lithograph is a full-page illustration from that atlas. Serviss was a county engineer who laid out the Knickerbocker-Durie intersection sometime after 1850.

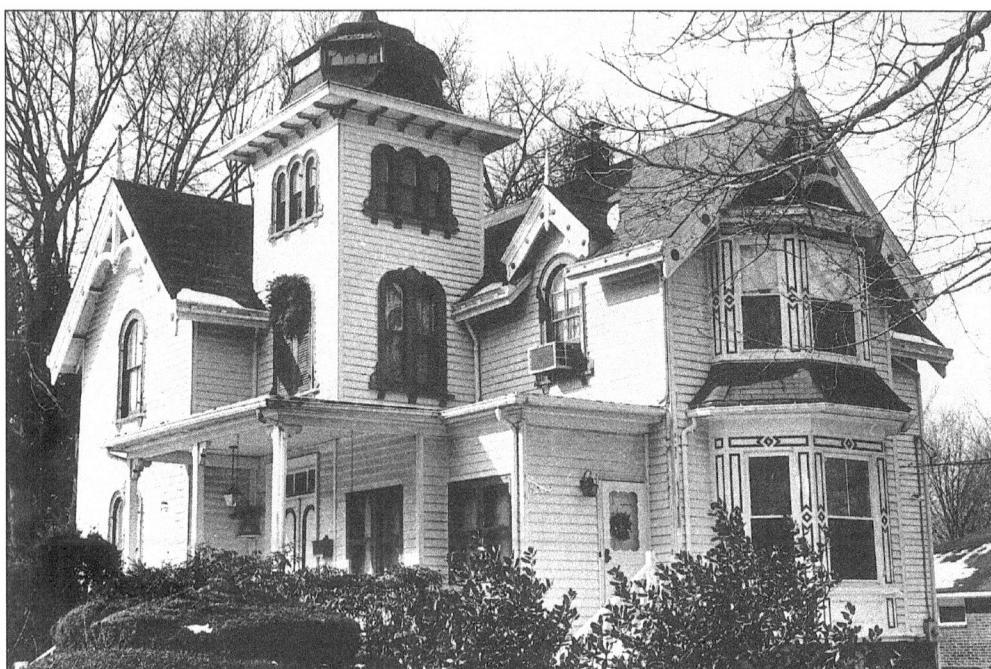

THE SERVISS HOUSE TODAY. The house has changed little and remains a visual landmark at the juncture of this busy intersection in Closter. This was the first house built (c. 1862) in the western section of the borough and is surrounded by a collection of larger, upper-middle-class, late-19th-century residences. The area is known as the Durie-Knickerbocker Historic District. (Photograph by Uma Reddy.)

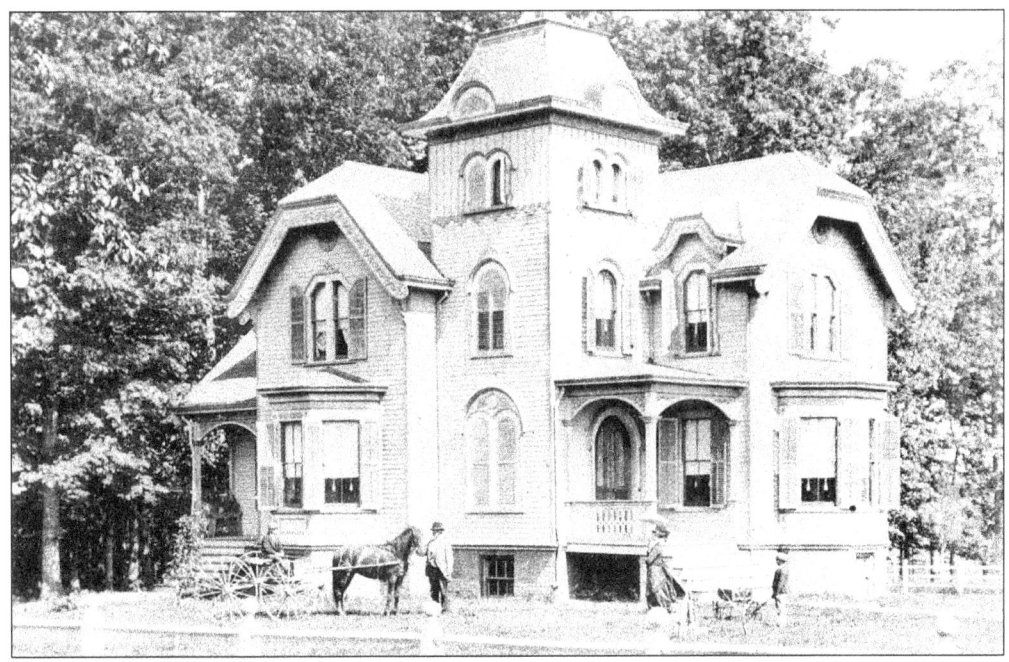

THE JOHN HENRY STEPHENS HOUSE. The original Stephens home was located on the corner opposite the Serviss house. Unfortunately, it was demolished years ago. Also designed by Stephens, this house was very similar in design and decorative details to the Serviss house. A third house in nearby Tenafly is another example of Stephens's distinctively picturesque and pleasing designs. (Courtesy Belskie Museum.)

THE C.C. POST HOUSE, 296 DURIE AVENUE. This two-story, vernacular, Italianate house has the typical low-pitched and cornice brackets that define this style. It was probably erected in the 1860s. In 1900, Post was listed in directories as the owner of an establishment called Dry Goods, at 53 Worth Street, New York City. The 1903 Closter Chamber of Commerce refers to this area as containing "country homes" located up on a hill away from the noise and soot of the railroad. Most of the residents who lived here commuted by rail to Manhattan for work. (Photograph by Uma Reddy.)

THE JAMES C. BLAUVELT HOUSE, 290 DURIE AVENUE. Blauvelt built his house in 1862 and was obviously a man of wealth. He chose the elegant and stately Second Empire style for his home. A notable feature is the slate-covered mansard roofs with multicolored slates and metal roof cresting. Also important are the projecting bracketed cornices and dormers. Unique to this house is the magnificent porte cochere, which extended on the east side of the high stone foundation. (Photograph by H. Weber.)

MRS. STEPHENS AND DAUGHTER MARION. Marion was the granddaughter of town founder John Henry Stephens. (Courtesy Charles Lyons.)

MARION STEPHENS'S HOME, 639 DURIE AVENUE. The house is a "cookie-cutter" Gothic-style home. Such intricate wood trim was available after the invention of the jig-saw. Unfortunately, the house was demolished. (Courtesy Walter Mall Collection.)

GRACE VAN VALEN. Grace was born in 1908 and grew up in the house at 663 Piermont Road. She married Charles Scherer in 1930 and was a charter member of the Ladies Auxiliary of the Closter Fire Department. (Courtesy Pat Gianotti.)

THE VAN VALEN HOUSE, 663 PIERMONT ROAD. Originally a handsome Queen Anne–style home erected by George W. Van Valen in 1908, this house has been stripped of most of its design detail. The Van Valens of New York differed from their New Jersey relatives, spelling their name Ven Valen. (Courtesy Pat Gianotti.)

MINNIE GRUBEN. Gruben is shown in a Confirmation dress in front of her house on Chestnut Street. (Courtesy Pat Gianotti.)

CHRISTIAN HOFFMAN. Hoffman emigrated from Germany in 1868 and lived in the Parcell's farmstead and house on the east side of Anderson Avenue in present-day Alpine. (Courtesy Pat Gianotti.)

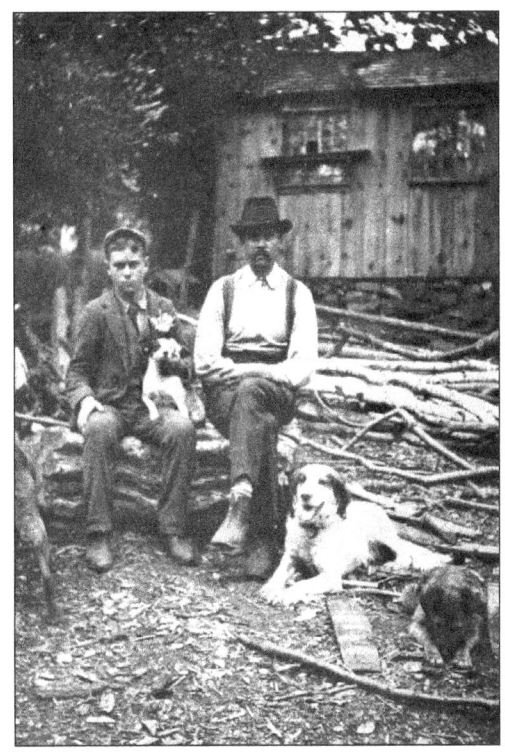

JOHN HOFFMAN AND EDO V. PARCELLS. The men are shown with their dogs on an Alpine farm on the east side of Piermont Road. (Courtesy Pat Gianotti.)

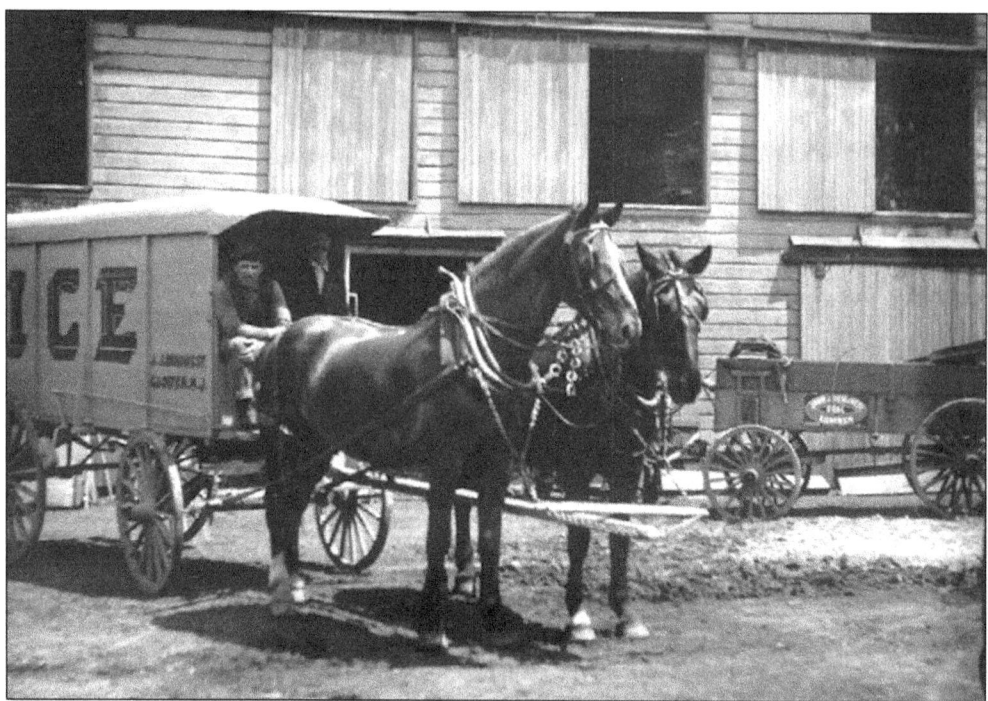

THE HOFFMAN ICEHOUSE, KNICKERBOCKER ROAD. John Hoffman son of Christian began the family ice business in the late 19th century. Above is the horse-drawn ice wagon. The photograph below shows the family putting ice cut from the pond into the icehouse. (Courtesy Barbara Guile.)

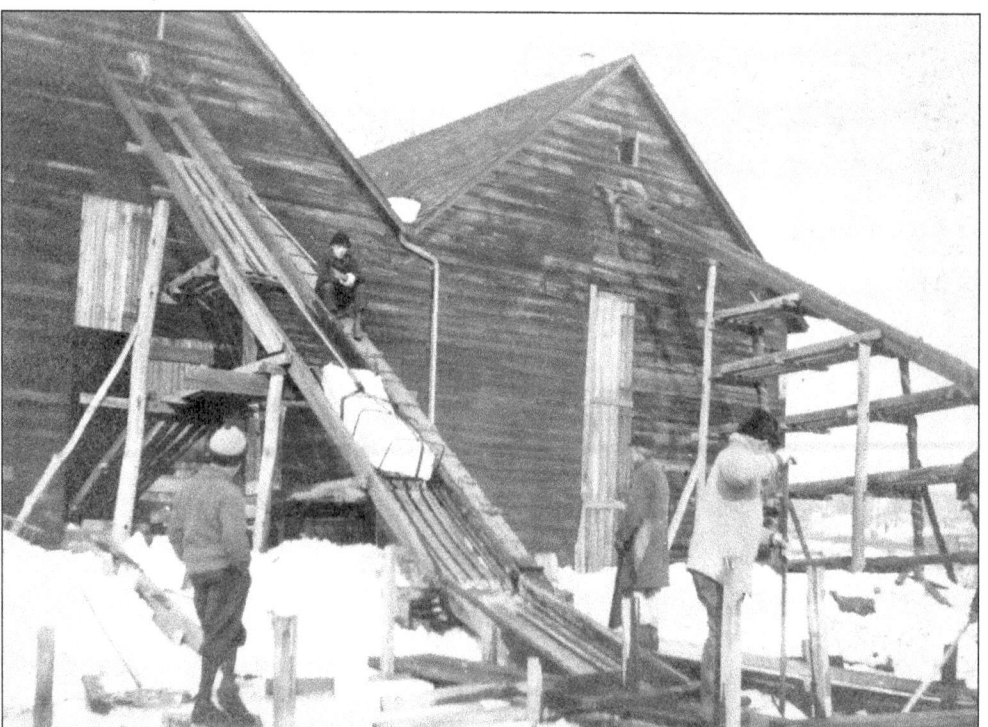

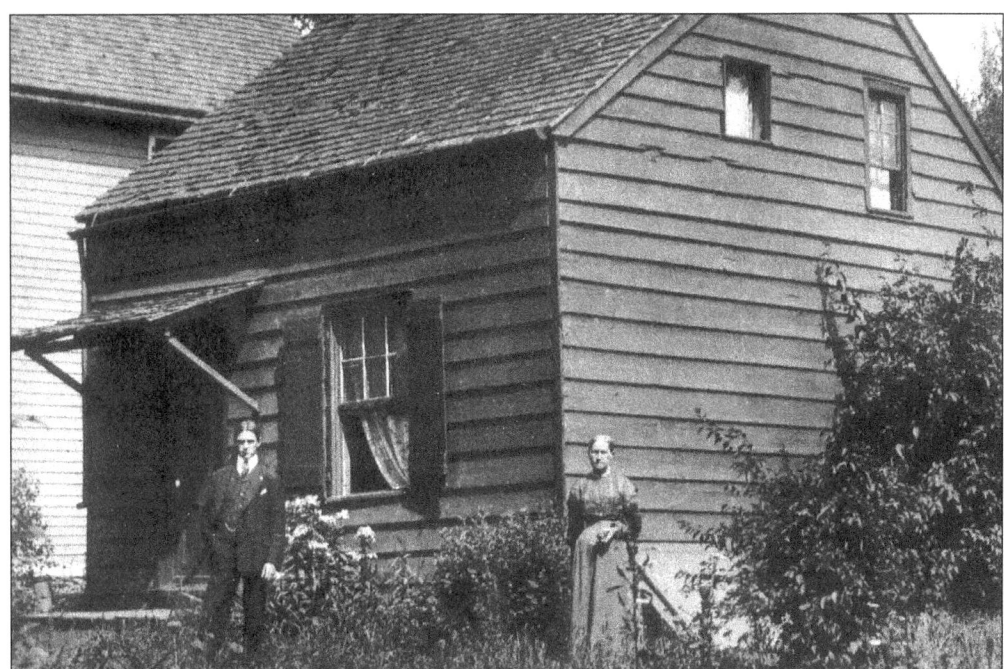

VANDERBECK SLAVE HOUSE, PIERMONT ROAD. In this c. 1895 picture, Marcellus Cole and his mother are standing in front of an 18th-century tenant farmhouse on the Vanderbeck property. It was commonly known as the slave house by residents before it was moved. Today the house has been restored and is located in Wyckoff. Marcellus Cole served for many years as the Closter Police Chief. (Courtesy Charles Lyons.)

PHINIS AURYANSEN. When the Civil War broke out in 1861, Auryansen was 14 years old, too young to join the army legitimately, so he joined the New York State Militia regiment under an assumed name. Thus his death is not shown in battlefield fatalities. Family oral history says he perished in battle. He was the son of John J. Auryansen (Adriance) and Mary Jane Jordan. Had he enlisted with the 22nd Regiment in Bergen County, he would have survived, since this New Jersey regiment never saw battle. (Courtesy Tim Adriance.)

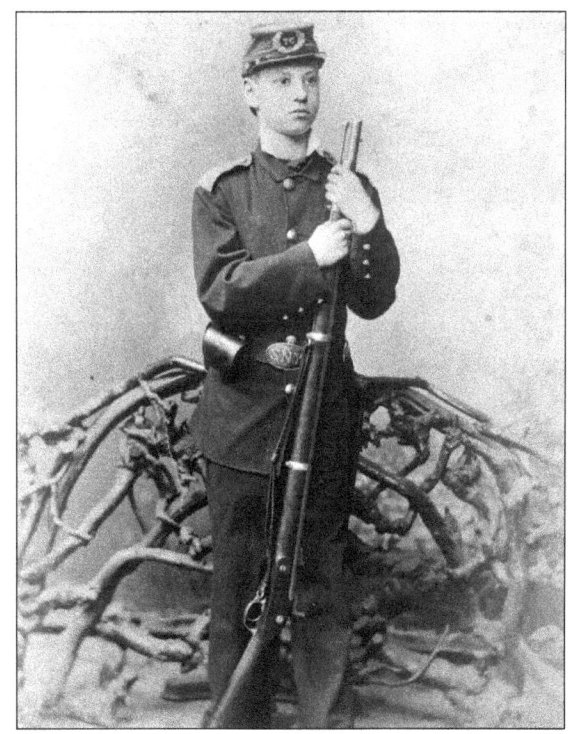

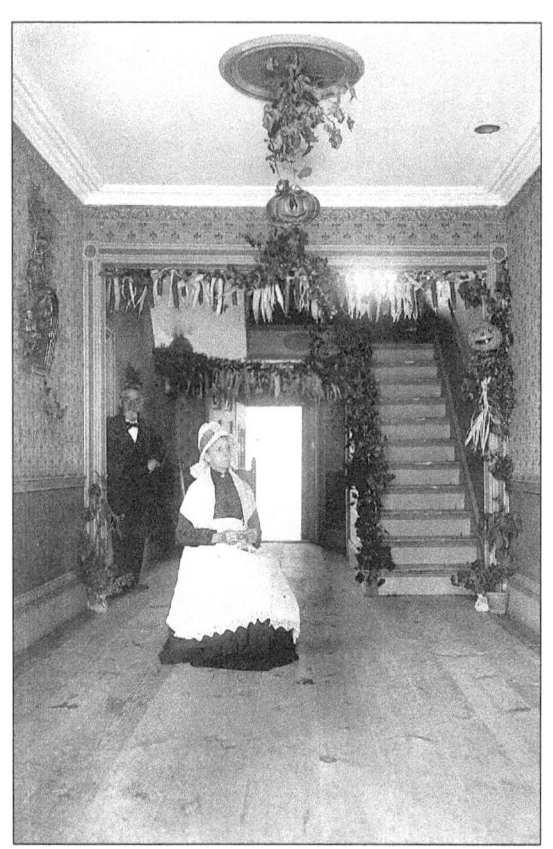

MRS. SLOAT IN HER FOYER. The Sloats lived along the road to Snedens Landing in present-day Rockleigh. The photograph shows Mrs. Sloat inside the entrance foyer of her home, which was decorated for Halloween. The photograph was taken c. 1890, probably by Harvey Conklin.

THE FERDON HOUSE, NORWOOD. This stone house was built by John Ferdon c. 1825. His daughter Maria was born in 1827 and lived here with her parents. She is known today for her diaries, which described events and life in 19th-century Closter, including the coming of the railroad in 1859. She was unmarried and had no children, though she recorded every birth, marriage, and death in the Northern Valley. For this reason, her diaries are excellent sources of genealogical history. She died in 1912 and is buried in the Naugle-Auryansen cemetery on Hickory Lane. (Photograph by Uma Reddy.)

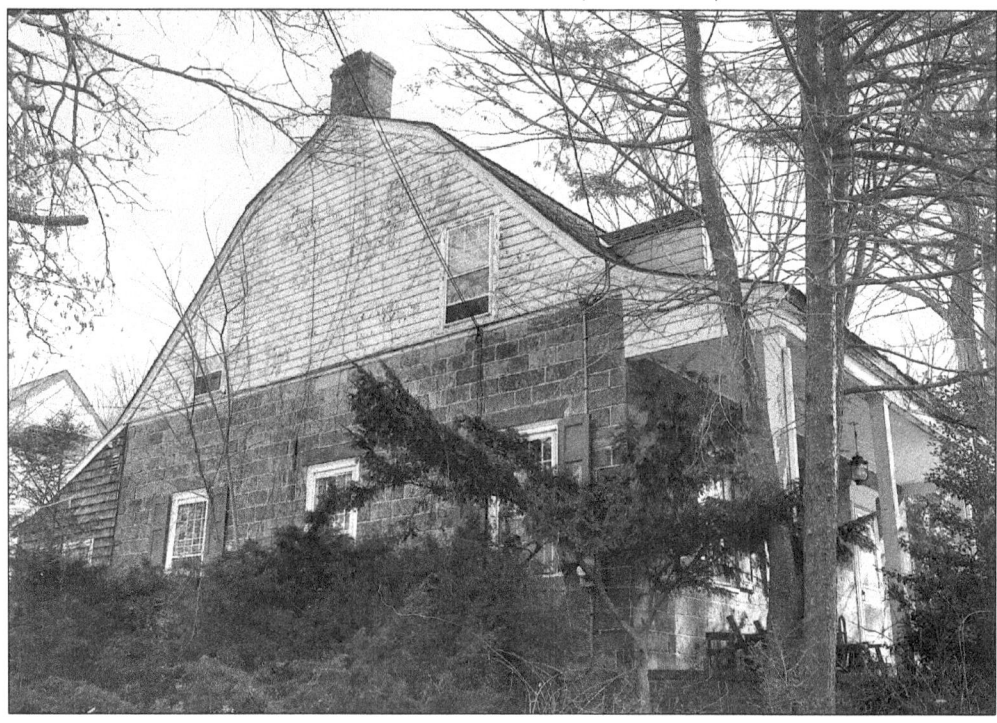

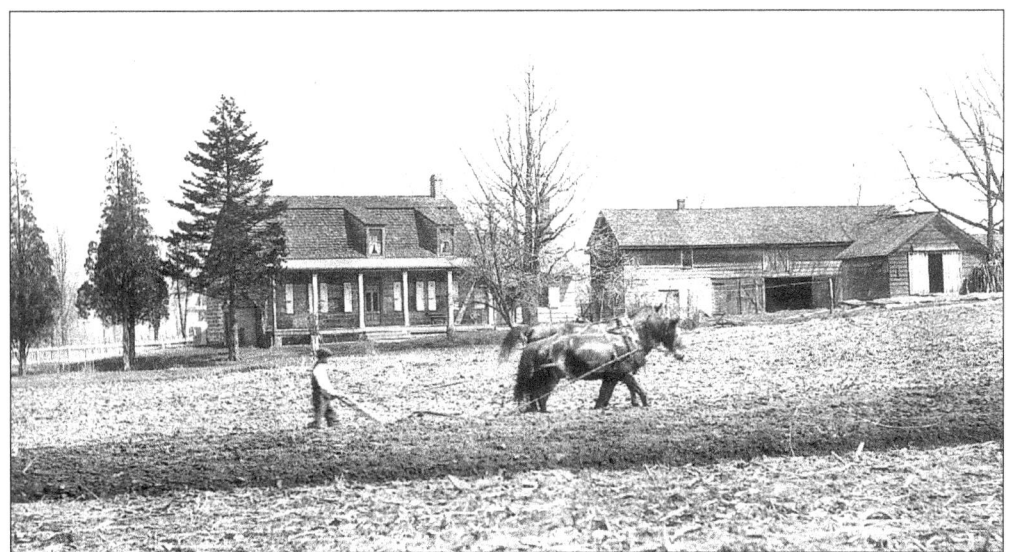

BREISACHER FARMS, 145 PIERMONT ROAD. Farming did not disappear with the railroad and suburban phases of the borough's development. Truck farming, first with horse and wagon and then trucks, continued to supply the New York City markets until the mid-20th century. This photograph was taken c. 1905. (Courtesy Charles Lyons.)

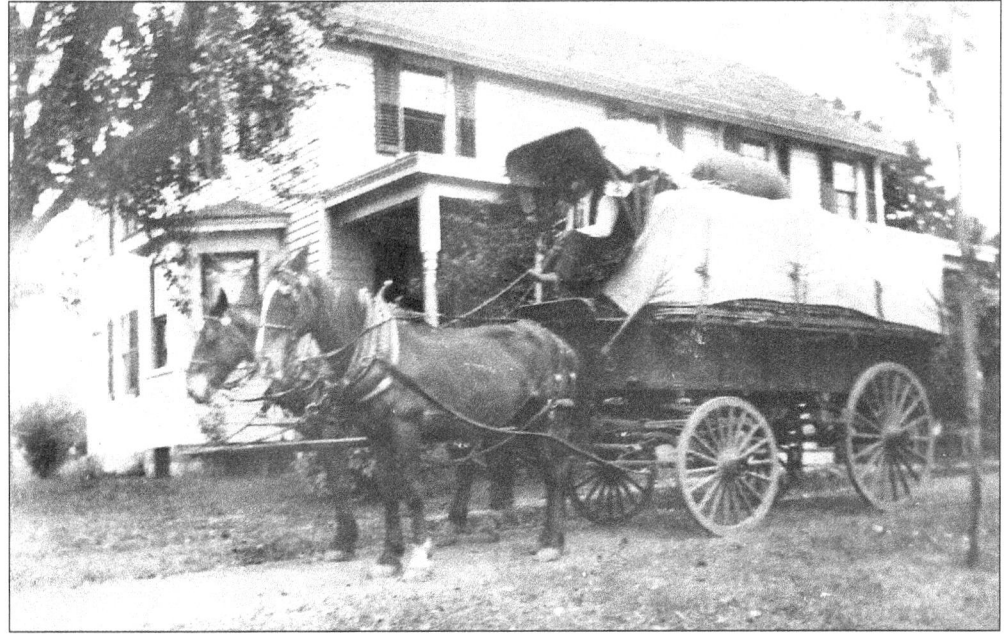

TRAUTWEIN FARMS. This market wagon was photographed in front of an 1898 farmhouse on Piermont Road. According to George Trautwein, three times a week at 2 p.m. his father took this wagon to the Gaansenvoot market in Manhattan. "The first stop was to water the horses and a beer stop at the Tenafly Saloon [Charlie Brown's]. Then hire a team to get up Dan Kelly's Hill, continue down Bergenline Avenue, take the Hoboken Ferry to 23rd Street (for a seven hour trip), spend the night and market produce in the morning." For the return, "most times we slept, it was OK 'cause the horses knew the way home. With trucks we could do the same trip in one day." (Courtesy George Trautwein.)

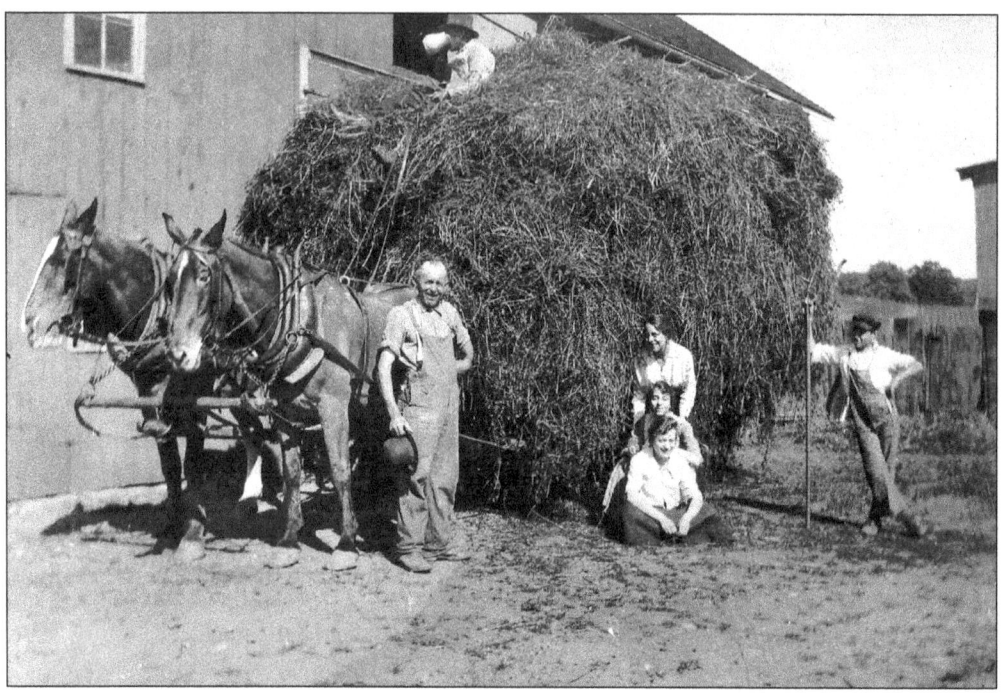

THE TRAUTWEIN HAY WAGON. Gustav Trautwein is on top of the hay. The others, loading the barn loft with hay from the wagon in 1913 are, from left to right, William Breisacher, Katherine Trautwein, Amy Trautwein, unidentified, and George Trauwein. (Courtesy George Trautwein.)

CARING FOR TWIN CALVES. It was the job of farm children, like Milton Breisacher and George Trautwein, to take care of the calves. In 1913, both boys were 10 years old. (Courtesy George Trautwein.)

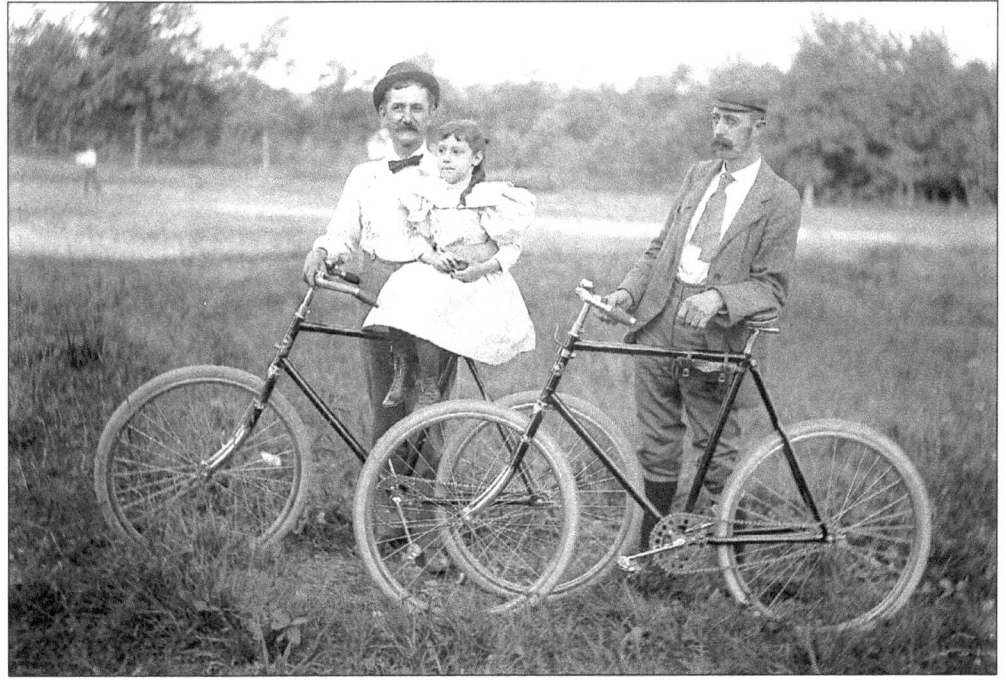

BERT AND VAN DAVIES MAKING CIDER. Apple orchards were among the many fruit trees in the Northern Valley. Most Closter area farms had apple trees. (Courtesy Harvey Conklin Studios.)

BICYCLING IN THE COUNTRY. This image is from a glass negative by Harvey Conklin.

CLOSTER INSTITUTE–HAMMOND HALL. Belle Hammond, daughter of Reverend Hammond, opened a private school in the basement of the Reformed Church. The photograph is of the first school, erected in 1863, in District 15 of Closter City. Pupils traveled by rail and came from communities as far as Englewood and Piermont. In 1882, Bell Hammond's Closter institute boasted between 60 and 80 students, taught by three teachers. Later, the building was occupied by the American Legion and used for town social functions. It burned in the 1980s.

PUBLIC SCHOOL NO. 2, DURIE AVENUE. The first public school building was erected on Durie and Demarest Avenues at a cost of $9,000 in 1871. While the four-room, brick building was being built, the district held classes in the Van Ostrand barn on High Street. (Courtesy Charles Lyons.)

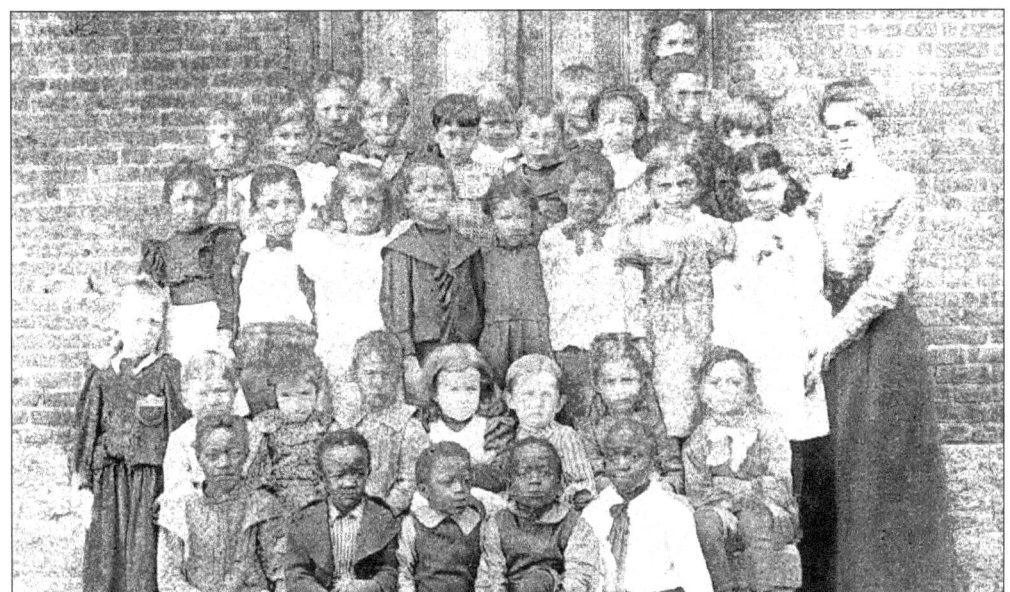

A CLASS FROM SCHOOL NO. 2, C. 1885. Closter public schools were integrated from their earliest days. Most students cannot recall much prejudice. Numerous African Americans moved to Closter after the Civil War when the freed slave colony at Skunk Hollow began to disintegrate. (Courtesy Alice Parsells.)

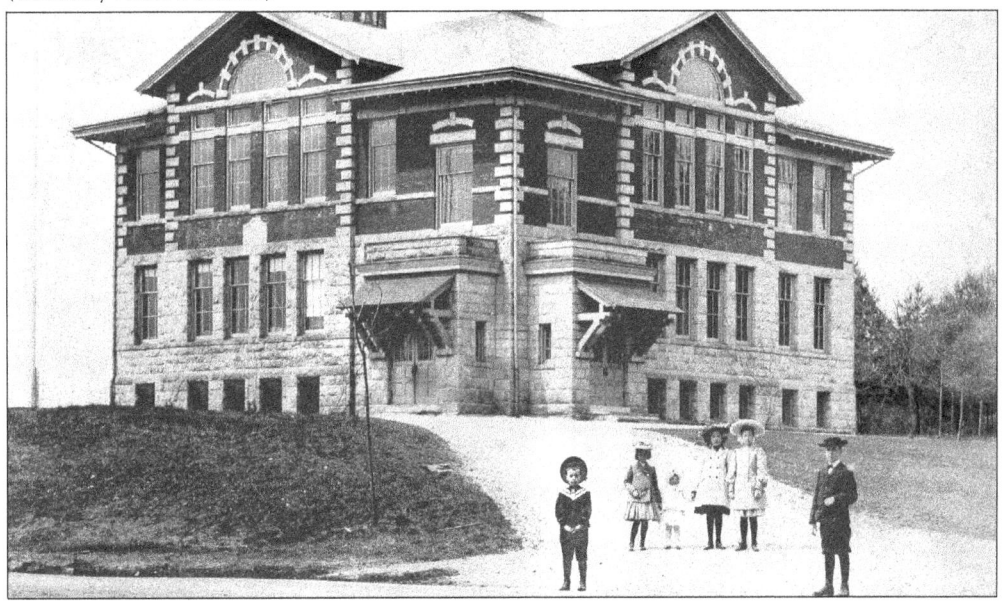

THE CLOSTER SCHOOL, DURIE AVENUE, 1902. Known to be in this picture are Dorius, Inez, and Stanley Taveniere; Hazel Johnson; and Walt Herron. By 1899, land was sought to build a new school, and the Closter School on Durie Avenue opened in 1900. The handsome, original, two-story, brick and stone building combines design elements from the Romanesque and Renaissance Revival styles. Characteristics of these styles include stone ashlar walls for the basement and first story; stonework for details such as the corner quoins, window sills, and lintels; and arch designs over the windows with central keystones. Originally the school had only three classrooms and an assembly room and housed kindergarten to eighth grade. (Courtesy Charles Lyons.)

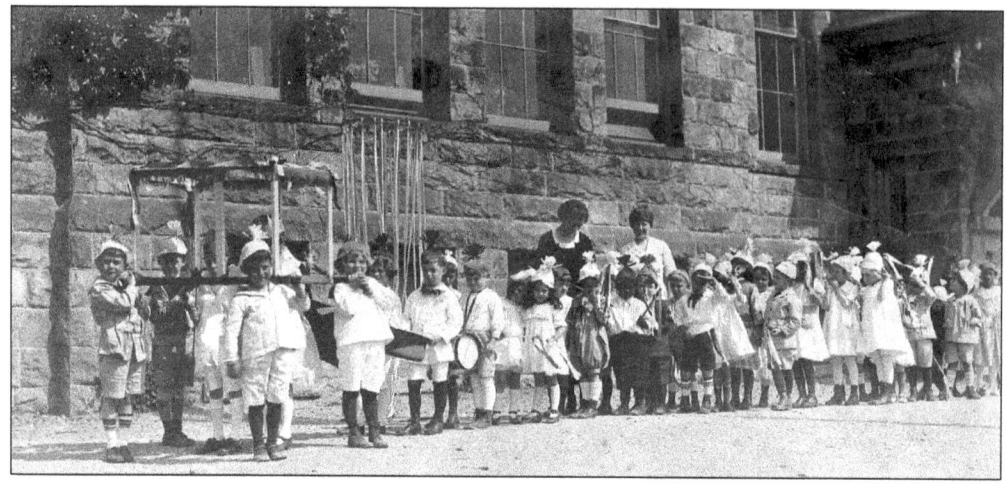

THE MAY DAY PARADE. These lower-grade students celebrated May Day in front of the Closter School. This day was widely celebrated by communities in the area until about the 1950s. (Courtesy Charles Lyons.)

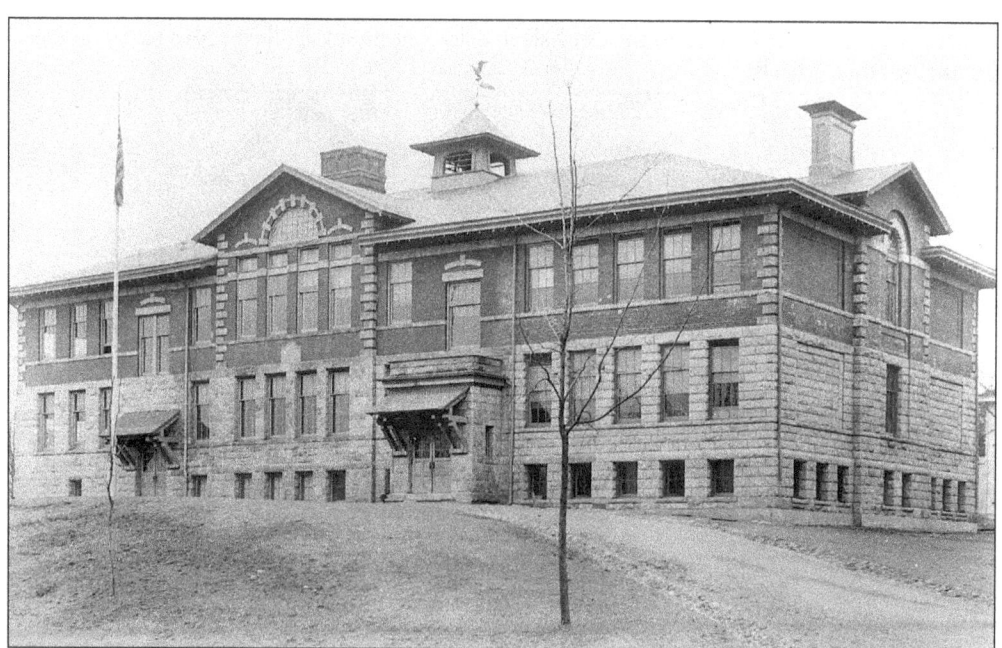

THE CLOSTER SCHOOL AND CLOSTER HIGH SCHOOL. This c. 1913 photograph shows the growth of the school through the years. In 1907, four new classrooms were added to the south side. When six classrooms were added to the north side in 1912, the school opened to high school students. It also operated as a receiving high school for surrounding communities for many years—students from communities with no high school attended school here. With the construction of nearby Tenakill Grammar School in 1929, this school became the Closter Junior-Senior High School from 1929 to 1955. It was renamed the Village Middle School in 1955 and housed the sixth, seventh, and eighth grades until it closed in 1996. Two regional high schools were built in the Northern Valley area in 1955.

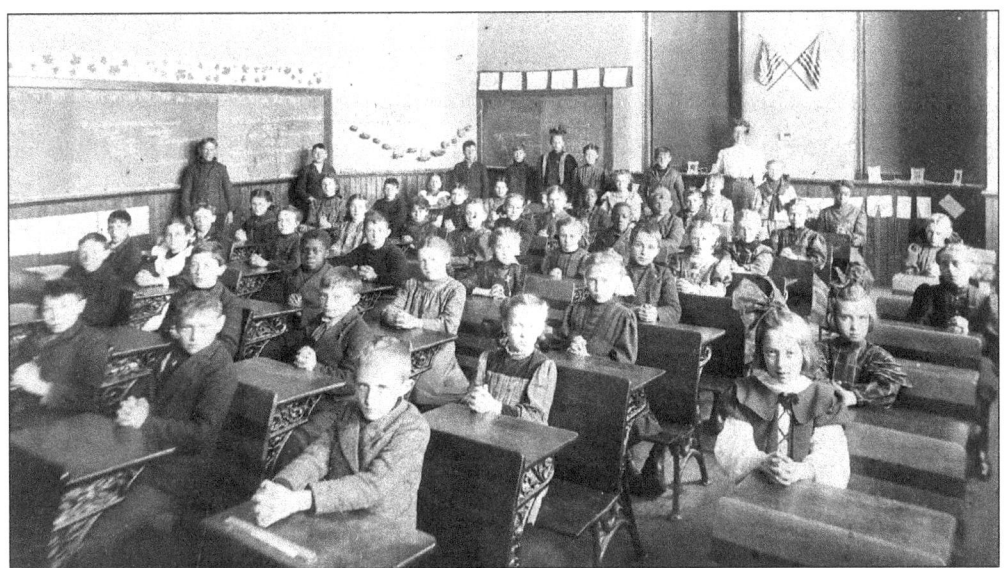

A CLOSTER SCHOOL CLASSROOM. As the population grew in the 20th century, expansion of the school system became necessary. (Courtesy Kenneth Thompson.)

THE CLOSTER HIGH SCHOOL BASKETBALL TEAM. Only one person can be identified in this 1923 photograph. He is Charles Hesker, in the back row, second from the left. He lived in Alpine. The high school was a receiving school and functioned as a regional secondary school. Basketball was a very popular early-20th-century sport; the girls also had a team. (Courtesy Bert Pieringer.)

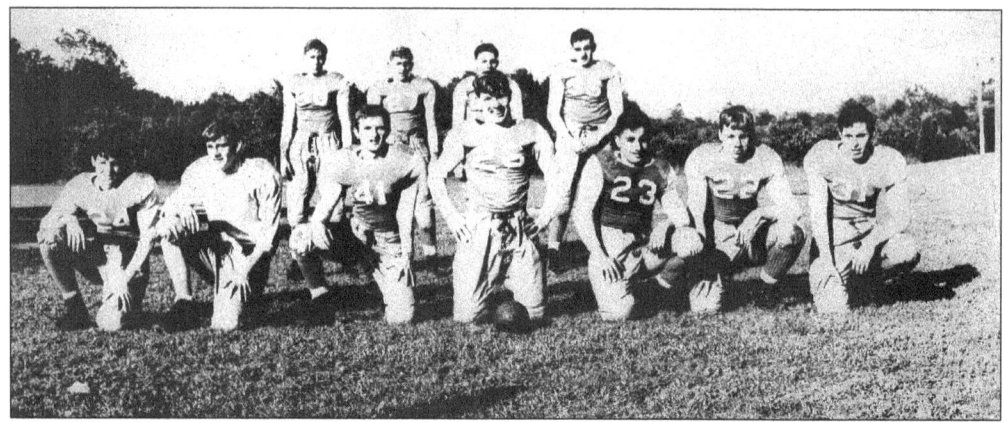

THE FIRST CLOSTER HIGH SCHOOL FOOTBALL TEAM, 1946. Team members are, from left to right, as follows: (front row) Warren Kightlinger, Robert Crowe, John Nally, James Pratt, Charles Boccino, Thomas Morgan, and Gil Buhler; (back row) Robert Daw, Raymond Johnson, Joe Bender, and Russell Ward. Since the principal of the high school was seriously injured in a football accident, he resisted the formation of a team for some time. According to cheerleading captain Diane Crowe, "They are dressed in obsolete clothing from 'caring' league teams up to and including leather helmets. They won three games that season It was a LONG season! . . . John J. Demarest and Weyerhauser [companies in town] used to let workers [leave work so the team could have] 11 more players so they could scrimmage." (Courtesy Diane Crowe.)

CLOSTER HIGH SCHOOL CHEERLEADING SQUAD, 1946. The first group for the 1946 football season included, from left to right, the following: (front row) Jean Methven Buhler and Ann Foss; (back row) Vilma Schreuer Potterton, Audrey Marriet, Diane Crowe (captain), Ann Wray Upchurch, and Lois Viola. The uniform included wool kelly green blazers, which according to team captain Diane Crowe were "great for football but rather a trial in basketball season!" (Courtesy D. Crowe.)

TENAKILL GRAMMAR SCHOOL, 275 HIGH STREET, 1929. This handsome school was designed by the firm of Lee & Hewitt in the Renaissance Revival style and was built on the eve of the Great Depression. It was the third public school in Closter. Some interesting design features from the period include separate boys' and girls' entrances, a large U-shaped courtyard for ventilation, an auditorium with a balcony, and a tall cupola tower. Today the building is used as a middle school.

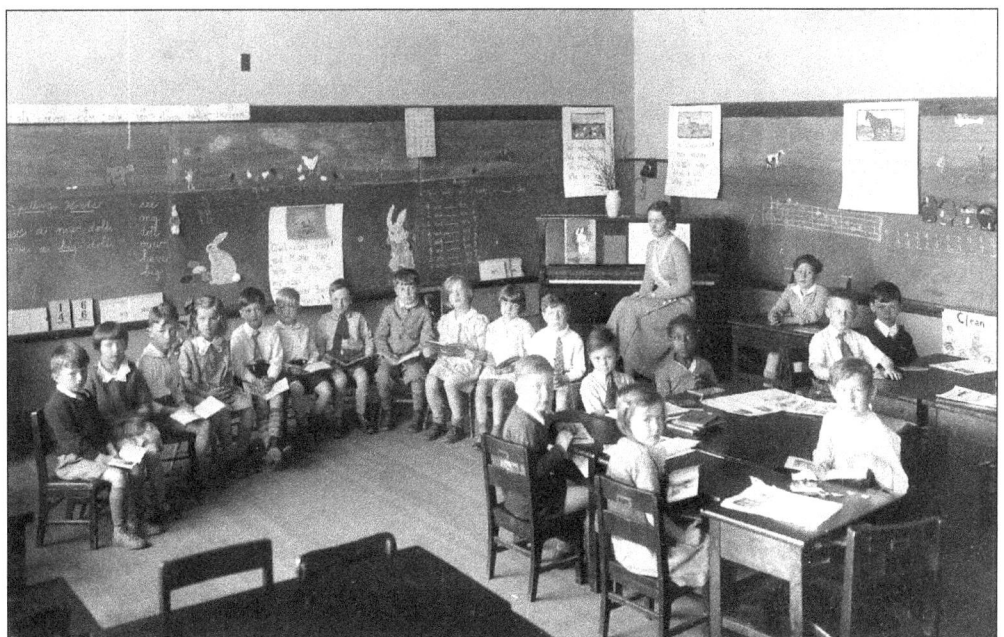

A GRAMMAR SCHOOL CLASS AT TENAKILL. Children pause for the camera in this c. 1930 photograph. (Courtesy Kenneth Thompson.)

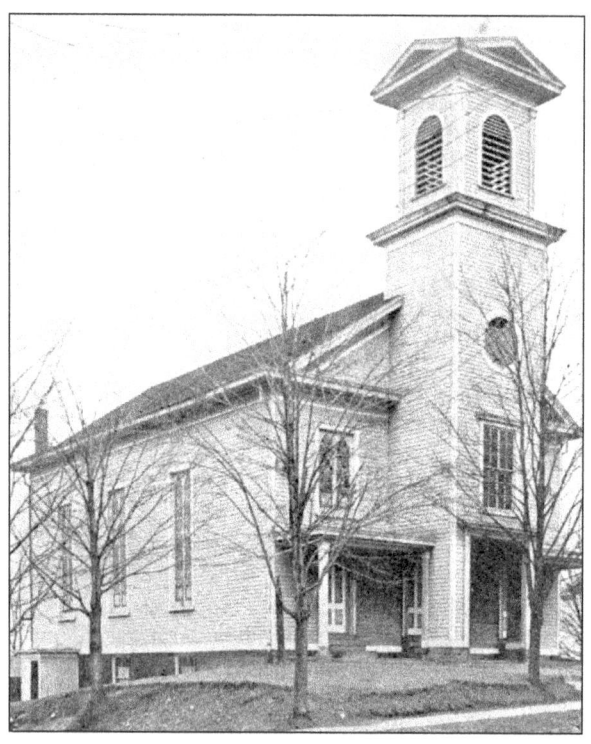

THE PROTESTANT REFORMED DUTCH CHURCH OF CLOSTER CITY, 328 WEST STREET. Designed by John Henry Stephens, this handsome vernacular building was erected in 1862 when Reverend Hammond's congregation numbered only 14. On the eve of the construction of this church in 1861, Abraham Lincoln was drafting 10,500 New Jersey boys into service for the Civil War. The Harrington Rifles, a volunteer company drill team organized in 1861, practiced in the church during the war. Two town members of the company, Garret I. Demarest and David Bogert, were Civil War casualties. In 1894, stained-glass windows were installed and crafted in the nearby Lamb Studios. In keeping with Dutch austerity, they are masterpieces of geometric muted colors instead of religious figures.

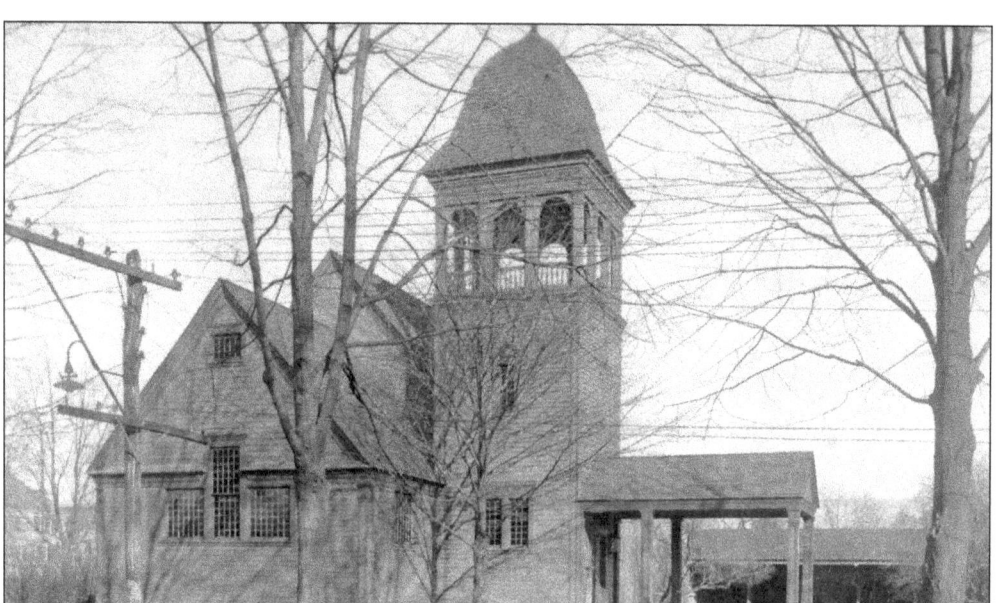

THE FIRST CONGREGATIONAL CHURCH AND RECTORY, HARRINGTON AVENUE AND WEST STREET. Rev. A.R. Shaw, pastor of the Methodist Episcopal Church in Alpine, was one of the main organizers in the building of the Closter church in 1878. The first full-time pastor was Rev. Herbert B. Turner, who served until 1883. The church is another example of a single-nave church. The window of the alter triptych, "Eden Restored," was designed by Closter artist Robert Alexander Baillie and executed by the Lamb Studios.

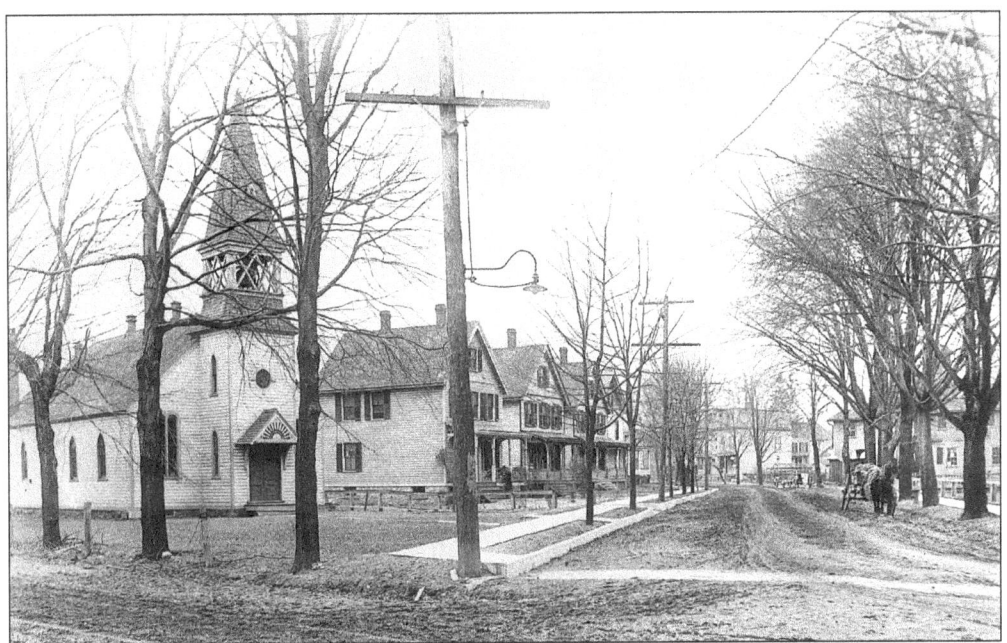

ST. PAUL'S EVANGELICAL LUTHERAN CHURCH, 171 CLOSTER DOCK ROAD. This 1888, picturesque, three-bay building with pointed Gothic windows and a square tower with spire was the third church erected in the historic district. The property was donated by William Lindemann. In 1929, alterations included raising the building for a basement and stripping the interior. The stained-glass windows represent magnificent washes of bright colors and are masterpieces of later works from the J & R Lamb Studios.

ST. MARY'S CATHOLIC CHURCH, DURIE AVENUE. This small church was erected in November 1913 and served as the parish church until 1953, when the new church and school were built on High Street. The postcard dates from c. 1915. The first pastor was Fr. Ferdinand Vander Staay.

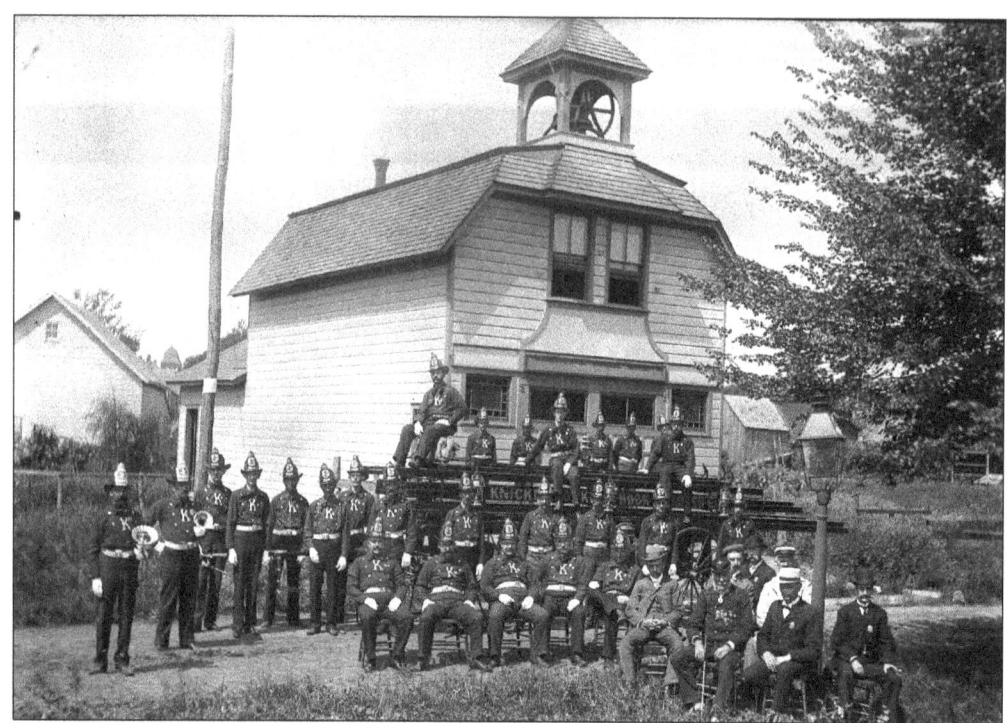

THE KNICKERBOCKER HOOK AND LADDER COMPANY, C. 1895. The volunteer fire company was organized in 1893 and named after the local Knickerbocker baseball team. The original two-story building on Railroad Avenue remains today; however it is very altered. The photograph shows many generations of volunteers, including aged Civil War veterans with their war medals on the right. The first chief was Charles L. Wenger (1893–1894), followed by Darius Johnson (1894), and Thomas Sherman (1920–1924). This image is from a glass negative by Harvey Conklin.

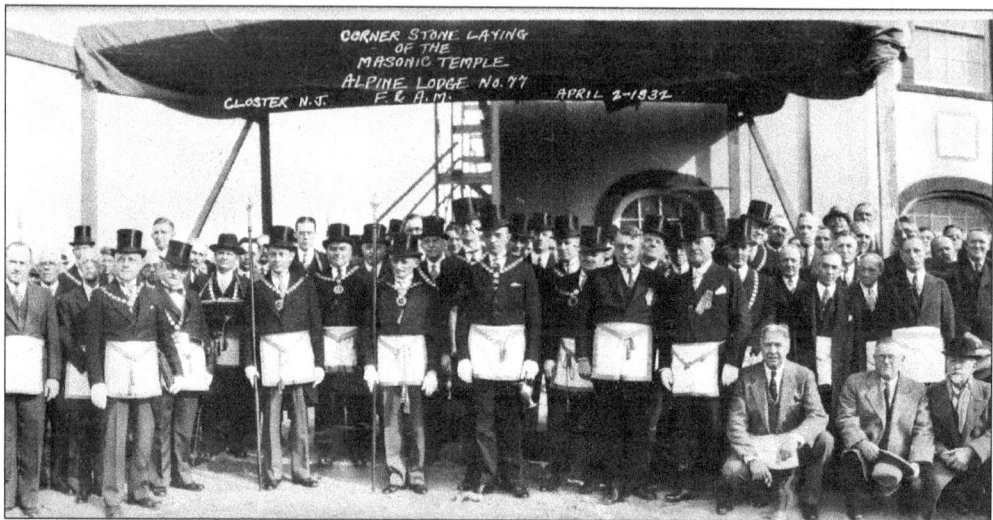

THE MASONS, ALPINE LODGE, NO. 77. The photograph shows the dedication of the new Masonic Lodge on Durie Avenue across from the Village School, April 2, 1932. (Courtesy Clive Pearce.)

Five

SKUNK HOLLOW

Skunk Hollow, also known as the Mountain, was located atop the Palisades cliffs four miles north of Closter, near present-day exit 3 of the Palisades Interstate Parkway in Alpine. The colony provided a haven for freed blacks for a century and was most populated between 1870 and 1880, with a peak population of 75 in 1880.

Skunk Hollow was founded in 1806 by a slave living in what is now Rockleigh who became known as Jack Ernest. He was born in 1770 and owned by Jacob Conklin on Piermont Road. When freed, he purchased some land on the mountain and, by 1822, deed records show his holdings at 11 acres, making his the most expansive freed-black-owned lands in old Harrington Township. Tragically in 1841, a cinder from his fireplace ignited his clothes and he burned to death, leaving no heirs. The community was bequeathed to two of its early settlers, Jim Oliver and Rev. "Willie" Thompson. Thompson became the mainstay and glue of the community, which had a "colored" Methodist church and a burying ground. When Thompson died in 1886, many families began to move from Skunk Hollow to surrounding towns, especially Closter, and Sparkill, New York. All of the Thompsons and Olivers in Closter are probably descendants of these two men. Other common surnames from here include Sisco, Brown, Williams, and Jackson.

Skunk Hollow remained virtually unknown in the 20th century—as an African American settlement, it was not included on mainstream 19th-century maps. Only the foundations of buildings and buried archaeological information remain. In the 1970s, Dr. Joan Geismer spent five years researching and excavating the site. The results produced a Ph.D. dissertation at Columbia University and a book published by Academy Press in 1982.

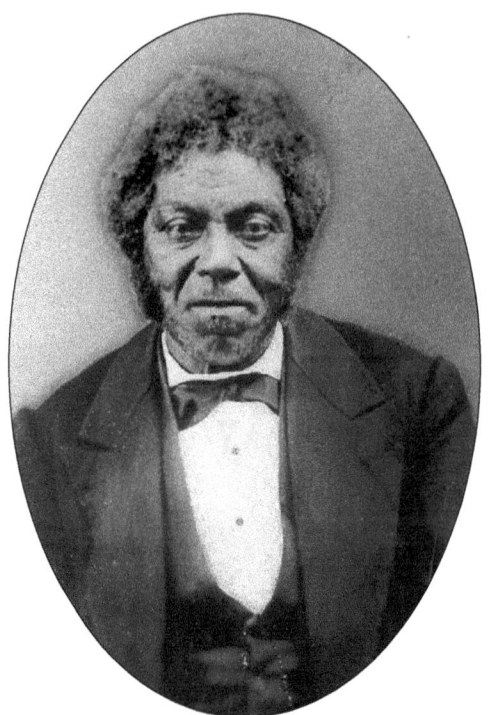 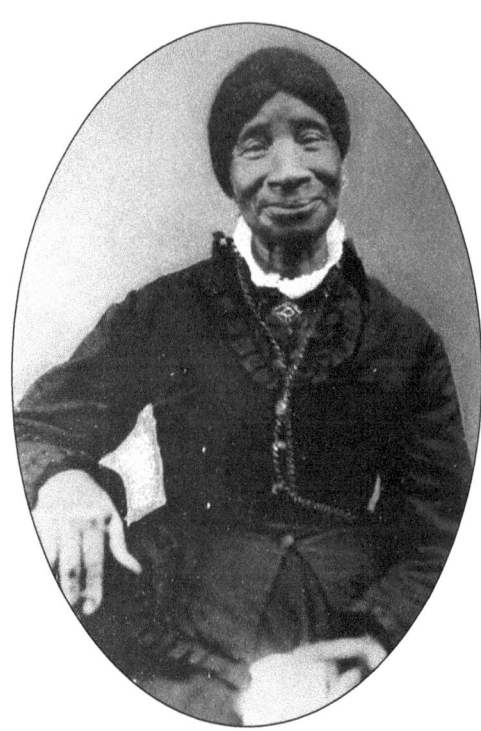

REV. WILLIAM THOMPSON AND WIFE, BETSY. Thompson was an outstanding preacher and leader in the community who often came to the Dutch Reformed Church in Closter. Maria Ferdon, a Closter resident, noted in her diary how impressive his preaching was when she heard him speak at a funeral. He was probably born a freed slave. He fell in love with Betsy, a slave, on a trip to Yonkers. He purchased her and they married, settling in Skunk Hollow. (Courtesy of Palisades Library.)

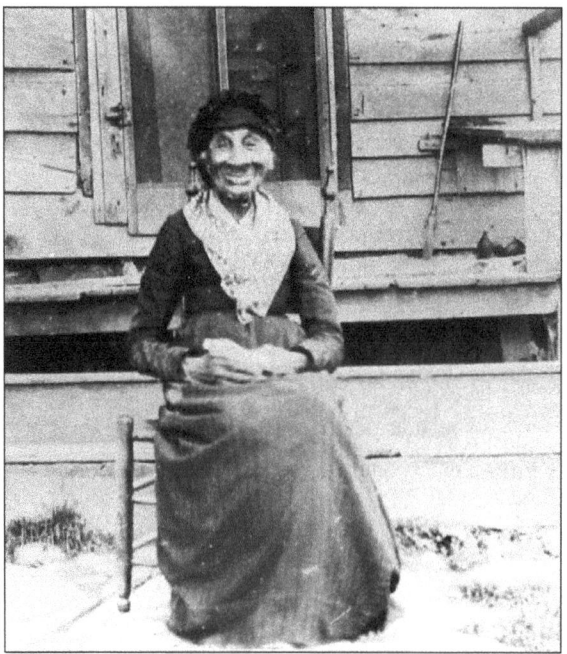

BETSY THOMPSON IN 1906. Shown at age 99, Betsy died only one year later. Following her husband's death in 1886, the widow moved farther south to live with one of her sons in Closter. (Courtesy Palisades Library.)

SKUNK HOLLOW SITE, ALPINE. John Spring, Cresskill borough historian, is shown inside the cellar and foundation wall of a Skunk Hollow residence while conducting a tour to the archaeological site. All of the buildings, the church, and cemetery have been demolished or removed. (Photograph by Alan Urkowitz.)

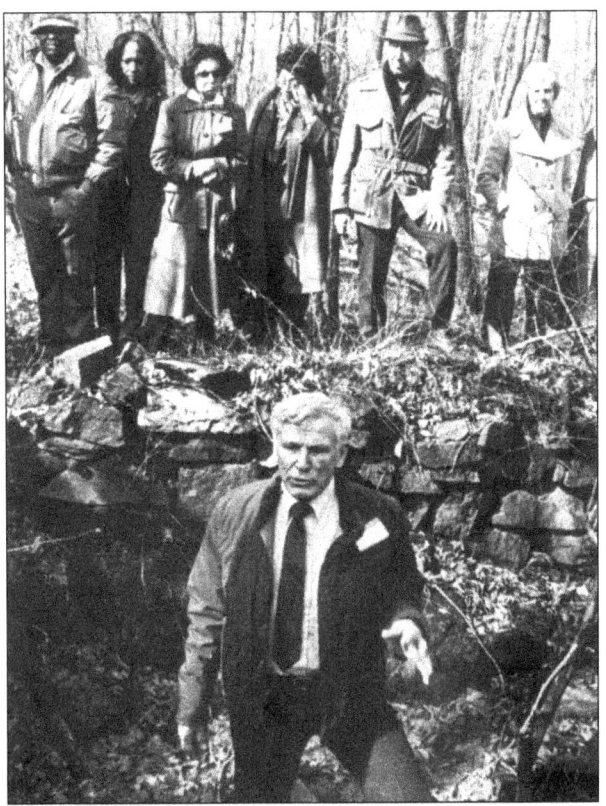

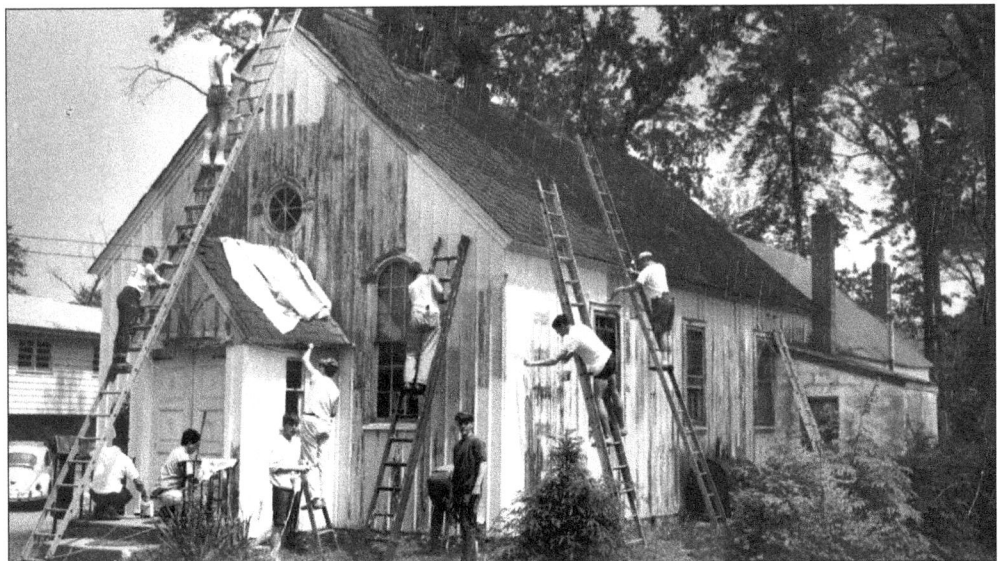

THE CENTENNIAL AME ZION CHURCH, CAMPBELL STREET. This small frame church with board-and-batten siding was built on the edge of the old town of Closter in 1896 by descendants of Skunk Hollow residents. The land was donated by the Pelhamdale Land Company, and the building constructed by local resident J.C. Gruben. The building was the mainstay of the African American community in Closter. The first minister was Rev. T.J. Tillman. (Courtesy AME Zion Church.)

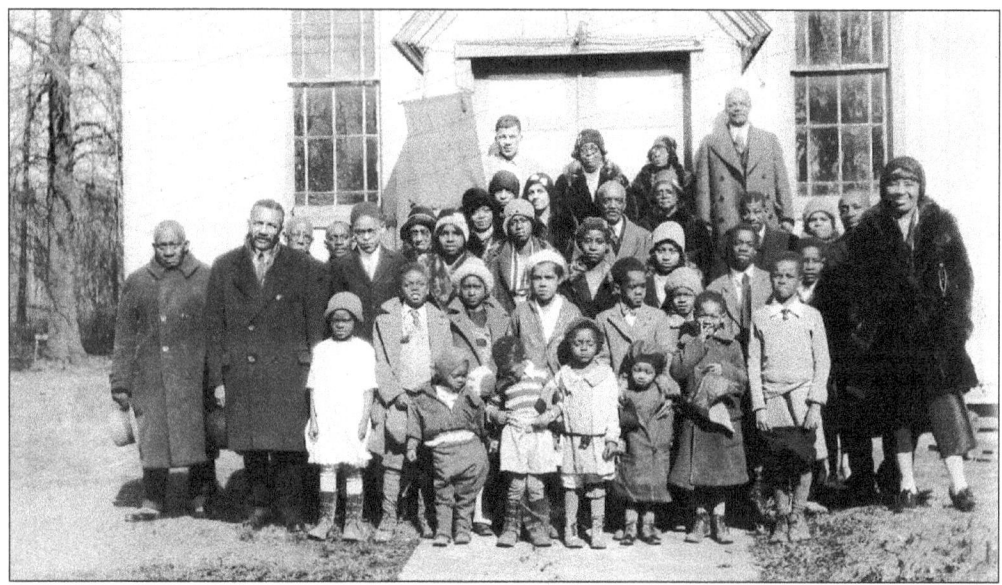

THE CONGREGATION. This group photograph was taken after a 1933 Sunday service at the AME Zion Church. (Courtesy Kenneth Thompson.)

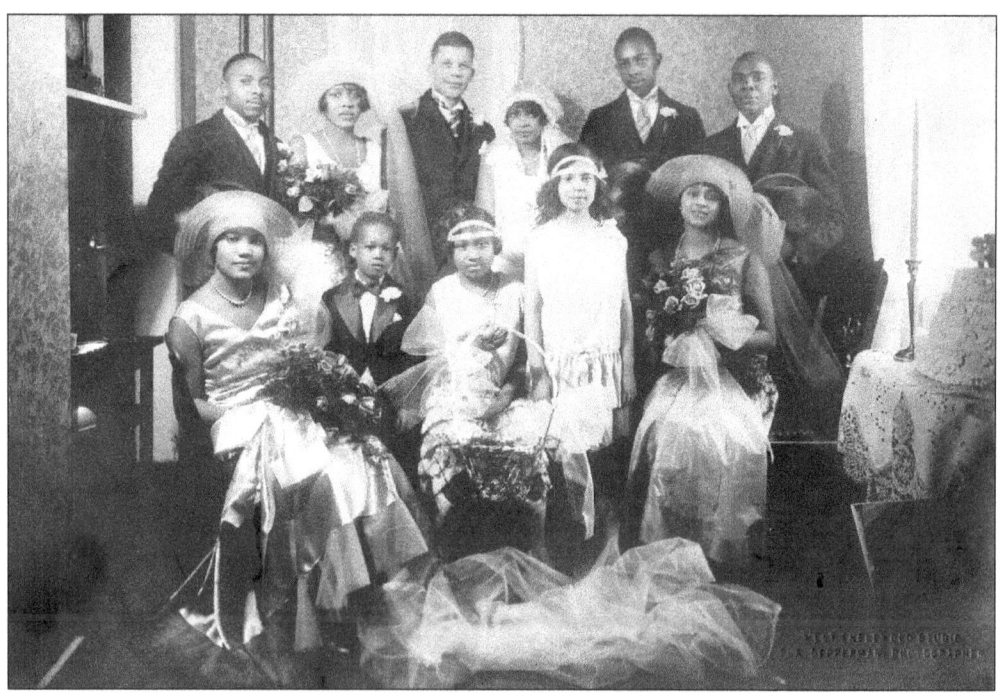

KITTY OLIVER'S WEDDING. There were two talk-of-the-town weddings in 1930, and Kitty Oliver's was one of them. Shown at the wedding are, from left to right, the following: (front row) Edna Patterson, Eddie Thompson, Millie James, unidentified, and Florence Raglin; (back row) Edward Oliver, Hattie May Johnson, Wilbert Clark (groom), Kitty Oliver (bride), Arthur Farrar, and Charles Oliver. Potted palms and latticework of pink and white crepe paper adorned the AME Zion Church. The reception was held at the Oliver's home on Maple Avenue. (Courtesy Gerry Marshall.)

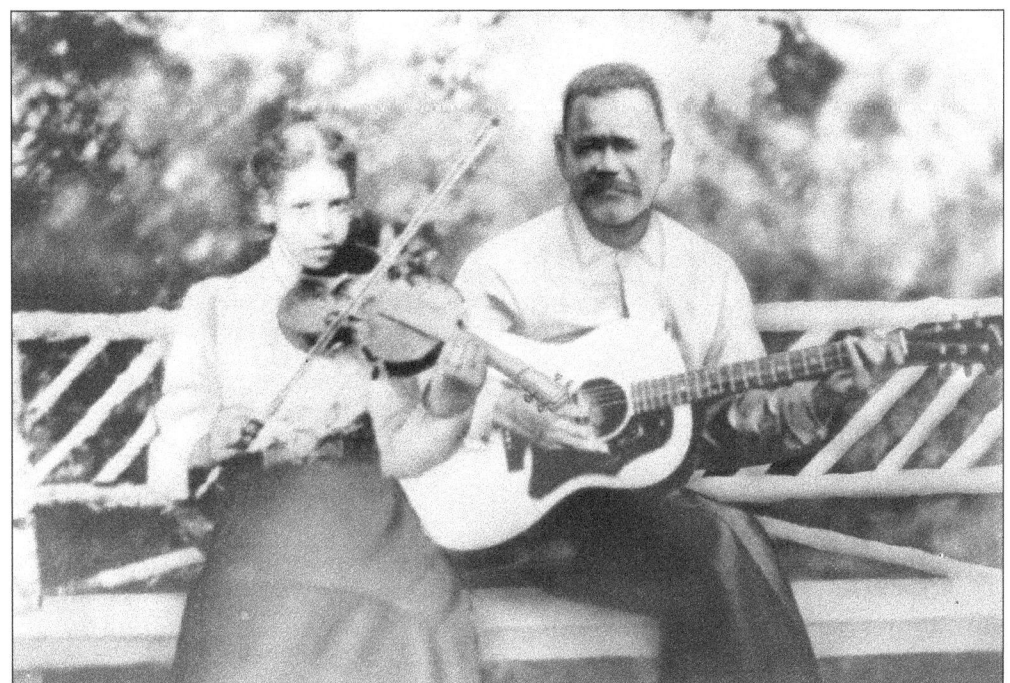

THE OLIVERS. Kitty (Oliver) Clark and Wilbert Clark lived on Maple Street This street and First Street were an enclave of settlement in town by former Skunk Hollow residents. (Courtesy Gerry Marshall.)

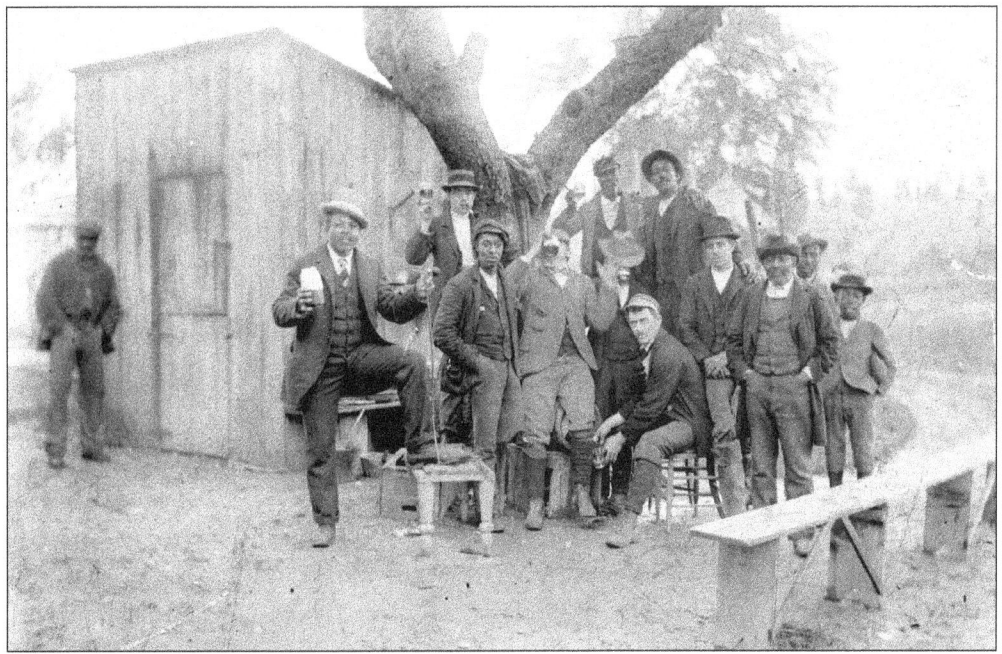

A PICNIC ON FAYETTE AVENUE, C. 1900. The Thompson brothers and some friends gathered in their backyard on Fayette Avenue. The three houses in this neighborhood were owned by members of the Oliver and Thompson families and have since been demolished. They were located in the vicinity of West Street and the reservoir. (Courtesy Kenneth Thompson.)

MATTIE "MOTHER" OLIVER. Mother Oliver was a matriarch and a leader in the African American community in Closter. Of all her activities, she was best known for her Election Day potluck dinners at the AME Zion Church. Everyone in town attended. Mattie was also Bergen County chairman of the International Relations Committee of the National Council of Negro Women and head of the Missionary Society for the New Jersey Chapter of the AME Zion Church. She is shown here in 1947. She died in 1995 at the age of 97. (Courtesy Madlyn Cooper.)

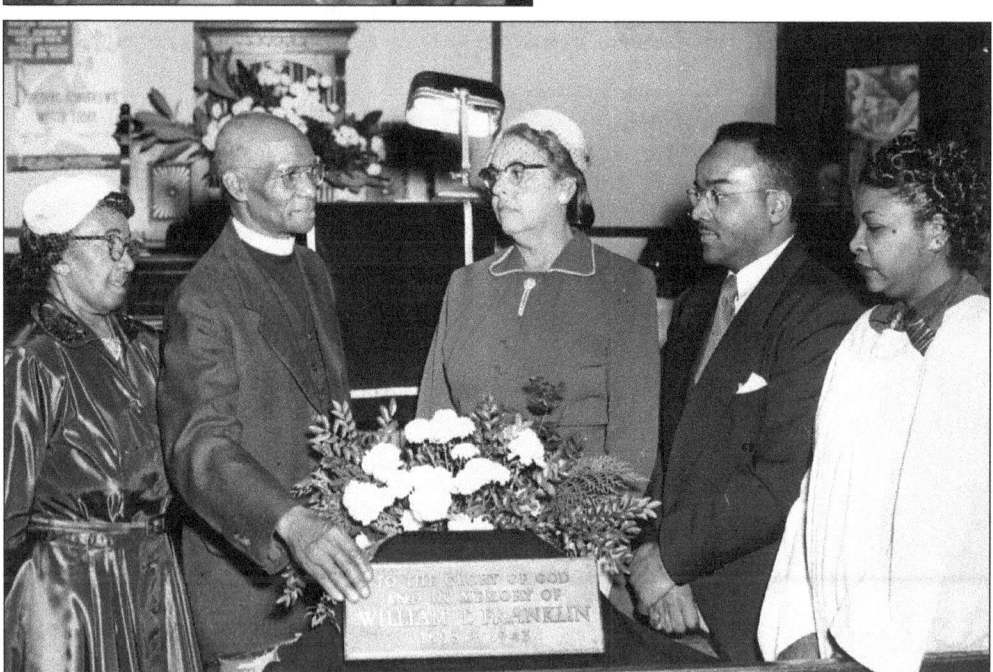

THE DEDICATION OF FRANKLIN PLAQUE AT THE AME ZION CHURCH, 1943. Shown at the dedication are, from left to right, Lulu Lloyd, Reverend Pyle, Mattie Oliver, Thomas Brokins, and Kittie Clark. The plaque was dedicated to William Franklin, who was very active in church affairs. He raised funds and built the kitchen wing addition to the church in the 1930s. Franklin and Mattie Oliver were neighbors on First Street at the corner of Maple Avenue. (Courtesy Madyln Cooper.)

Six
ALPINE:
THE HUDSON RIVER AND THE PALISADES

The Borough of Alpine straddles the crest of the rugged mountainous ridge of the Palisades along the Hudson River. Long and narrow, it runs for six miles between the New York border to Tenafly.

Alpine has essentially two separate histories. The hamlet atop the crest of the Palisades was known as Closter Mountain in 19th-century deeds, or more commonly Upper Closter, because of its location on the high ridge above Closter Village. The incredible scenery atop the cliffs attracted New York society members who built lavish estate homes in the late 19th and early 20th centuries. The area of settlements along the narrow strip of land on the Hudson River and the foot of the Palisades cliffs was called Under-the-Hill, or the Undercliff. It was lined with fishing villages, docks, wharves, and tidal water–powered industries. The Upper Closter Landing (Alpine Landing) and Lower Closter Landing (Huyler's Landing) were the main areas of population and served as the main ports to New York markets. Almost all evidence of Alpine's early history disappeared when buildings and structures were systematically demolished in the 1930s to return this area to its natural state and create the Palisades Interstate Park.

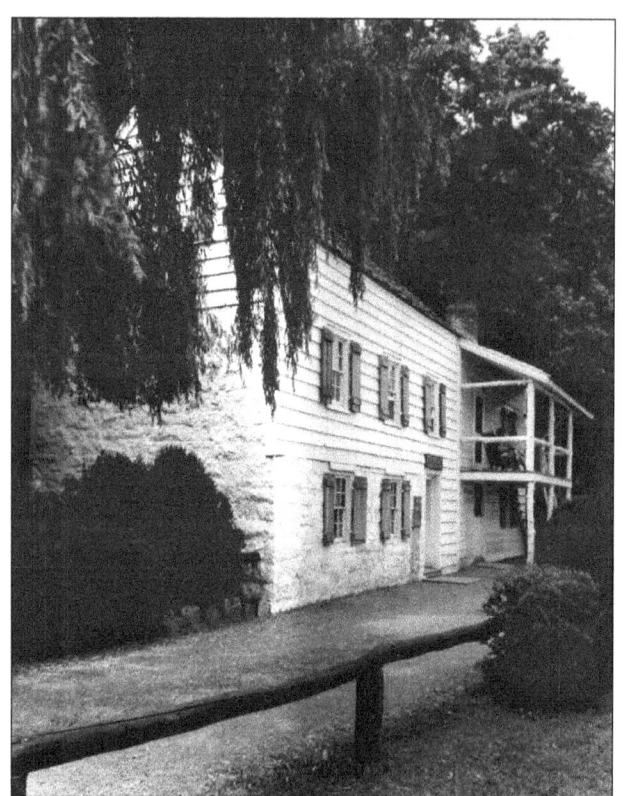

BLACKLEDGE-KEARNEY HOUSE, UPPER CLOSTER (ALPINE) LANDING. This house was one of two spared demolition by the Palisades Interstate Park Commission in the 1930s because it was erroneously believed that Cornwallis landed and set up headquarters here when he invaded New Jersey. It is a traditional Bergen County stone house, the earliest portion of which may date to as early as 1750. The sheer cliffs of the Palisades rise dramatically directly behind this house to a point of about 400 feet. (Courtesy Palisades Interstate Park Commission.)

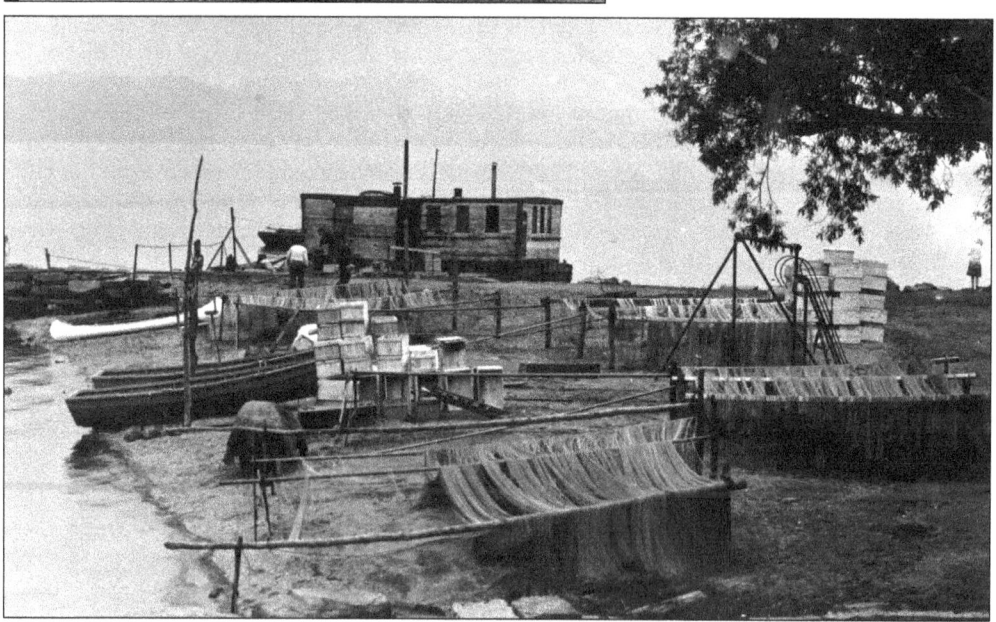

SHAD FISHING STATION. In the past, between March and June, stations were set up to catch shad migrating up the Hudson River to spawn. This was usually quite successful, some families earning enough to sustain them for the entire year. The Undercliff area was the first area to be settled in Colonial times. Here, nets are drying and crates await shipment. (Courtesy Palisades Interstate Park Commission.)

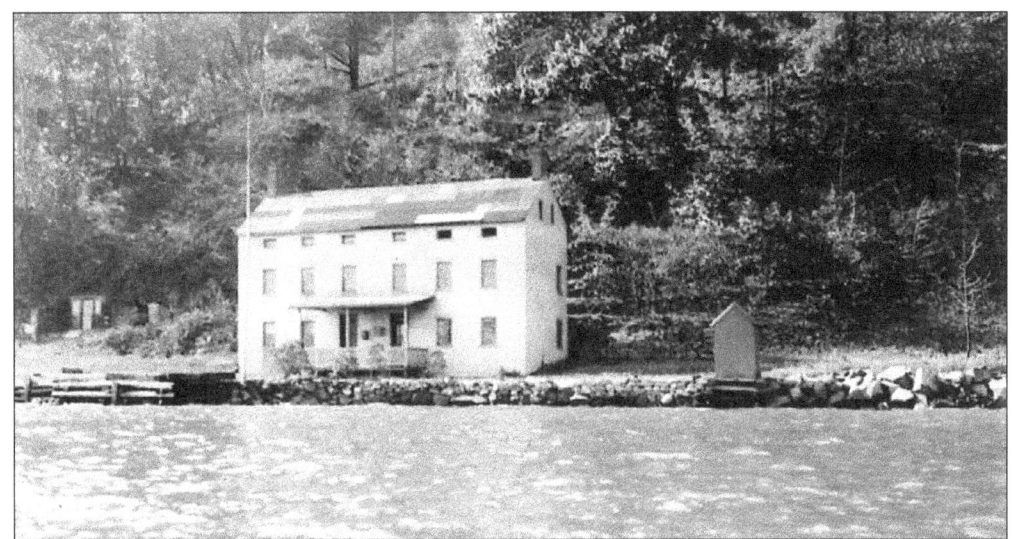

LOWER CLOSTER-HUYLERS LANDING. This photograph shows one of several barrack-type buildings built by the Huyler family to house stonecutters and dock workers. The Huyler's confiscated this land during the American Revolution; descendant George Huyler improved the road up the cliffs and also developed the river property c. 1840. The Huyler road was not as steep as the Upper Landing and became very popular with farmers and others. This is where the British invasion took place. When the road was finished, there were ferries three times a day. Walker's 1876 Atlas shows more than 50 buildings along the river strip between these two ports. (Courtesy Palisades Interstate Park Commission.)

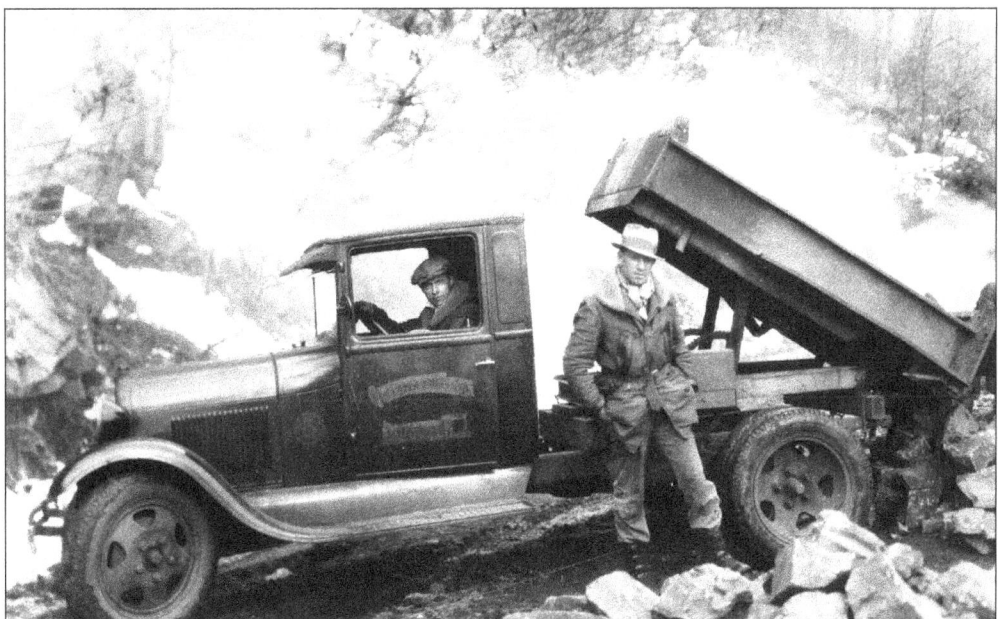

CIVIL WORKS ADMINISTRATION ROAD BUILDERS. The Civilian Conservation Corps and Civil Works Administration constructed the roadways along the river and built recreational facilities and buildings in the park during the Great Depression. Unskilled young workers and experienced engineers lived in camps in the park while undertaking these huge public works projects funded by the federal government. (Courtesy Palisades Interstate Park Commission.)

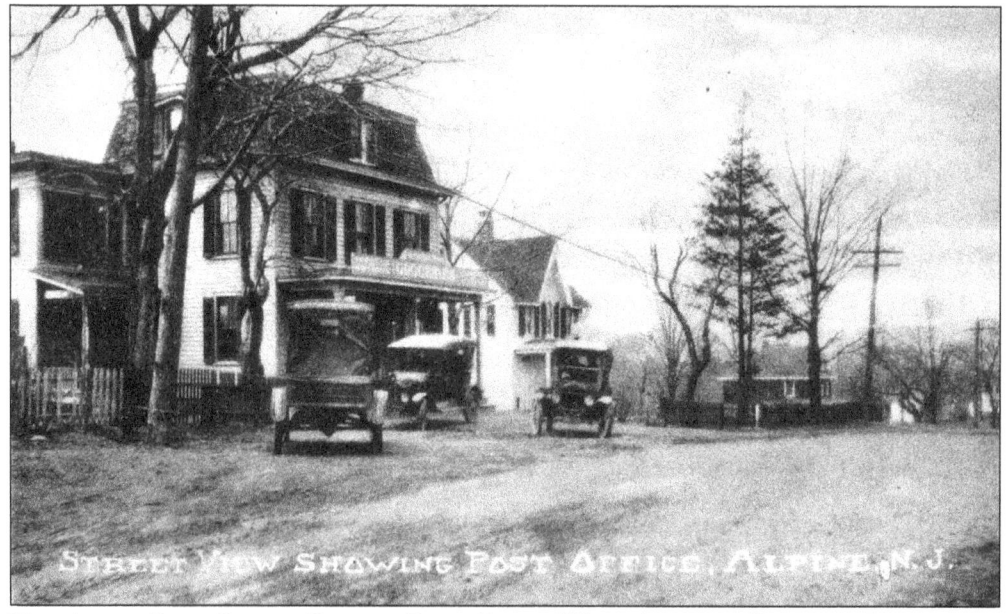

THE ALPINE POST OFFICE, CLOSTER DOCK ROAD. When the post office opened in 1870, it was called Alpine; that became the future name of the borough when it incorporated in 1903. (Courtesy Bert Pieringer.)

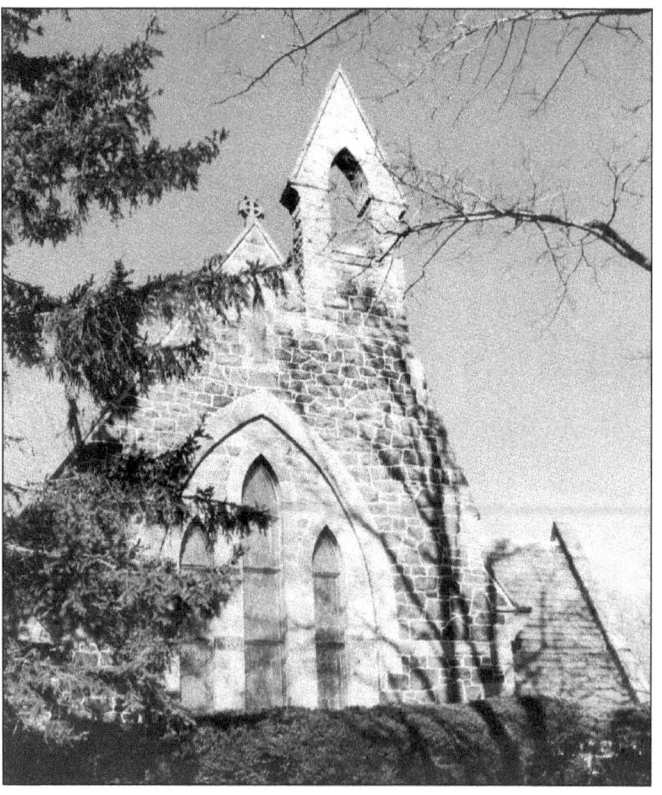

THE ALPINE COMMUNITY CHURCH, CLOSTER DOCK ROAD. This handsome, High Victorian, Gothic Revival church was designed by J. Cleveland Cady and finished in 1871. The stone is diabase, or what is locally known as Palisades bluestone. This building is the focal point of the old Alpine hamlet, which was located on the north side of Closter Dock Road, just before the Upper Closter Landing. Numerous small homes and a cemetery still exist. Many workers on the estates lived here as well as some having business on the Hudson River. (Courtesy Gayle Metzkier.)

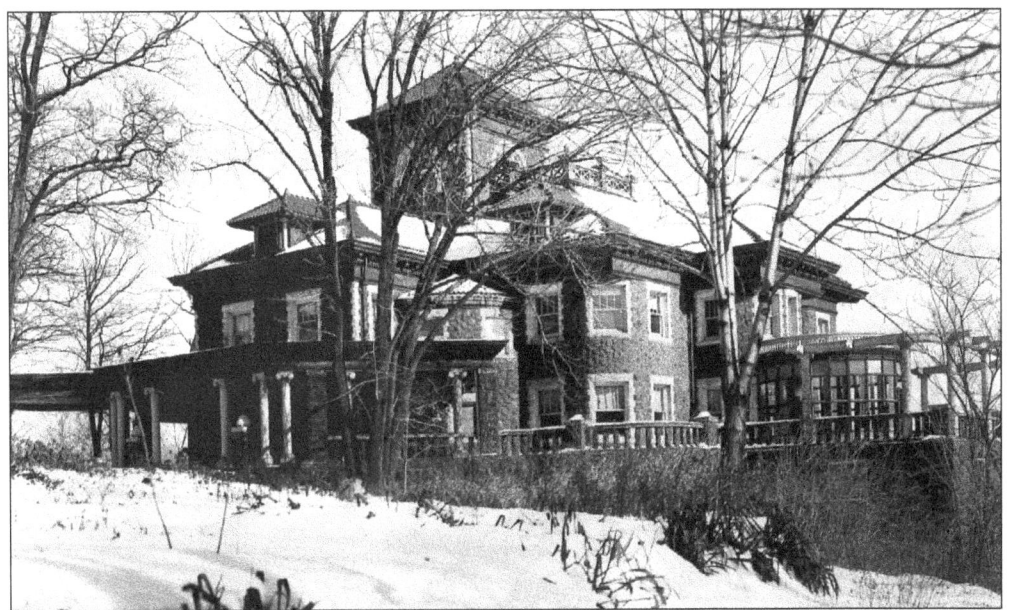

CLIFF DALE, ZABRISKIE ESTATE. George Zabriskie built his magnificent estate house with outbuildings, pools, and rambling gardens on the crest of the palisades in 1911. Zabriskie owned flour mills, which were later owned by the Pillsbury Company. Other famous estate owners were J. Cleveland Cady (architect), Calvert Vaux (landscape architect), the Lamb family (stained glass studios), John Ringling (circus entrepreneur), and inventors and business successes. All of their homes are nonextant, and only remnants of foundations remain today. (Courtesy Palisades Interstate Park Commission.)

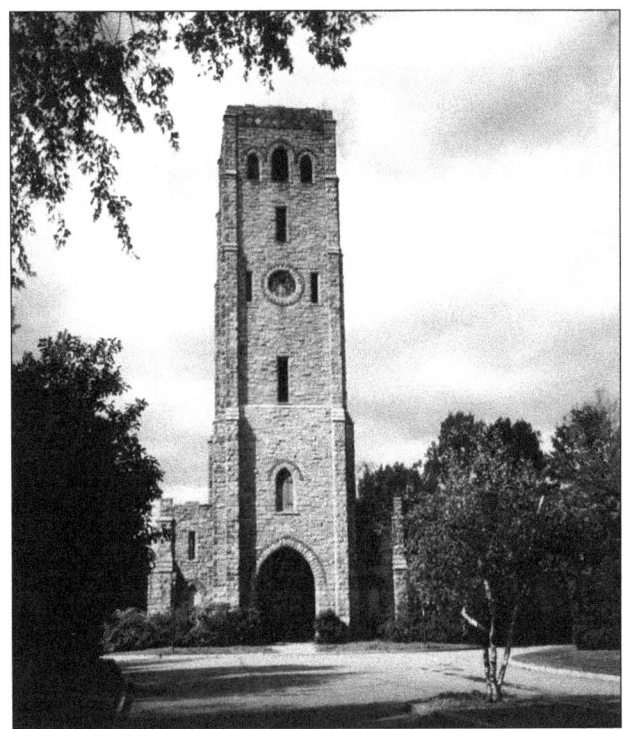

THE RIO VISTA TOWER. Built in 1910 on the Manuel Rionda estate, the tower is a four-stage, Gothic Revival–style, stone tower with a clock. Rionda was a Cuban immigrant who remained close to the New York sugar exchanges. His tower was probably built to model the towers built by the sugar barons in the Valle de los Ingenios in central Cuba. There they were used to monitor the slaves in the cane fields. Rionda delighted in escorting guests to the top by elevator. His estate house was located where the Alpine Look Out is today. (Photograph by Gayle Metzkier.)

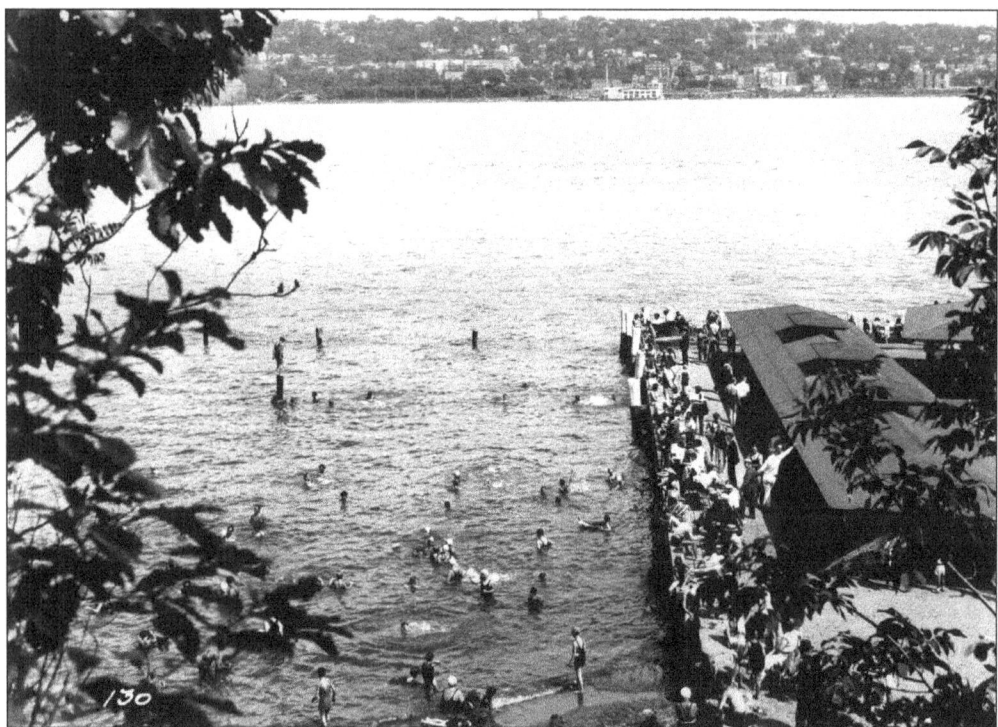

THE BATHING BEACH AT ALPINE LANDING. A sandy beach was located just north of the ferry dock. Bathers in the 1930s enjoyed guest facilities and clean river water. Most came via the Yonkers ferry, other excursion boats, or by car from New York City or other parts of New Jersey. Yonkers, New York, can be seen across the river in the background. (Courtesy Palisades Interstate Park Commission.)

THE BOULEVARD TURNOFF FOR THE YONKERS FERRY. Also known as Route 1 or Route 9W, this main thoroughfare above the cliffs became heavily trafficked during the 1930s, when the ferry and recreation facilities were at their peak use. The building was the headquarters of the Palisades Interstate Park Commission and was built in 1928. It was demolished when the Palisades Interstate Parkway was built in the 1950s. (Courtesy Palisades Interstate Park Commission.)

Seven

THE TWENTIETH CENTURY

The beginning of the 20th century saw the demise of Old Harrington Township when the passage of a General Boroughs Act in 1878 offered the possibility of incorporating boroughs. Many of the new boroughs surrounding Closter assumed their present boundaries and some took lands that were formerly known as Closter. Alpine received borough status in 1903, Closter in 1904.

The opening of bridges and tunnels to Manhattan allowed large numbers of automobiles to cross to and from the city. As automobile use became more common, there was no need to settle in a concentrated area around a depot. The settlement pattern became more dispersed and tract housing projects sprang up in all corners of the borough and the Northern Valley. The post–World War II housing shortage was spurred by returning veterans, since little construction had taken place during the Great Depression and the war. Prefabricated housing was an attractive alternative.

The most unusual development in housing of the period was the Lustron Corporation's all-metal, porcelain-finished, steel houses. Closter and Apine have the only two of these left in Bergen County. The automobile caused other changes in transportation in the 20th century. When the George Washington Bridge was finished in 1931 and the Lincoln Tunnel in 1937, ferry service on the Hudson River began to decline and most companies soon went out of business. Commuter service on the Erie Railroad out of the Closter depot lasted several decades longer. The last passenger train ran through the Northern Valley on this line in 1966.

CAR CRASH ON PIERMONT ROAD. This car was taken to the gas station owned by Arthur Parsells Sr. for repair. The station was on the corner of Piermont Road and Homans Avenue where the Shell station is today. (Courtesy Alice Parsells.)

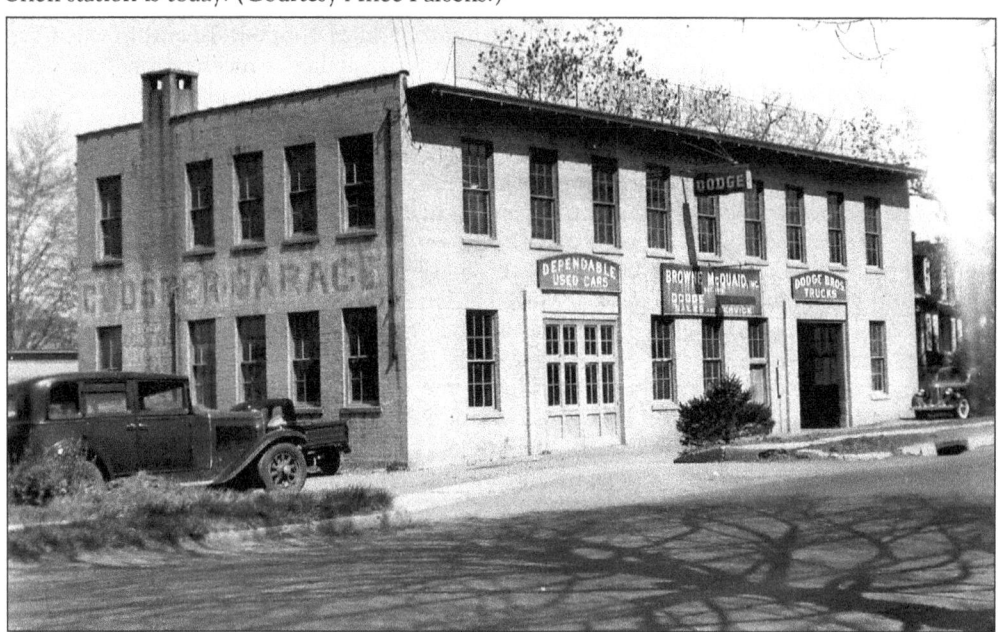

THE CLOSTER GARAGE, 395 CLOSTER DOCK ROAD. The original Closter Garage was built c. 1910. It was one of the earliest automobile repair garages, including parts, new and used car sales, and taxi service in Bergen County. The trendy *Ye Scribe's Club's Touring Book,* published in 1913, recognized only the Closter Garage in the entire geographical area between Jersey City and Nyack. This establishment later became McQuaid & Brown Motors. (Courtesy Jane Westervelt.)

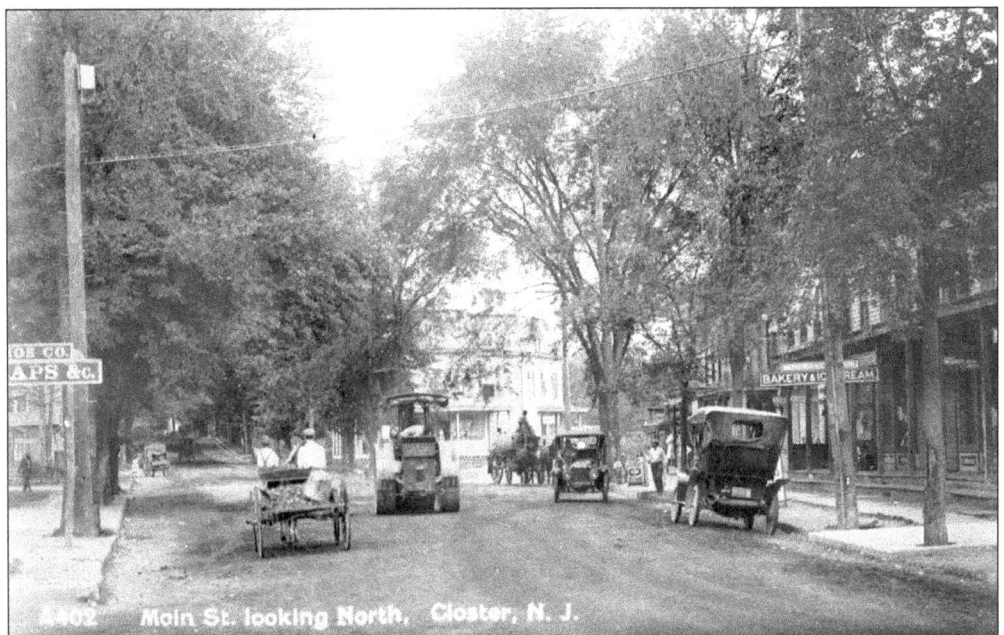

MAIN STREET, LOOKING WEST. This c. 1915 postcard shows the combination of horse and car traffic and the new mechanized steamroller used for road building.

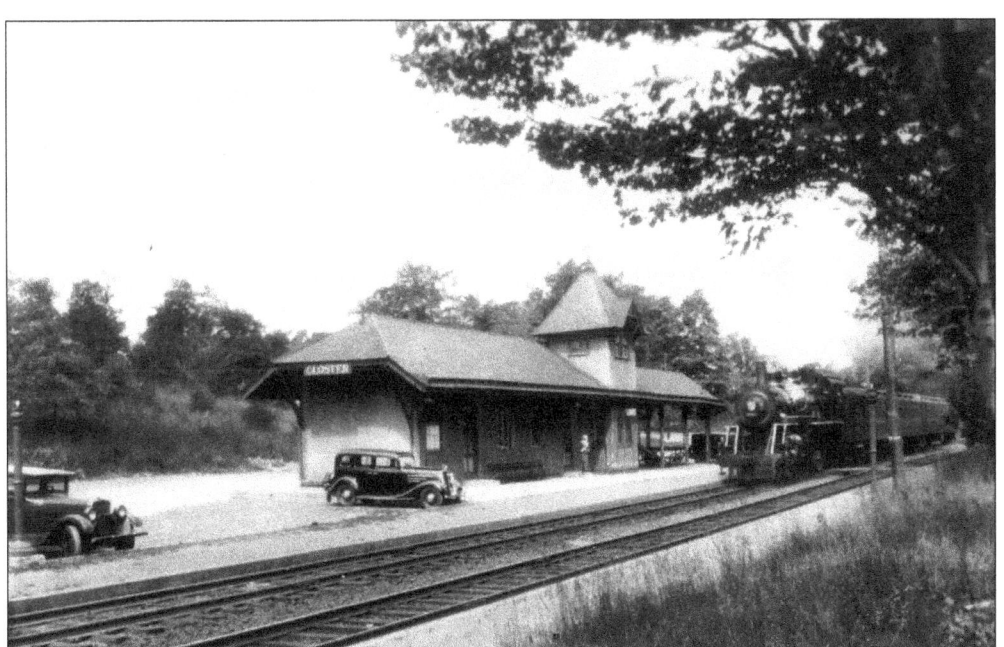

THE RAILROAD DEPOT, C. 1930s. Automobile traffic led to the Northern line's reduction of passenger service throughout the mid-20th century. The three tracks were reduced to one and, in 1966, passenger service was discontinued. (Courtesy Mark Gerub.)

THE FIRE DEPARTMENT'S NEW TRUCK. In 1922, the Knickerbocker Hook & Ladder Company retired the horse-drawn pumpers and turned to trucks. (Courtesy Closter Fire Department.)

DICK AND INEZ WRAY, 1918. The photograph shows Dick in uniform. The couple built the Craftsmen-style home at 323 Durie Avenue in 1928. (Courtesy Charles Lyons.)

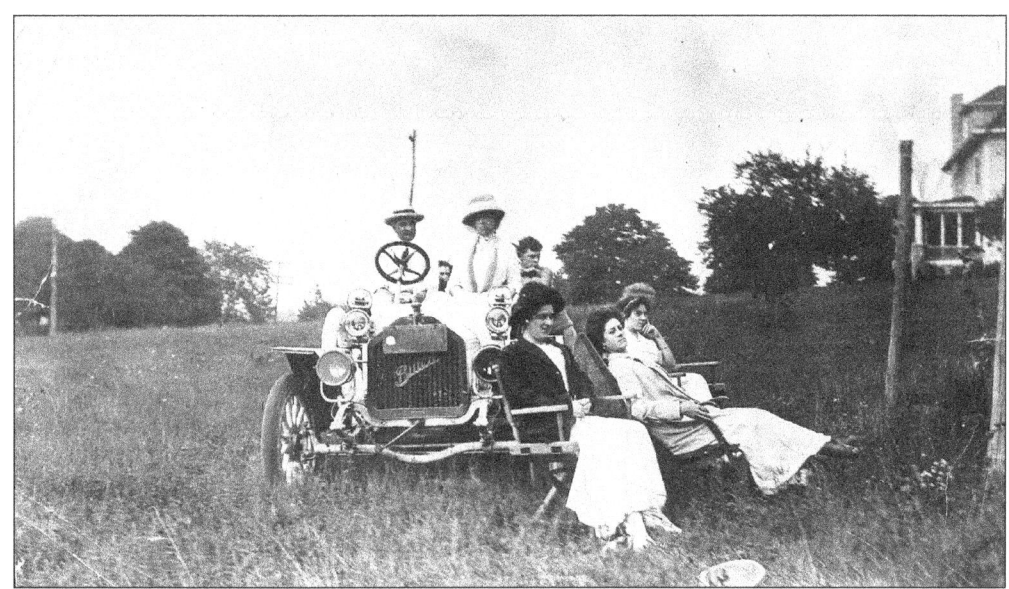

A PICNIC ON SCHRAALENBURGH ROAD. Members of the Wray family and friends enjoy an outing at the corner of Durie Avenue in 1913. (Courtesy Charles Lyons.)

DEER HUNTING ON ANDERSON AVENUE. Shown, from left to right, are William Hoffman, Fred Parsells, Henry Hoffman, William Bell, Elwood Hoffman, Victor Bell, and Elmer Hoffman. This photograph was published in the *American Pictorial* newspaper on January 11, 1922, with the caption "Deer Hunt at Home. It is not necessary to travel to the North Woods for a venison steak. This is one of two deer shot in the Palisades near Closter." (Courtesy Alice Parsells.)

REVOLUTIONARY FIFE AND DRUM. This 1932 parade showcased the town's ties to Revolutionary events. (Courtesy Charles Lyons.)

THE CLOSTER THEATER, CLOSTER DOCK ROAD. The theater was built soon after 1900 and was demolished after 1915. It was located near the present-day municipal building and doubled as a gymnasium and basketball court. According to George Trautwein, it did not have a stage proper. Well-known actors and playwrights performed Broadway plays here; James O'Neil (father of Eugene O'Neal) was featured in the *Count of Monte Cristo* on April 21, 1914. (Courtesy John Mangano.)

Monster Monster

LEAP YEAR DANCE
of the

ORIGINAL JAZZ BOYS

To be held at the **NEMO THEATRE** Closter N.J.

FRIDAY EVENING ❋ APRIL 16th, 1920

Music by the Famous EUREKA MELODY CLUB

Dancing at Eight O'clock Sharp

Tickets 50 Cents War Tax 5 Cents Total 55 Cents 6

NEMO THEATRE DANCE TICKET. The Nemo theater was built after the Closter Theater behind the Ferdon-Eckerson Store on Durie Avenue at the railroad tracks. It was one of the most luxurious in the Northern Valley. George Trautwein remembers silent films here: "They would wait until the 8:20 train arrived from Nyack and the train coming from the other direction from Hoboken to start the movie. This way all the people would be there and there would be no interruptions from trains." Eddie Oliver and his brother would play the music for the films. The theater floundered during the Great Depression and even a Shirley Temple talkie in the 1930s could not bring it back. It then became Wrixon's Bowling Alley. (Courtesy Charles Lyons.)

J. MASSEY RHIND, C. 1923. Rhind was born in 1860 in Scotland to a family of famous sculptors. He immigrated to America and developed a reputation for his sculptural renditions on architecture, including portions of Grant's Tomb. In 1899, he set up a marble- and stone-carving concern on Demarest Avenue (site of the A & P) near the railroad tracks in Closter. He became popular and his work can be found in the Newark Museum and as outdoor sculpture in the parks there. Future artists, including younger Scotsman Robert Alexander Baillie, apprenticed in his studio and carried the studio tradition here for the next two generations. (Courtesy Belskie Museum.)

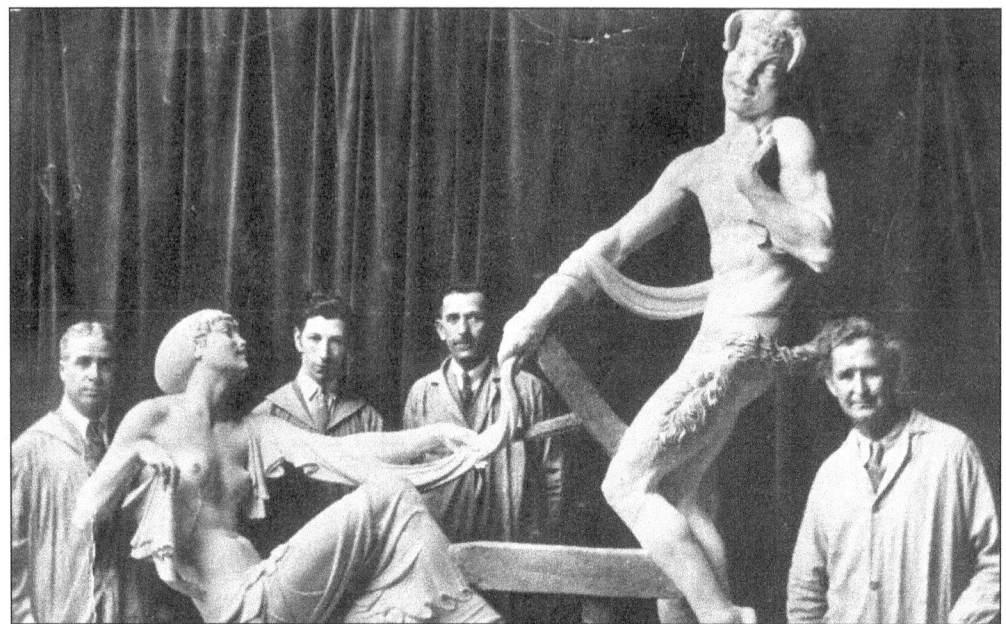

AFTERNOON OF A FAUN, BY BRYANT BAKER. Photographed with the work are, from left to right, unidentified, Abram Belskie, Charlie Semano, and Robert Alexander Baillie, whose studio carved the piece. Baillie formally studied at the Cooper Union in New York but returned to Closter in 1916 to open his own studio (also on Demarest Avenue). This piece was completed in 1934 and is in Brookgreen Gardens in South Carolina. Abram Belskie was a talented protégée in the studio and several of his pieces are also in the same outdoor museum. (Courtesy Belskie Museum.)

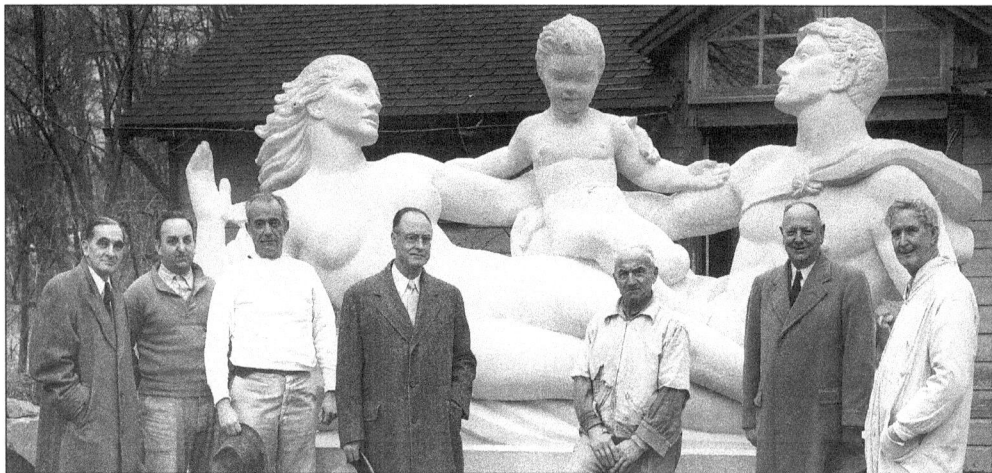

THE BAILLIE STUDIO. The artists pose in front of an unidentified piece by Joseph Di Lorenzo, third from left, Joseph Giannotti, third from right, and Baillie, far right. Di Lorenzo was a Closter resident and lived on Alpine Drive. Baillie was a master carver who transposed clay models into stone for some of the most famous artists of the day, including Anna Hyatt Huntington, Malvina Hoffman, and Brenda Putnam. When Archer Huntington established Brookgreen Gardens, a model for American outdoor sculpture, Baille did much of the carving. He also worked for 30 years as a trustee member. Many older residents remember sitting outside of these studios after school watching these masterpieces take shape. (Courtesy Belskie Museum.)

HENRY H. MANDLE. Mandle was a leading civic and municipal figure in Closter and the Northern Valley. He was chairman of the building committee for Pascack Valley Hospital (in nearby Emerson) and served as president of the trustee board for many years. In Closter, he was instrumental in establishing the library, Temple Beth-El, building the borough hall, and involved as trustee with the 150-acre Closter Nature Center. He also served two terms as councilman. He was born in New York City in October 1892 and married in 1918. He lived in Closter at 333 Demarest Avenue from 1914 until the 1950s.

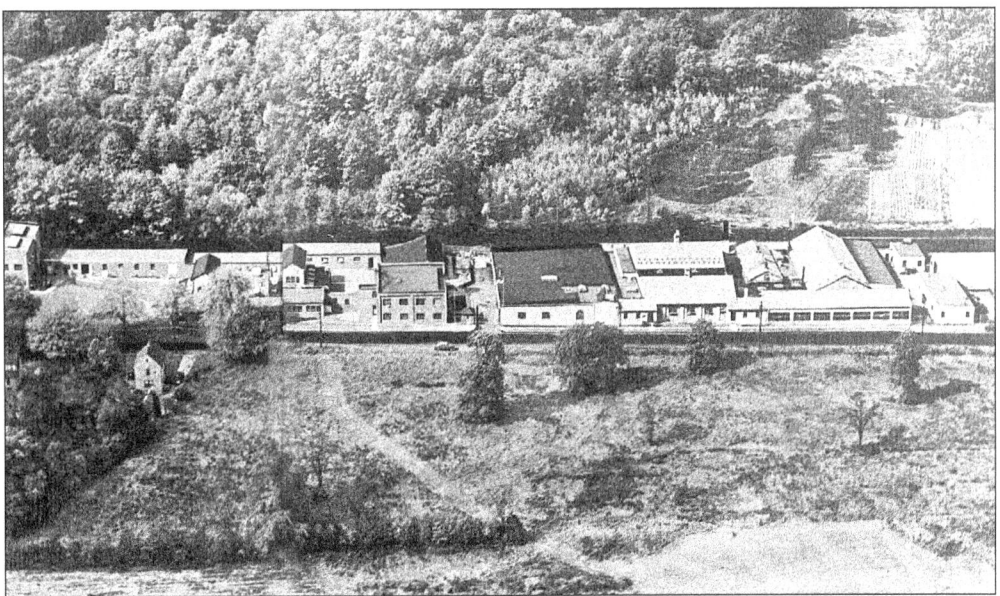

THE U.S. BRONZE AND POWDER WORKS, 80 HERBERT AVENUE. This was the largest industry and employer in the Northern Valley in the first half of the 20th century. Original sections of the building were built in 1918 and expanded until the factory closed in 1955. Factory owner Mandle graduated from Columbia University with a degree in chemical engineering in 1914. He purchased the building formerly known as the B. Ulmann & Company in Closter in 1918. His concern manufactured explosives during World War II but, after the war, returned to peacetime products such as bronze and aluminum powders used in the graphics and painting industries.

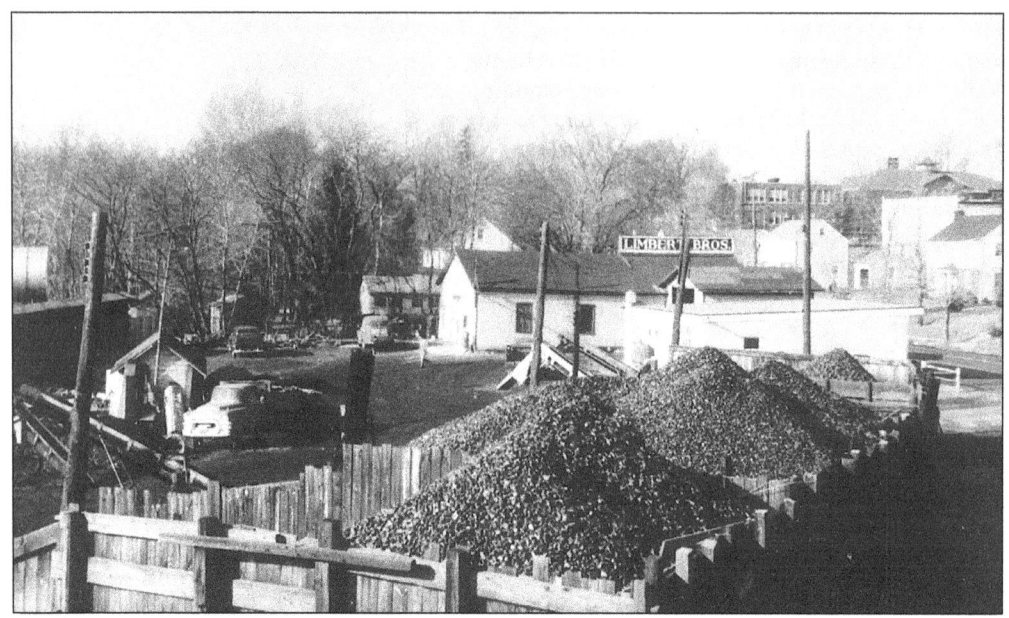

THE LIMBERT BROTHERS COAL YARD, 396 DEMAREST AVENUE. This photograph, looking west, shows the coal yards in 1948. The Village School is in the background. It was on the site of the A & P. (Courtesy Limbert family.)

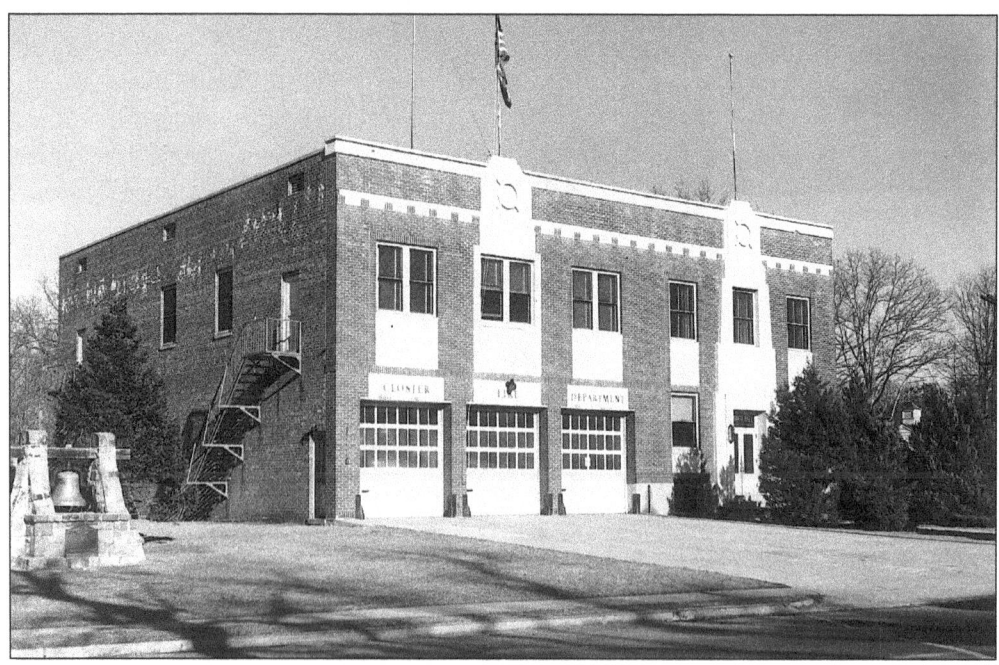

BOROUGH HALL, CLOSTER DOCK ROAD, 1938. This building was once home to the fire department. A Works Projects Administration project built in the Moderne style, it remains the only civic building in town.

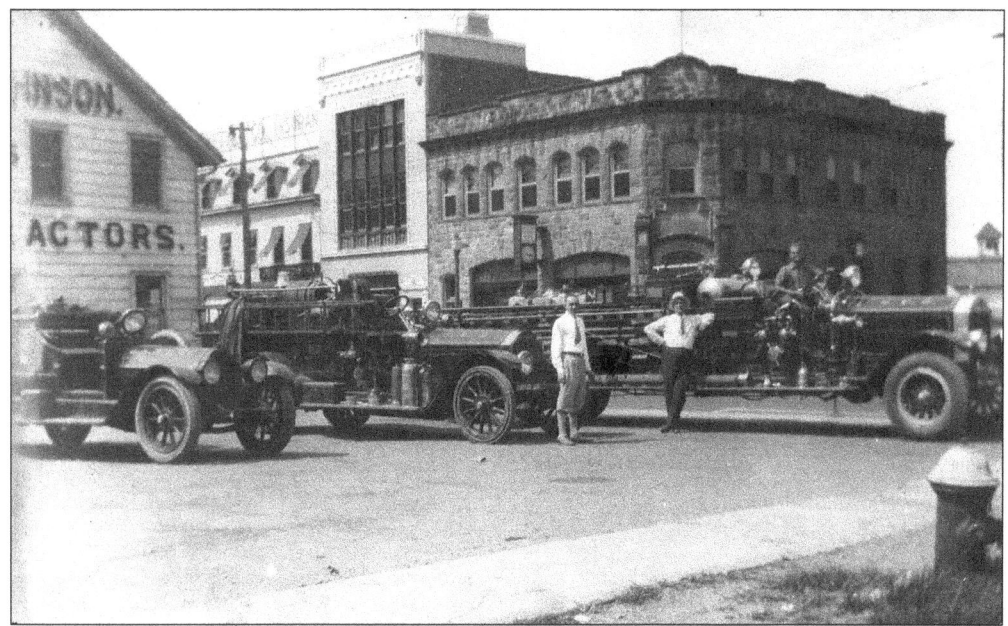

FIRE ENGINES ON PARADE, C. 1928. This parade on Main Street proceeded in front of the Closter Bank building (1913). Next to that is the only terra cotta–clad building in town, which was built c. 1920 by L.C. Waldwick. Linndemann Row is also shown. (Courtesy Closter Fire Department.)

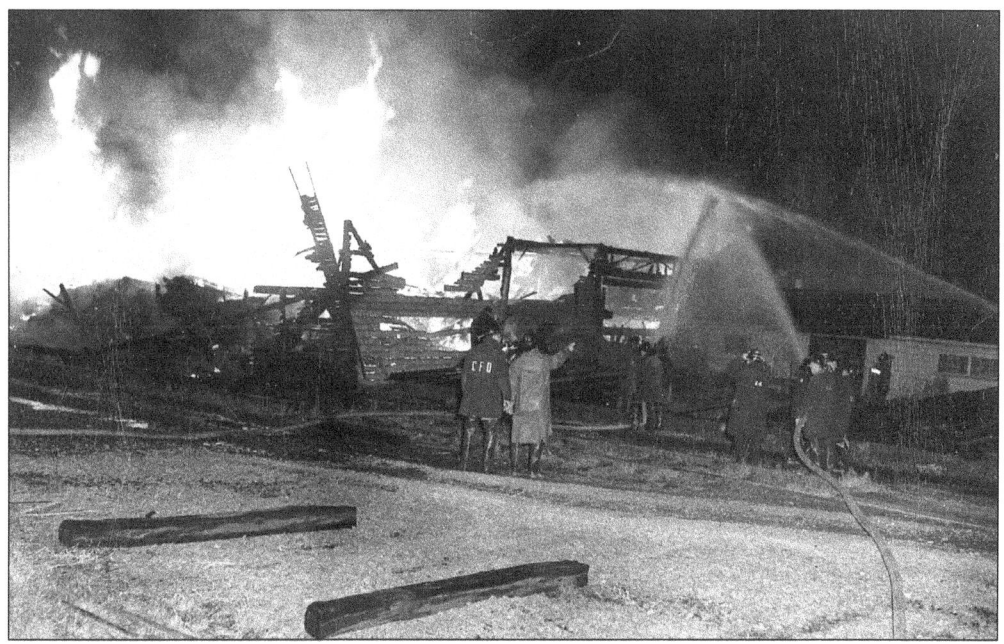

A FIRE. There were two great fires in town in the 20th century. One was at the J.J. Demarest Store and another at Reuten Windows. (Courtesy Closter Fire Department.)

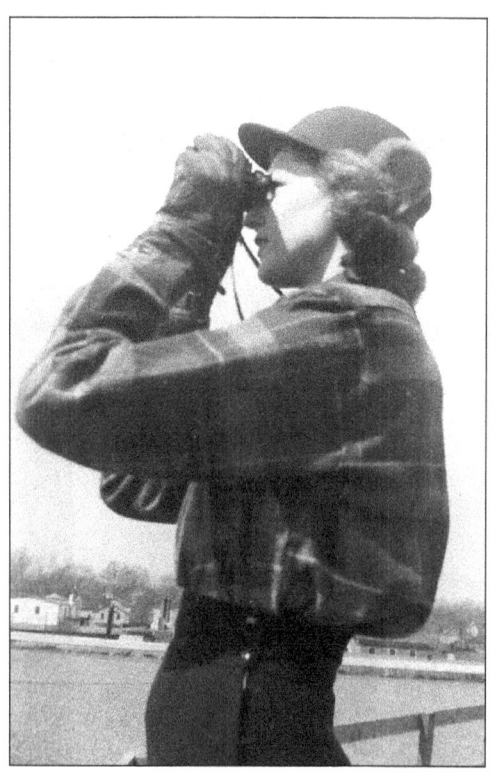

GROUND OBSERVER CORPS, WORLD WAR II SPOTTERS. M.J. Bogert, shown on the roof of the borough hall, was part of a 24-hour watch that reported aircraft to authorities at a time when the country feared invasion. She recalls: "In the early days of the post we were required to attend classes in plane identification. The identification code we used when calling headquarters changed occasionally, but 'Baker 22' still stands out in my mind. The headquarters was in White Plains, New York, and . . . they actually plotted each plane as it moved across the map." (Courtesy M.J. Bogert-Semmens.)

FOOD SHOPPING. Walter Mall and his wife, Ruth, shop at the A & P in downtown Closter during World War II. Mall had a photography studio in town; many of the 20th-century photographs in this book are from his collection. (Courtesy Walter Mall Collection.)

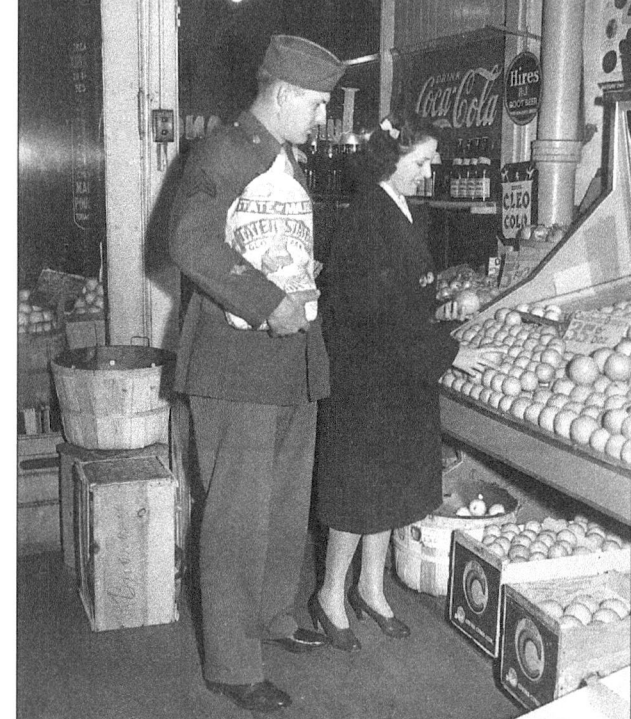

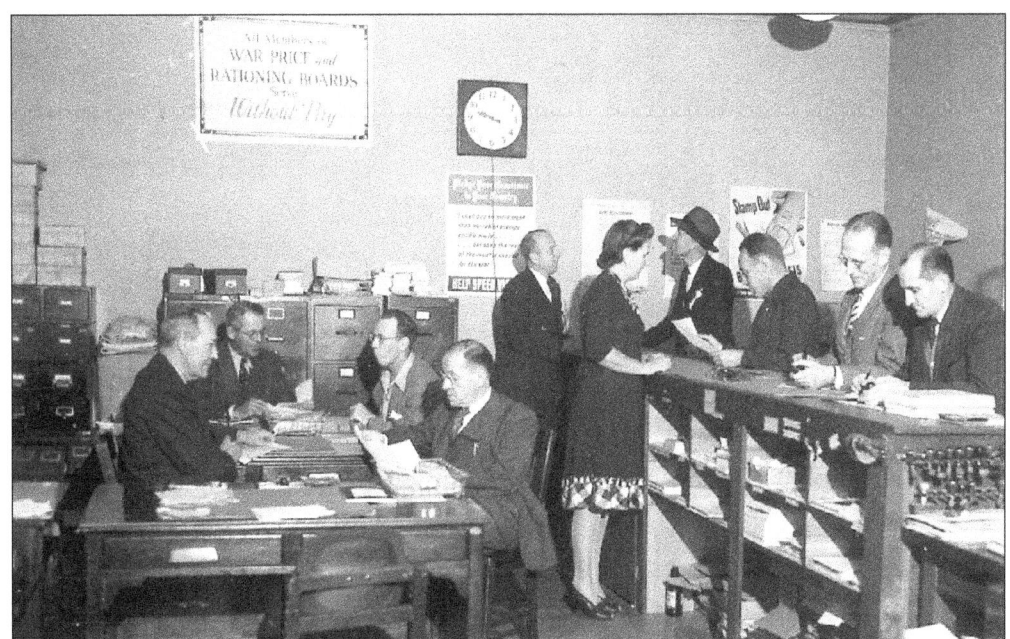

RATION BOARD HEADQUARTERS, 1944. The rations board was located in the council chambers of the borough hall and started in 1941. Pictured, from left to right, are the following: (sitting) Frank Nagel, two unidentified workers (near filing cabinets), and ? Wilson; (standing) Mel Quackenbush, Lucille and Ed Bogert, Gene Fetler, John Green, and an unidentified worker. M.J. Bogert recalls that "ration stamp books were issued to each individual. These were for canned goods, meat, sugar, shoes, tires, etc., and the merchant took the number of stamps required for each item. Gasoline was rationed according to driver's needs. The board location in Closter also covered Alpine, Harrington Park, Norwood, Northvale and Rockleigh." (Courtesy M.J. Bogert-Semmens.)

COLONEL CLIFFORD TATE AND FAMILY. Tate served in both world wars. The son of William Tate, he grew up on West Street and returned to Closter to retire after his army career. He is shown with daughters Sally and Anne. (Courtesy Sally Tate Joslin.)

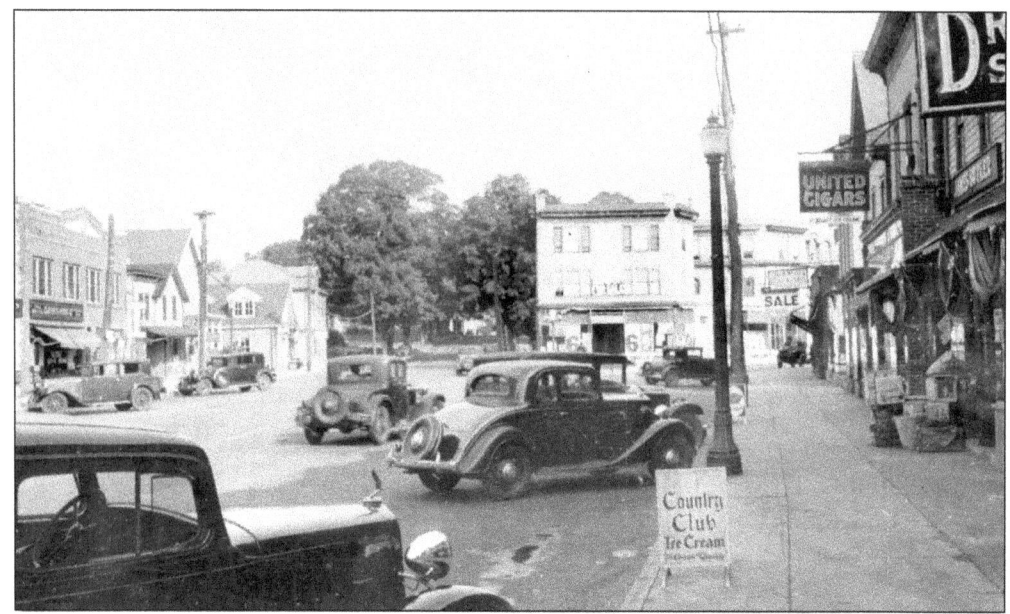

MAIN STREET, VIEW WEST, 1930S. Main Street is shown during the Great Depression. (Courtesy Orlando Tobia.)

MAIN STREET, VIEW WEST, 1954. A modernized downtown is poised to celebrate the 50th anniversary of the borough, which was incorporated in 1904. (Courtesy Walter Mall Collection.)

THE HAROLD HESS HOUSE, 421 DURIE AVENUE, 1950. In 1949, Hess was a returning World War II veteran and newly married. While searching for a new home, the couple spotted a metal prefabricated model at the Palisades Amusement Park in Fort Lee. The Lustron Corporation only produced 4,498 homes between 1947 and 1950. The more than 3,000 metal parts—including chimneys, roof tiles, insulated tiles, heater, bathroom fixtures, lights, windows, doors, and frame—were delivered by a trailer truck and assembled on site. (Courtesy Harold Hess.)

THE HESS HOUSE. The Hess family poses in front of their completed Lustron home. This is the Westchester Deluxe model, with breezeway and one-car garage. The deluxe two-bedroom package included a built-in metal dining room hutch, mirrored bookshelves, and bedroom vanity. The maintenance-free porcelain finish needed only to be cleaned with a damp cloth. Hanging pictures with magnets and spring cleaning with auto polish were just some minor adjustments. (Courtesy Harold Hess.)

THE WITMER-HIORTH HOUSE, DUBOIS AVENUE, ALPINE. A second Westchester Deluxe model made its way to Alpine. These are the only two remaining Lustron homes in Bergen County. Fewer than 16 were shipped from headquarters in Ohio to New Jersey. In 1946, Carl Strandlund invented the concept and received $37 million in federal financing to manufacture affordable prefabricated porcelain-enameled steel houses to ease the postwar housing shortage. The enterprise was short-lived because of distribution problems, resistance by local building trades, and municipal zoning boards. (Photograph by Uma Reddy.)

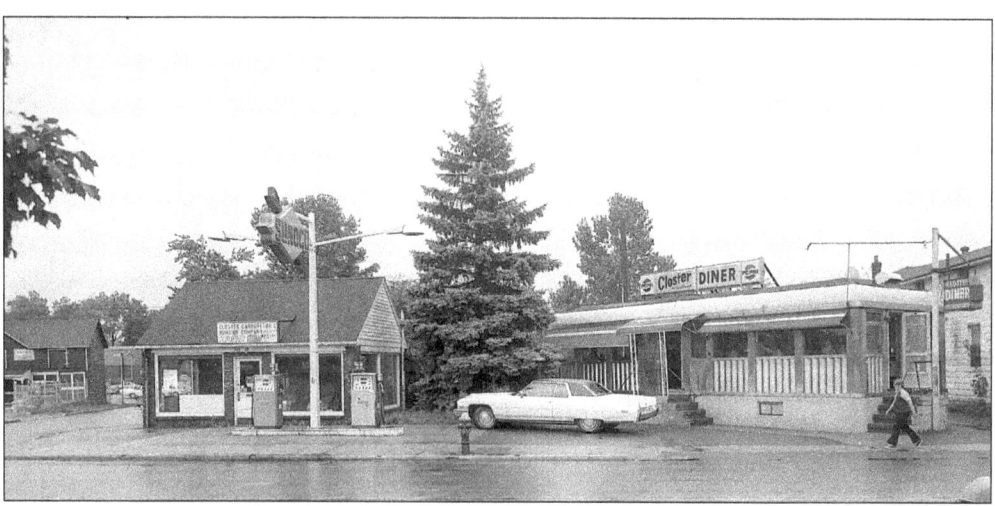

THE CLOSTER DINER. Another uniquely American building type was the prefabricated, metal, and streamlined restaurant. This mid-1960s photograph shows the c. 1940 diner when it was still sited on a diagonal line. Later, it was named the Plaza Diner and lined up horizontally with the curb. Unfortunately it was removed to New England in the late 1980s. (Courtesy Walter Mall Collection.)

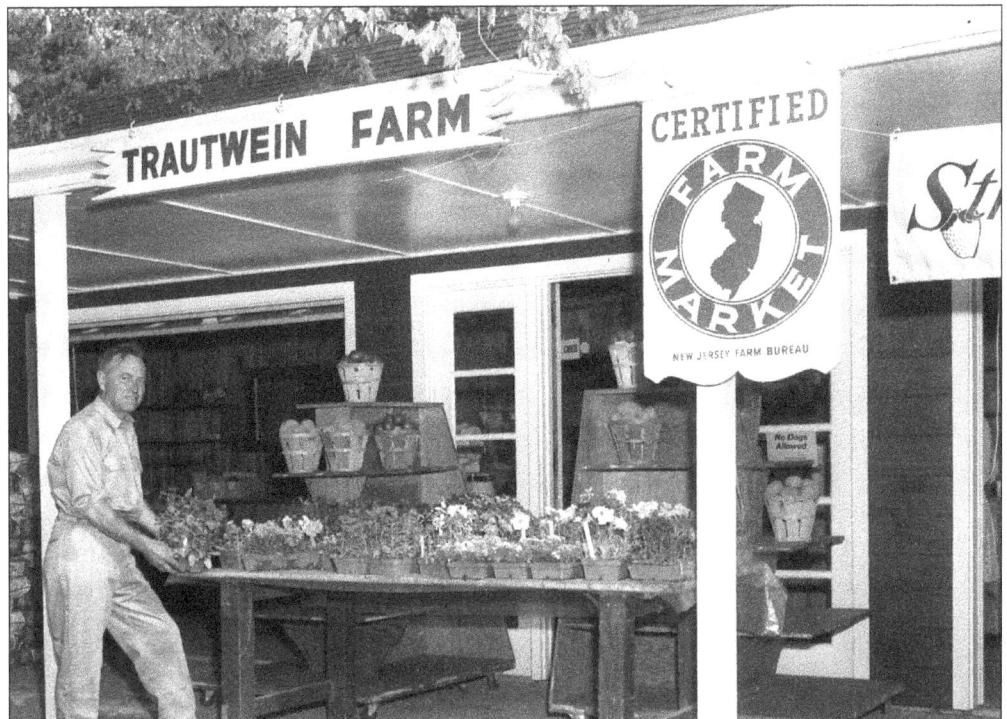

THE TRAUTWEIN ROADSIDE PRODUCE STAND, C. 1950. Many Closter farms extended their small roadside seasonal stands into larger markets and garden centers during the last half of the 20th century. George Trautwein's business became a state-certified market during the 1950s. He earned a degree in agriculture from Rutgers University and served as president of the state-certified farm market program for many years. (Courtesy George Trautwein.)

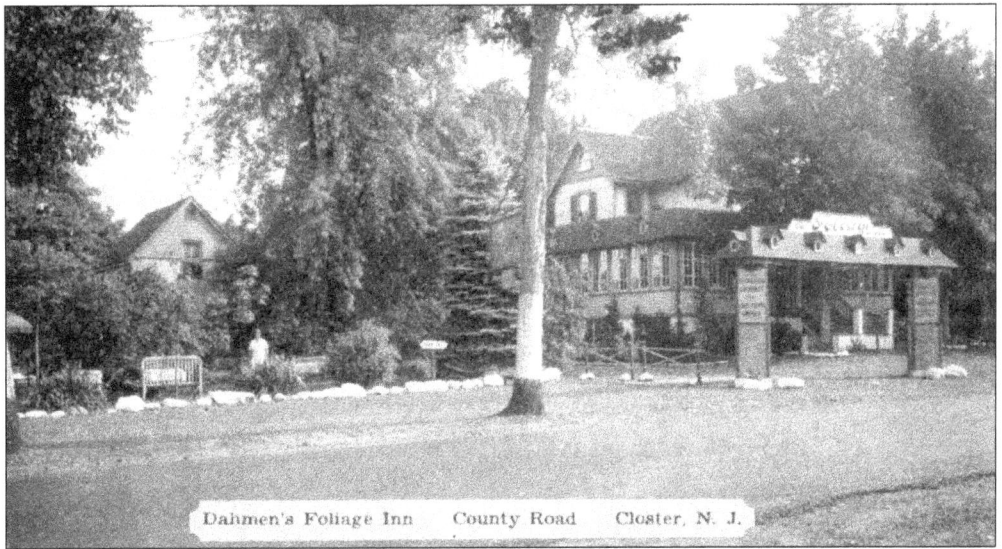

DAHMEN'S FOLIAGE INN (ONDINES), PIERMONT ROAD. Numerous restaurants, catering halls, and taverns lined Piermont Road in the 20th century, including Henry Schmidt's Closter Manor Inn, the Old Mill Inn (Peking Duck), the Red Coach Inn (China Chalet), and Victor's Chateau (Top Side).

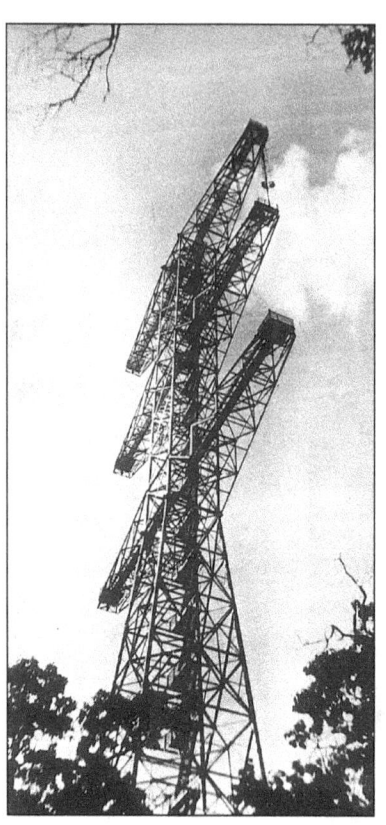

THE ARMSTRONG RADIO TOWER, ALPINE. This photograph of the Alpine tower was taken c. 1938 soon after its construction. It is a visual and historical landmark along Route 9W and is the site where Maj. Edwin Howard Armstrong, the inventor of FM radio, perfected FM transmissions. The tower is 400 feet high with three 150-foot cross arms and is located at an elevation of 520 feet on old Closter Mountain. Armstrong built the tower with $300,000 that he cashed in from previous inventions. He spent much of his time in legal battles over patent rights with RCA. (Courtesy Alpine Tower Company.)

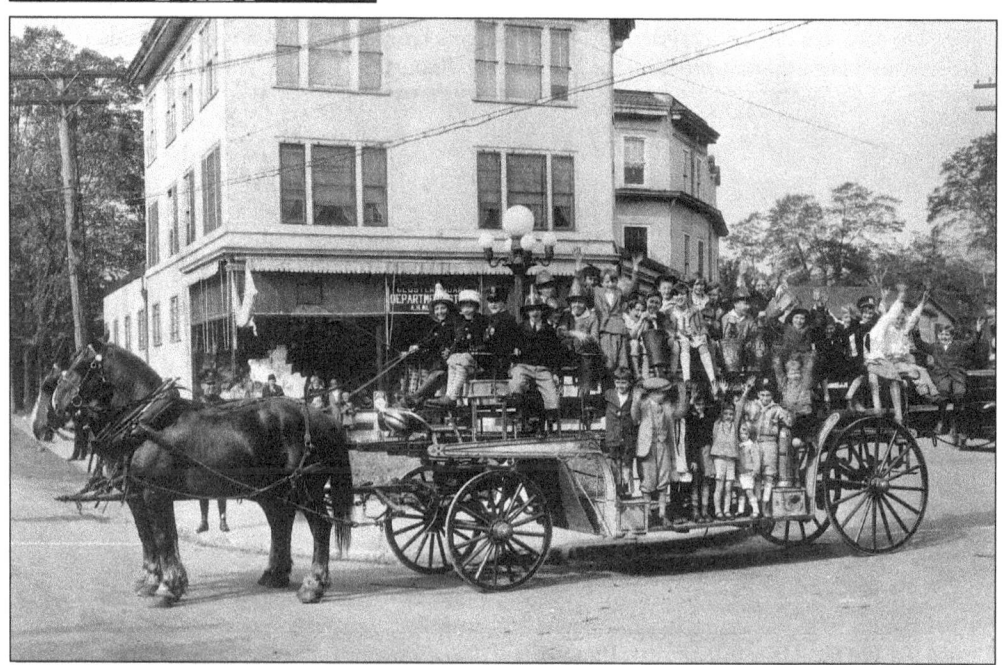

CHILDREN WAVING. Children are piled onto an old horse-drawn fire wagon the day it was retired by the Knickerbocker Hook & Ladder Company in 1922. Behind is Moskovitz's Department Store. (Courtesy Frank Saladino.)

www.ingramcontent.com/pod-product-compliance
Lightning Source LLC
Chambersburg PA
CBHW080854100426
42812CB00007B/2022